Mr. Willie Logan
1305 Dixon St.
Fredericksbrg, VA 22401

W9-BYG-790

ESSENTIAL

History of American Art

ESSENTIAL

History of American Art

Suzanne Bailey

p

This is a Parragon Publishing Book
This edition published in 2002

Parragon Publishing
Queen Street House
4 Queen Street
Bath BA1 1HE, UK

Copyright © Parragon 2001

ISBN: 0-75255-355-0

The author and publishers have made every reason-
able effort to contact all copyright holders. Any errors
that may have occurred are inadvertent and anyone
who for any reason has not been contacted is invited
to write to the publishers so that a full acknowledge-
ment may be made in subsequent editions of this
work.

A copy of the CIP data for this book is available from
the British Library upon request.

The right of Suzanne Bailey to be identified as the
author of this work has been asserted in accordance
with Section 77 of the Copyright, Designs and Patents
Act of 1988.

Editorial, design and layout by Essential Books,
7 Stucley Place, London NW1 8NS

Picture research: Image Select International

Printed and bound in China

The publishers are grateful to the following copyright holders for the permission to reproduce images:

Jean-Michel Basquiat *Man from Naples* © DACS 2001
Louise Bourgeois *Fée Couturière* © DACS 2001
Stuart Davis *Gasoline Tank* © DACS 2001
Stuart Davis *International Surface No. 1* © DACS 2001
Willem de Kooning *The Wave* © DACS 2001
Arthur Dove *Cow and Calves* © Arthur Dove 2001
Arthur Dove *Sun* © Arthur Dove 2001
Marcel Duchamp *Fountain* © DACS 2001
Marcel Duchamp *Nude Descending a Staircase, No. 1* © DACS 2001
Arshile Gorky *Untitled* © DACS 2001
David Hockney *Pacific Coast Highway and Santa Monica* © David Hockney 2001
Jasper Johns *Diver* © DACS 2001
Jasper Johns *Three Flags* © DACS 2001
Franz Kline *Blueberry Eyes* © DACS 2001
Roy Lichtenstein *In the Car* © DACS 2001
Bruce Nauman *My Life as though It were Written on the Surface of the Moon* © DACS 2001
Bruce Nauman *Run from Fear/Fun from Rear* © DACS 2001
Alice Neel *Self-Portrait* © Alice Neel 2001
Barnett Newman *Be I* © DACS 2001
Georgia O'Keeffe *New York with Moon* © DACS 2001
Georgia O'Keeffe *Purple Petunias* © DACS 2001
Claes Oldenburg *Cheesecake from Javatine* © DACS 2001
Claes Oldenburg *Floorburger* © DACS 2001
Maxfield Parrish *Lusisti Statis* © DACS 2001
Jackson Pollock *Autumn Rhythm (Number 30)* © DACS 2001
Jackson Pollock *Going West* © DACS 2001
Jackson Pollock *Lavender Mist, No. 1* © DACS 2001
Robert Rauschenburg *Reservoir* © DACS 2001
James Rosenquist *The Margin Between* © DACS 2001
Mark Rothko *Blue, Green, Blue on Blue Ground* © DACS 2001
Mark Rothko *Untitled (Reds)* © DACS 2001
Frank Stella *Flin Flon* © DACS 2001
Frank Stella *Green Border* © DACS 2001
Clyfford Still *Indian Red and Black* © DACS 2001
Andy Warhol *Dollar Signs* © DACS 2001
Andy Warhol *Marilyn* © DACS 2001
Andy Warhol *Soup Can* © DACS 2001
Andy Warhol *Tuna Fish Disaster* © DACS 2001
Grant Wood *Landscape* © DACS 2001

CONTENTS

INTRODUCTION

"We must consider that we shall be a city upon a hill,
the eyes of all people are on us;
so that if we shall deal falsely with our God in this work
we have undertaken, and so cause Him to withdraw His present help from us, we
shall be made a story and a byword through the world."

John Winthrop, early colonist (1588–1649)1630

THE United States of America, America, the States, Stateside, Land of Liberty, Land of the Free, the Melting Pot, the US of A, Uncle Sam—whatever one chooses to call it, since the first settlers claimed America as their own in the seventeenth century it has always stood at the center of the world stage.

The study of American art helps us understand who Americans are and how they connect to their history and culture. Whilst this book does not try to be an encyclopedia of American art, it touches upon many of the major art movements in America from the seventeenth century to the present day. The selection of images by American artists covers a broad range and many of the images are not often reproduced. The text attempts to provide information about the artist and the artistic movements of the time. Arranged chronologically the pictures are complemented by historical background of the period. Most of the artists are well known, but others less well known are also included and worthy of a reappraisal. While this book focuses on European immigrant artists in America, efforts have been made to cover previously neglected artists or subjects in American art, for example Native Americans, and African-American artists. Many early histories neglect women artists and this book aims to make good that omission. American art is a constantly evolving field, as art historians identify forgotten minorities and demand that their work be reassessed in the wider context of American art.

The impossible question that many art historians have struggled with is, "What is it that makes American art American?" There are a number of reasons why an artist may have been included in this present selection. Many of the artists usually associated with American art were not born in America but have spent the greater part of their lives there, such as Marcel Duchamp. Others have left America but maintained ties to their homeland and have historically been thought of as American, like John Singer Sargent or Benjamin West. Others have adopted America as their homeland and painted stereotypical American subject matter, like David Hockney. Others are immigrants who create and embrace American styles and techniques, such as Willem de Kooning, while others have been inspired by European artists, as John Singleton Copley was.

It is no easier to identify American art by its subject matter. Critics, however, have been keen to see art as a vehicle for Americans to express their hopes and fears. The recurrent themes cited include alienation, isolation, dislocation, democracy, independence, freedom, competition, and man's desire to conquer new frontiers. It is difficult to claim these as peculiar to American art, but they do suggest that American art, like all other art histories, is subject to social, cultural, and political interpretation. They also indicate that since the first boats reached the eastern seaboard Americans and the rest of the world have sought to create an American identity. American art really came into its own in the twentieth century and it is this period that the book focuses on. To summarize nearly four hundred years of American art is no easy task, but brief highlights of some of the artists and events may be a helpful introduction to the field.

Most people consider the beginning of America's history to be the seventeenth century, when the first colonists traveled by boat to an undeveloped and unexplored land. The first settlers landed in Jamestown, Virginia in 1607 and in 1620 the Pilgrims, who were Puritans, landed in Plymouth, Massachusetts. They were European immigrants, many from England and Germany, searching for political

and religious freedom, and brought with them many different cultures and traditions. Although they were keen to create their own utopia, this was not an empty land ripe for the picking but a homeland for millions of Native Americans—a fact often overlooked. Several American artists have attempted to show the often antagonistic relationship between these two peoples.

Very little art was produced by or commissioned by the religious early settlers, who believed that it was sacrilegious to worship secular images. By the 1700s, however, portraiture was the main type of painting in the American colonies and came to denote new-found prosperity and survival in a hostile land. The names of the early immigrant artists working in America are not known. They are referred to simply as "limners" (from "lim" meaning "to record a face"). The settlers, on arriving in America, tried to recreate their old lives and cultures from their homelands and give the impression of an established heritage by adopting the European tradition of portrait painting. The artist at this time had no status at all and did not sign the painting—the focus was the sitter, not the painter.

The history of American art is fascinating as it not only reflects the influence of European art but at certain times has taken the artistic lead itself. Portraiture continued to be fashionable in America for many years, while in Europe history painting was considered to be a much higher form of painting. Some American artists, including Benjamin West and John Trumbull, painted history paintings, inspired by classical subjects and contemporary subjects, like the War of Independence (1775–83). The American Revolution, as it is also known, resulted in a formal separation from the homeland and a new beginning for the people. In brief, the war was started when the colonists became dissatisfied with the English parliament claiming the right to collect taxes from them. This resentment led to such incidents as the Boston Massacre in 1770 and the Boston Tea Party in 1773. In April 1775 war broke out. In 1776 the Declaration of Independence was issued and several years of fighting ensued. In 1781

American victory came with the English surrendering at the battle in Yorktown and in 1783 England recognized American independence in the Treaty of Versailles.

The status of the artist in America began to rise in the eighteenth century and the nation's first major painters—Benjamin West, John Singleton Copley, Charles Willson Peale, and Gilbert Stuart—were sought after and recognized. This period marked the evolution of a new American culture, illustrated most clearly in Copley's portraits, which catalogue a generation of colonists who knew how they wished to present themselves and who were now rich and powerful enough to govern themselves.

A highlight of the history of American art is the type of landscape painting, which became very popular in the nineteenth century. As the settlers began to go west they recorded the beautiful panoramic views of the unspoilt wilderness that they saw, and reflected man's efforts to find his place within the enormity of the landscape. Often the paintings celebrated the divine power of the landscape and America's "Manifest Destiny," for example in the work of Thomas Cole. Other landscape artists included Frederic Church, who was part of the Hudson River School, and George Catlin, who painted Native Americans in their own environment. As industrialization spread through America, landscape painters and photographers also began to document the invasion of the railroad through the countryside. Likewise, the California Gold Rush and the onslaught of the Industrial Revolution had a major impact on the idyllic landscape. Albert Bierstadt and others were commissioned by the government and the railroad barons to paint pictures, which were in turn used to encourage tourism to the newly discovered West. The West that they had been sold, however, no longer existed. But the myth of the West had been born and was perpetuated by the works of artists such as Frederic Remington.

A landmark in America's demise as the new Promised Land came with the Civil War and Abraham Lincoln's assassination. The vision of

innocence the country had started with was lost, along with the thousands of men who died in battle. Some artists, like Winslow Homer, tried to recreate the utopia the early settlers had aspired to build. Others chose to depict realism and produced history paintings and genre paintings of the abolitionist movement, the Civil War, and the difficulties of life after the war.

Art education and the impact of art distribution for the general public is an interesting subject in the history of American art. The nineteenth century saw the creation of Art Unions in Europe and America, and in exchange for a subscription fee the member was sent engravings and kept abreast of current artistic trends. This was also a time when people began traveling for pleasure and journeyed to Europe to visit artists' studios. A pilgrimage of American artists to Europe also began at this time and many were influenced by the Impressionist movement in France. Mary Cassatt, James Whistler, Childe Hassam, and John Singer Sargent were significant not only in the American art of the late nineteenth and early twentieth centuries, but in Europe too. Not only were Americans traveling a lot more, but the advent of the twentieth century saw immigration to America increase considerably. Enticed by a Hollywood version of America, the immigrants no doubt found a very different reality. The Ashcan School of artists, such as John Sloan and Robert Henri, painted this reality in the slums and scenes of city life, in particular New York City. A more positive side of city life was celebrated by the Precisionists, such as Georgia O'Keeffe and Charles Sheeler, who painted the impressive new architecture of the city skyscrapers and bridges.

In 1913 the famous Armory Show took place. Many historians believe it was the seminal moment for American art. It exposed the American public and artists to European avant-garde styles and many, especially after seeing Marcel Duchamp's *Fountain*, never looked back. Another significant influence on American art was the Federal Art Project, which was part of President F. D. Roosevelt's New Deal from

1935 to 1943. It supported artists who had become impoverished by the Depression by employing them to paint public buildings and spaces. The 1920s and 1930s saw the Regionalist art movement, with chief exponents Grant Wood, Thomas Hart Benton, and John Steuart Curry. Again artists tried to recapture a simpler, more innocent agrarian past, in the light of the horrors of the First World War. Alongside the Regionalists were the Social Realists such Stuart Davis and Philip Evergood, who refused to ignore these horrors and addressed the modern age and its problems directly.

Abstract Expressionism and Pop Art did much to secure America a place in world art history. Abstract Expressionists such as Jackson Pollock, Willem de Kooning, and Barnett Newman became international celebrities, as did Pop artists Andy Warhol and Claes Oldenburg. Pop art reacted to the novelties of modern-day life, such as the cheeseburger or the tin of Campbell's soup, and drew on the new techniques of advertising. The buoyancy of mood evoked by these new movements was soon destroyed, however, by the seemingly never-ending casualties of the Vietnam War between 1957 and 1975. Artists such as Ed Kienholz, Bruce Nauman, and Louise Bourgeois produced work that reflected the nation's sadness and vulnerable state. Movements such as Minimalism, Body Art, Earth Art, Video Art and Conceptual Art, Neo-Expressionism and Postmodernism found their place and still thrive today. The art boom and the excesses of the 1980s brought artist-marketeers like Jeff Koons, who manipulated the art market and made millions of dollars in the process. Artists working today in a pluralist and postmodern culture, such as Cindy Sherman, Nan Goldin, Sherrie Levine, and Fred Wilson, mark an exciting time for American art, and the contemporary scene is flourishing.

Historically American art has not received the same respect as European art. It has rather been seen as a poor substitute for and derivation of European art; not a creation in its own right. Scholarship in American art was for many years underfunded and undervalued.

Many American art historians were self-taught, often coming from a background in European art. Art dealers and collectors took the lead and produced many artists' *catalogues raisonnés* and monographs, and while a more academic study of American art history is catching up, it has taken some time for this change.

In addition, until relatively recently American art has been considered of national, rather than international, interest. Viewers have formerly attached greater importance to more modern or contemporary American art, and earlier works have been largely neglected. Times do change, however, and so-called "blockbuster" exhibitions dedicated to the work of American artists have elevated these artists to the status enjoyed by European artists. Yet in spite of such shows American art remains a fairly insular field and it is mostly American museums that have substantial holdings of American art. The status of American art has perhaps suffered from its isolationist aspect. While few can criticize the remarkable American art collections at the Smithsonian American Art Museum, the Whitney Museum of American Art, the Pennsylvania Academy of the Fine Arts, or the American Wing at the Metropolitan Museum of Art, the works are seen in seclusion, away from the art of other countries.

While a work of art can be cherished for its beauty or for the skill of the artist who produced it, it can also act as a vital document of the cultural and political conditions of the period in which it was produced. In many museums American arts have traditionally been displayed in an "American" wing, gallery, or within the larger context of a period room alongside furnishings and architectural details. On the one hand this type of display benefits from the input of social historians and specialists in the decorative arts, and has spawned new generations of viewers interested in American material culture and art. On the other hand, however, it separates American art from its European relations and discourages comparative studies. This is changing in some quarters—the National Gallery of Art, Washington, DC is one gallery that endeavors to integrate its American and European collections effectively. On the commercial

side, American art is still being bought mainly by American clients, though this is not to say it is a limited market. Enormous prices are commanded in the auction houses and galleries for the work of American artists. American art may not have the illustrious past of European, but in commercial terms New York rules over London and Paris as the center of the art world.

JOHN SINGLETON COPLEY *(1738–1815)*

MRS GEORGE WATSON 1765

Smithsonian American Art Museum, Washington, DC/Courtesy of Art Resource/Scala

TO have a portrait painted by John Singleton Copley in eighteenth-century America was in itself a symbol of financial and social success. In this portrait of Elizabeth Watson, Copley endows his subject with an impression of confidence and poise, which was considered fitting for the wife of a prosperous merchant from Plymouth, Massachusetts. Elizabeth Watson was 28 when the portrait was painted but died three years later, leaving her husband and four children. While the faces of Copley's sitters seem realistic, the artist often used props and furnishings to embellish their personalities and status. The flowers denote beauty and the imported vase affluence. It is not known whether Mrs Watson owned a dress such as this one, but it is known that Copley concocted dresses in the latest styles. He exceled at painting textiles and surface effects.

Despite his success as a portraitist in the Colonies, Copley moved to London in 1775, at the beginning of the War of Independence. He continued working in the field of portraiture but also moved into history painting, which was considered the highest genre of painting in England at that time, but which was not popular in America. From his repertoire of history paintings one of the most famous is *The Death of Major Pierson*, which he painted in 1783. In later life John Singleton Copley's work became more Romantic and therefore outdated and the artist died poverty-stricken.

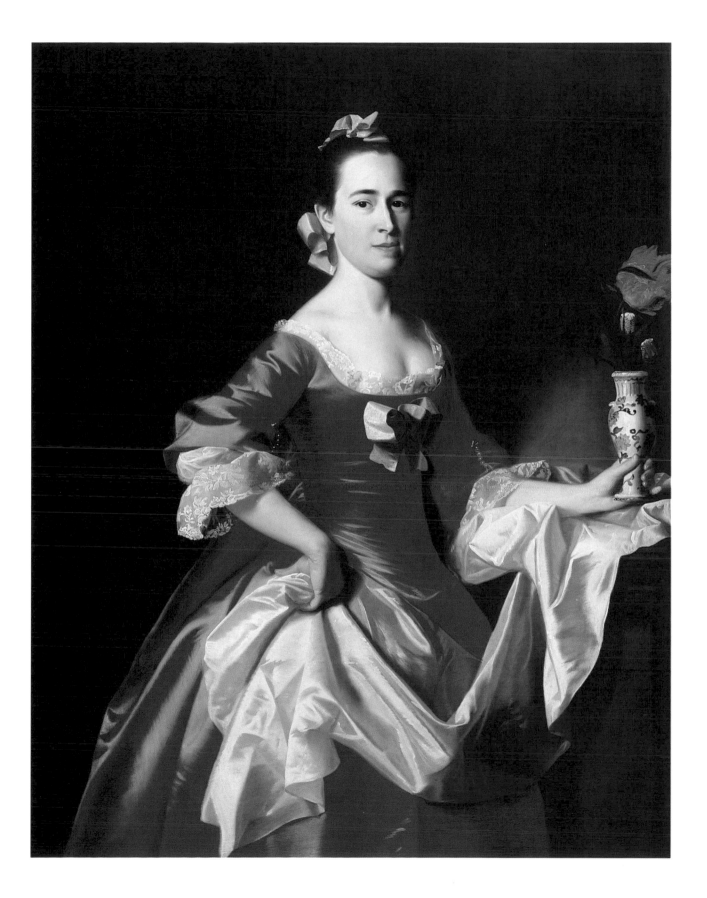

JOHN SINGLETON COPLEY (1738–1815)

SELF-PORTRAIT 1780–84

National Portrait Gallery, Smithsonian American Art Museum/Courtesy of Art Resource/Scala

THE city of Boston is very proud of John Singleton Copley, the son of Irish immigrant parents. He was largely self-taught but was introduced to European traditions by his stepfather, who worked as a painter and engraver. In 1765 Copley painted *Boy with a Squirrel (Henry Pelham)* (1795), and sent it to London for an exhibition at the Society of Artists. Not only was this portrait of his half-brother the first American painting to be exhibited abroad, it was also the first important American painting that was not the result of a commission. One of the people who was full of praise for *Boy with a Squirrel (Henry Pelham)* was Sir Joshua Reynolds, who was the leading English portraitist at the time. This painting, and the praise it received, marked a turning point in Copley's career.

The Bostonian went on to monopolize the portrait market in both Boston and New York and his work provides a revealing pictorial record of eighteenth-century society in those two cities. Copley offered an English style of portraiture to complement the other English imports that his patrons had in their homes. In a society where appearance and status counted for everything, Copley's success depended partly on his collaboration and relationship with the client, as this greatly affected how he was presented to the viewer. He offered a complete package to the patron by working with a framer who would provide him with a suitable frame for the portrait.

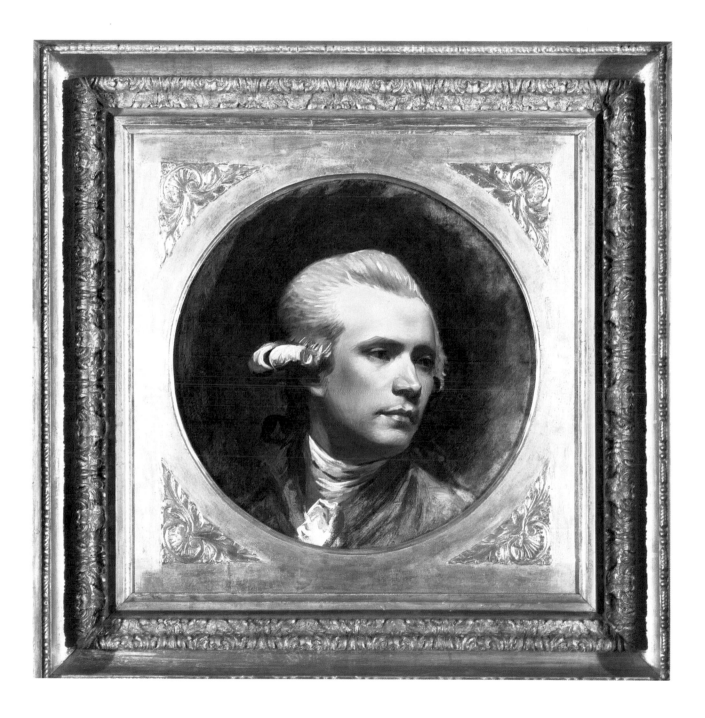

BENJAMIN WEST *(1738–1820)*

HELEN BROUGHT TO PARIS 1776

Smithsonian American Art Museum, Washington, DC / Courtesy of Art Resource / Scala

AT the age of twelve Benjamin West said: "My talent will make me the companion of kings and emperors." This is exactly what happened. The self-taught son of a Pennsylvania Quaker arrived in London after taking the Grand Tour and spending three years in Rome. He became historical painter to George III in 1769 and the second President of the Royal Academy, succeeding Joshua Reynolds. He spent the rest of his life in England, never returning to America. He was one of the first American painters to influence English art and art historians constantly debate as to whether West is more American or English.

Helen Brought to Paris was painted a few years after West arrived in London from Rome and illustrates the European interest in Neoclassicism and mythology at that time. A captivated Paris watches Venus and Cupid lead in Helen of Troy. Venus pushes Helen towards him, but Cupid tugs at her arm urgently, aware that this union will ultimately cause the Trojan War. History painting, which included mythological, religious, classical, and allegorical subjects, was considered to be the highest rank of painting in England at this time. America did not share this view and most American painters were portraitists. To many, West's history paintings are the pinnacle of his achievement, especially *The Death of General Wolfe* (1771), which depicts Wolfe being killed by the French while capturing Quebec eleven years before. West depicted it in contemporary rather than classical dress, signifying a new departure in English historical painting.

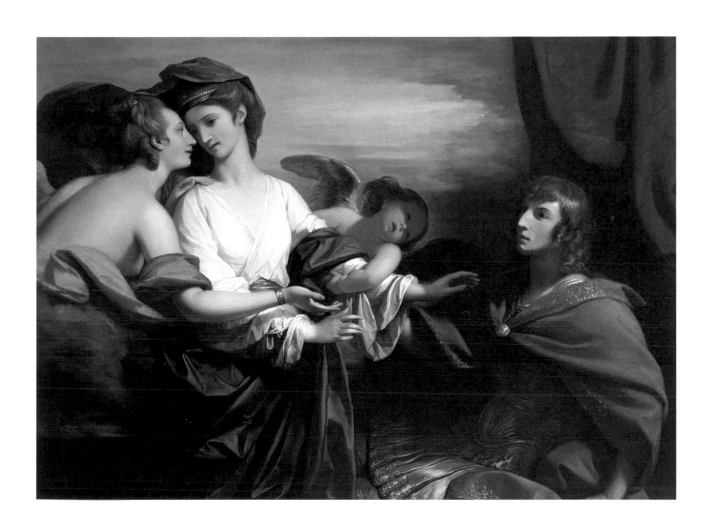

GILBERT STUART *(1755–1828)*

GEORGE WASHINGTON 1797

Metropolitan Museum of Art / Courtesy of the Bridgeman Art Library

GILBERT Stuart was born in Rhode Island and spent much of his early life traveling in Europe. He went to Edinburgh in the early 1770s, to London to study with Benjamin West during the War of Independence, and then to Ireland. He finally returned to America and lived in New York, Philadelphia, and Boston.

He is regarded, along with John Singleton Copley, as one of the country's best portraitists. Benjamin West was a great admirer of Stuart's portraits. In a rather graphic metaphor of admiration he said of Stuart's skill at characterization that he "nails the face to the canvas."

Stuart's most famous portraits are of George Washington, the first President of the United States of America. Washington was a descendant of the English royal family and was a Virginia landowner. Washington was an instrumental figure in the American Revolution, and took a stance in opposition to English rule. As a result it was proposed that he would be a most fitting man to lead the world's first republic. He was reelected as President but chose to return to his life in Virginia and died only two years later.

Stuart produced three portraits of Washington. These were the Vaughan Portrait, the Lansdowne Portrait, and the Athenian Portrait, which is used on the one-dollar bill. Hundreds of copies were made by Stuart himself and by other artists.

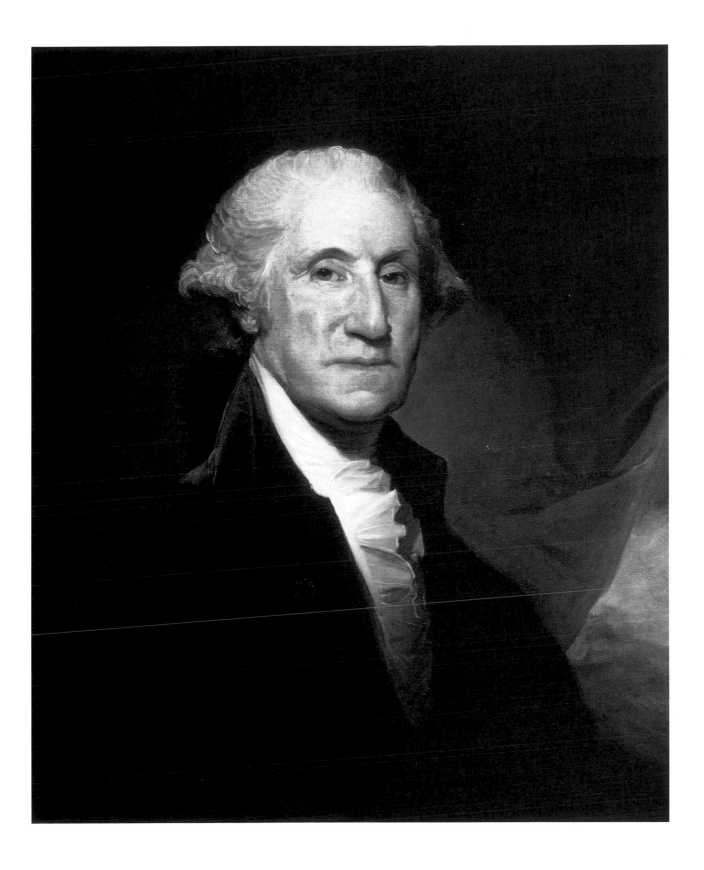

George Catlin *(1796–1872)*

Buffalo Chase, A Single Death 1832–3

Smithsonian American Art Museum, Washington, DC/Courtesy of Art Resource/Scala

GEORGE Catlin spent most of his life studying and painting scenes of Native American life, such as his series of *Buffalo Chase* pictures. Originally a lawyer, Catlin became an artist in the early 1820s and painted portraits of wealthy Philadelphians. He is a remarkable artist in the sense that he never received any formal training and was entirely self-taught.

In 1830 he visited a number of Native American tribes and painted scenes depicting their customs and lives. His visits culminated in a traveling exhibition entitled the "Gallery of Indians" between 1837 and 1845, which toured America and Europe. The relationship between Americans and Native Americans has always been an ambivalent one and Catlin's paintings captured some of that feeling.

In 1891 L. Frank Baum wrote of the Native Americans: "Having wronged them for centuries we had better, in order to protect our civilization, follow it up with one more wrong and wipe these untamed and untamable creatures from the earth." The so-called White Man destroyed the West by killing the Native Americans, culling the cattle and scarring the landscape with railroads. As a result, therefore, by the end of the nineteenth century the West had become a place of myth and nostalgia. American painters often depicted the Native Americans as enemies and, perhaps for that reason, Catlin's sympathetic pictures were better received in Europe than in his own country.

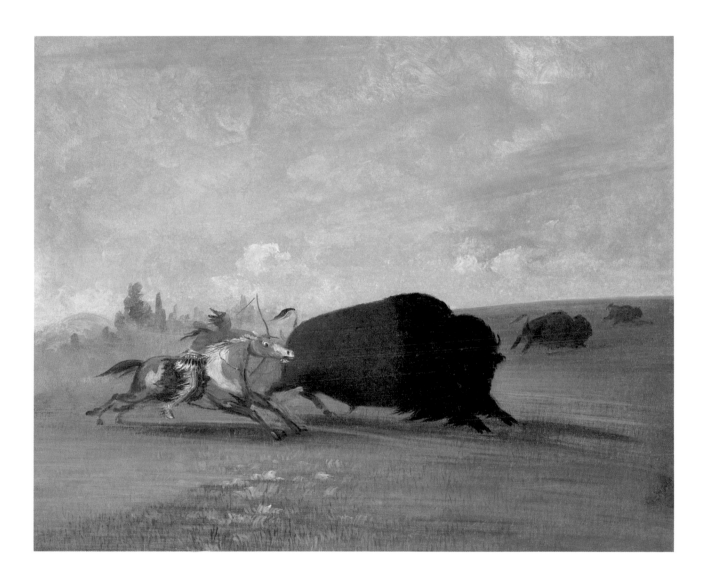

THOMAS COLE *(1801–48)*

THE ARCH OF NERO 1846

The Newark Museum / Courtesy of Art Resource / Scala

THOMAS Cole was the father of the Hudson River School, a group of nineteenth-century American painters who worked in the Catskills and in the Hudson River Valley. Cole, along with fellow painters Frederic Church, Albert Bierstadt (see page 32), and Thomas Doughty, specialized in Romantic landscape painting. The Romantic genre they practiced became extremely popular among wealthy Americans and the fashion for these pictures made these artists very rich and many of them built lavish mansions on the banks of the river.

Cole's family migrated to America from England in 1819 when he was seventeen years old. After studying for two years at the Academy of Fine Arts in Pennsylvania Cole left, saying that nature would be a better teacher. He first earned a living in New York as a portraitist, theater scene painter, and engraver. His landscapes began to generate interest and by 1826 he had moved to Catskill on the Hudson River to be nearer his subject matter. He spent his time walking in the mountains sketching and working his studies up into finished oil paintings in his studio. He traveled in England, France, and Italy and was inspired by Turner and John Martin. He began incorporating historical and mythic narratives into his landscapes. A gentleman in the nineteenth century would have been well versed in the English Romantic poets such as Byron, Wordsworth, Shelley, and Keats, and Cole's patrons would have recognized the Romantic references in his works.

MARTIN JOHNSON HEADE *(1819–1904)*

UNTITLED 1839

The Newark Museum / Courtesy of Art Resource / Scala

MARTIN Johnson Heade was one of America's greatest Romantic painters. A very versatile artist, Heade was equally at home painting marine pictures, landscapes, floral still lifes, and portraits.

Born in Bucks County, Pennsylvania, Heade was the son of a farming family. His neighbor was the folk artist Edward Hicks, famous for his series of paintings called the *Peaceable Kingdom*. Taking his inspiration from his neighbor, Martin Johnson Heade embarked upon a lifetime of traveling and painting the landscapes and people he encountered on his travels. He journeyed throughout America and Europe producing portraits, genre scenes, and copies of famous works of art. In 1858 he moved in to the Tenth Street Studio Building in New York, where many of the successful Hudson River School artists such as Frederic Edwin Church were also based. The Hudson River School had an enormous impact on Heade and from that time on he concentrated on painting landscapes and still lifes. His career spanned around 70 years and it read rather like a travel journal. He produced seascapes of New England, still lifes of orchids and hummingbirds from South America and magnolias from Florida.

Heade's considerable talent was not recognized during his lifetime and it was not until his masterpiece *Thunder Storm on Narragansett Bay* (1868) was rediscovered in 1943 that his work was reassessed and celebrated.

CARLETON WATKINS *(1829–1916)*

CAPE HORN, COLUMBIA RIVER, OREGON 1867

Courtesy of the National Gallery of Art, Washington, DC

"Go West, young man, and grow up with the country."
Horace Greeley, American politician and journalist (1811–72)

CARLETON Watkins, along with Ansel Adams, is one of the most accomplished landscape photographers America has ever seen. Originally from Oneonta in New York, Watkins was one of many young men who moved from the east coast of America to California to capitalize on the Gold Rush. Gold was discovered in 1848 and around 80,000 people moved there that year. Watkins arrived in 1853 and first worked in Sacramento as a teamster and a carpenter before moving to San Francisco two years later. His introduction to photography was purely accidental: he was asked to stand in for someone in a photography studio. It was the beginning of a great career and he started taking photographs for mining companies.

Watkins lived and worked in San Francisco between 1853 and 1906 and his photographs of the city and the bay area provide a detailed record of its growth. It was his photographs of the remote Yosemite Valley taken in 1861 that secured his position as a renowned photographer and he developed a new form of photography to suit his subject matter. His stereo camera produced two virtually identical images of the same view and when these images were viewed through a binocular viewer called a stereoscope they produced a three-dimensional view. Watkins constantly refined his techniques and commissioned a cabinetmaker to make him a camera which could make huge negatives called mammoth plates which encapsulated the vast scale of the landscapes while retaining fine details.

Watkins was admired by the landscape artists of the time and on seeing his work Albert Bierstadt was prompted to visit and paint the Yosemite Valley. He received a number of commissions during his career, including one from the Oregon Steam Company in 1867 to journey up the Willamette and Columbia Rivers and photograph the scenery and their railroad lines.

This Columbia River series, of which this photograph is part, was taken along the route to Cape Horn. Watkins was a master of light and it is the contrasts of the water, the mountains and the sky that produce a sense of the magnitude of the scenery and man's small place within it. Far from criticising industry's effect on the land, his work often celebrates man's interaction with nature.

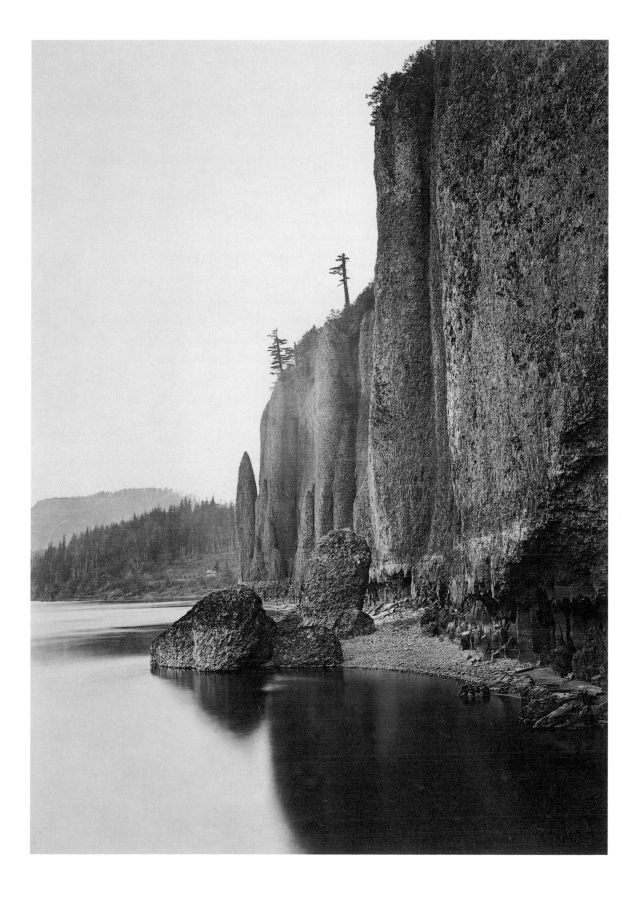

ALBERT BIERSTADT *(1830–1902)*

AMONG THE SIERRA NEVADA MOUNTAINS, CALIFORNIA 1868

Smithsonian American Art Museum, Washington, DC/Courtesy of Art Resource/Scala

BIERSTADT was a master of the American West landscape and associated with the group of painters referred to as the Hudson River and Rocky Mountain Schools, whose members included Thomas Cole, Frederic Church, and Thomas Doughty.

Albert Bierstadt was born in Düsseldorf in Germany and his family emigrated to New Bedford in Massachusetts when he was just two years old. In the nineteenth century Düsseldorf was seen as one of the most important centers for art in the world and Bierstadt therefore decided to return to his homeland at the age of twenty to embark upon his academic training. This move back to Germany had a huge impact on his subsequent career and output and is evident in his style, which shows a debt to the German Romantic School of the time. He also traveled to other areas in Germany, to Rome, and to the Alps in Switzerland and Italy.

Bierstadt returned to America in 1858 and the following year he joined an expedition to the Old Oregon Trail in the West. This trip was to have a great influence on the artist and it inspired his subsequent career and a love for painting vast mountains and wilderness, as can be seen from *Among the Sierra Nevada Mountains*. References from the artist's European travels crop up in his paintings repeatedly and viewers with a knowledge of the Sierra Nevadas might notice a certain artistic license in their similarities to the Alps.

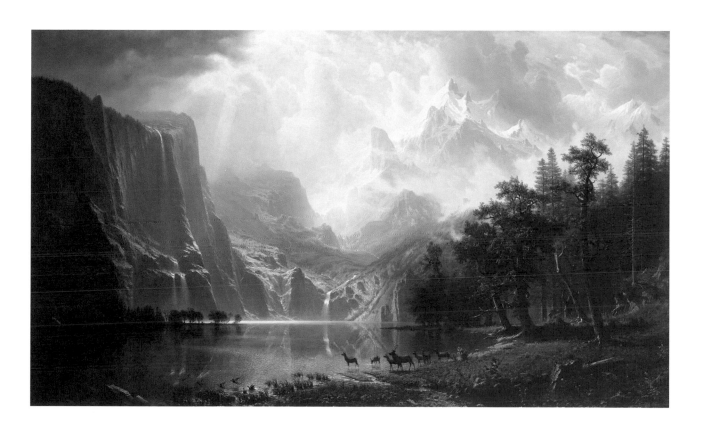

ALBERT BIERSTADT *(1830–1902)*

SAN FRANCISCO BAY 1871–73

Smithsonian American Art Museum, Washington, DC/Courtesy of Art Resource/Scala

BIERSTADT made several trips to the West throughout his life and sketched the mountainous landscapes of Alaska, Wyoming, Colorado, Utah, Nevada, Oregon, Washington, and California. Bierstadt was struck by the sheer beauty he found in these rugged and sparse American landscapes and said that "a lover of nature and Art could not wish for a better subject." Once Bierstadt had returned home from his various trips he would settle down in his studio and work up the sketches he had made into enormous oil paintings.

Many viewers appreciated a sense of majesty in Bierstadt's works as well as a celebration of the divine beauty of the natural world. This was a common element in the work of the members of the Hudson River School of American painters who worked in the Catskills and Hudson River Valley throughout the nineteenth century. The group also included Frederic Church, Thomas Cole, and Thomas Doughty.

Bierstadt became a very successful painter and with the money that he made from his pictures he built himself a mansion on the banks of the Hudson River. He became widely popular in both the US and Europe and was even granted an audience with Queen Victoria in 1867: "Her Majesty is a very charming and agreeable lady, and makes one feel quite at home in her presence. She seemed much pleased with my works. I was then invited to see the Palace, partake of lunch etc," said the artist.

JAMES ABBOTT McNEILL WHISTLER *(1834–1903)*

ARTIST IN THE STUDIO 1865–66

Courtesy of the Art Institute of Chicago/Bridgeman Art Library

WHISTLER was born in America, but as a young man emigrated to Europe in 1855. As with Sargent, the Americans and the British both try to claim him as their own countryman, but this debate aside, his influence was evident on both sides of the Atlantic. He began his artistic career as an etcher with a navy cartographer, after giving up his proposed career in the military. He traveled in Europe in 1855 and studied in Paris for four years at Gleyre's Academy, meeting artists such as Fantin-Latour and Courbet. His Realist style was seen in the etchings he produced after travels in France and Holland. In 1859 he moved to London and continued to produce his Realist works, choosing Wapping and Rotherhithe for his subject matter.

The turning point for his work came in 1862, when he painted *The White Girl, Symphony in White Number 1*. Whistler was an influential force behind the Aesthetic Movement and was inspired by the work of Rossetti. His move to Europe in 1855 had coincided with a renewal of trade with Japan. Then began a craze for the so-called Japonisme—a celebration of Japanese culture reflected in fine and decorative arts.

In the 1860s Whistler began to give his paintings musical titles such as *Symphony*, *Nocturne*, and *Arrangement*, which emphasized their aesthetic nature over representation. His *Nocturnes* were a series of night scenes on the Thames in London. It was one of these *Nocturnes* that caused one of the biggest scandals the art world has ever seen. Whistler exhibited several of them at the Grosvenor Gallery in 1877 and Ruskin took great offense at one called *Nocturne in Black and Gold, The Falling Rocket* (1874). He wrote accusingly: "I have seen, and heard, much of cockney impudence before now, but never expected to hear a coxcomb ask two hundred guineas for flinging a pot of paint in the public's face." Whistler sued Ruskin and although Whistler won the case, he was awarded just one farthing in damages and it ultimately bankrupted him and ruined his reputation. After selling his house in London, Whistler moved to Europe, where he spent much of the rest of his life.

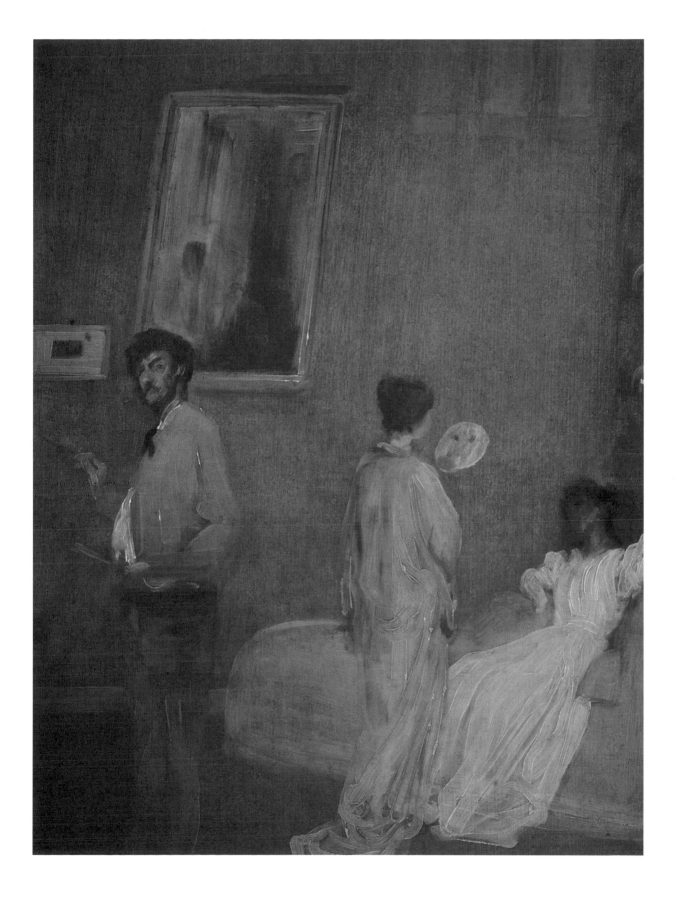

JAMES ABBOTT MCNEILL WHISTLER *(1834–1903)*

PORTRAIT OF HIS MOTHER:
ARRANGEMENT IN GREY AND BLACK, NO. 1 1871

Courtesy of the Musée d'Orsay, Paris/Bridgeman Art Library

WHISTLER'S wit is legendary and his reported exchanges with Oscar Wilde make very humorous reading, as does his book *The Gentle Art of Making Enemies*, published in 1890. He could be very argumentative and arrogant, as Wilde illustrated in 1885: "That he is indeed one of the very greatest masters of painting, is my opinion. And I may add that in this opinion Mr Whistler himself entirely concurs."

Legend has it that a rather grand lady asked Whistler why he had been born in such a drab place as Lowell in Massachusetts, to which he replied: "The explanation is quite simple. I wished to be near my mother." This picture of his mother helped establish his career and his reputation as a portraitist. A friend of Whistler's told the artist that he was surprised that he had a mother and Whistler replied that "a nice bit of color she was too." This is indicative of Whistler's view of portraits—a genre he turned to later in his career, meeting with great success and somewhat restoring his finances. He was less concerned with producing a true likeness of his sitter than producing a beautiful art object, with particular emphasis on composition and color and its tonal qualities.

Whistler was also recognized for his talent in interior decoration, but his relationships with his clients were not always as harmonious as his work. Most famous was his argument with F. R. Leyland, a Liverpool shipping tycoon, who had Thomas Jekyll design the Peacock Room for his house in Queen's Gate, London. He then employed Whistler to add a limited amount of decoration, but Whistler took it upon himself to cover the whole room with paintings of peacocks. Not only did this greatly displease Leyland, but Jekyll also went insane.

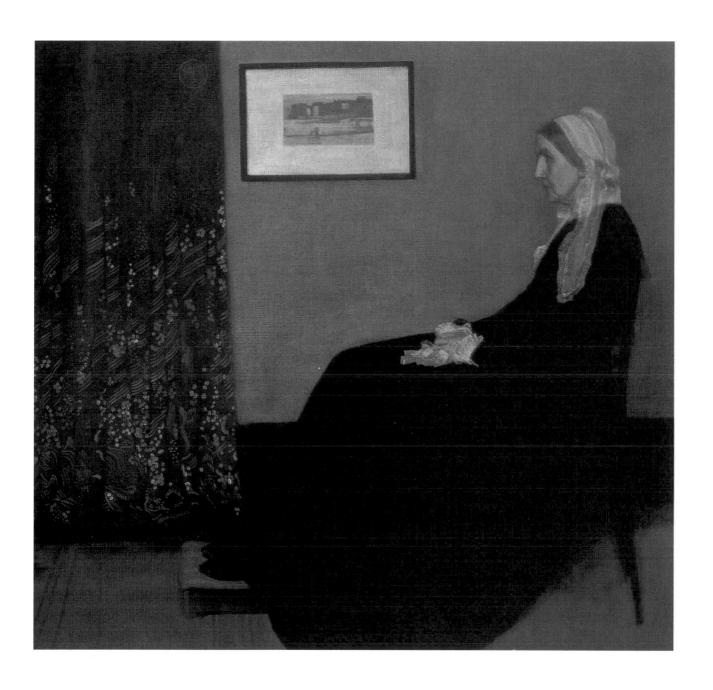

WINSLOW HOMER *(1836–1910)*

BEAR HUNTING, PROSPECT PARK 1892

Smithsonian American Art Museum, Washington, DC/Courtesy of Art Resource/Scala

WINSLOW Homer was born in Boston and for his first job he worked as an apprentice to a lithographer in his native city. He went on to study painting at the National Academy of Design and worked as a freelance illustrator, primarily for *Harper's Weekly*. He also served as an artist-correspondent for them during the Civil War in the 1860s.

The Civil War was the first great war to be photographed, but papers and magazines also employed illustrators and Homer's war images were prized. The most well known of these are *The Veteran in the New Field* (1865) and *Prisoners from the Front* (1866). After recording the harsh conditions of war Homer focused on a different area of painting. This was probably the result of a reaction against the troubles of wartime, coupled with a desire to return to a more innocent vision of America. He painted scenes of nature and of people pursuing leisure activities out of doors, such as in *Bear Hunting, Prospect Park*.

Of all his artistic output, however, Winslow Homer is probably best known for his seascapes. He began painting these during the two years that he lived in Tynemouth on the Northumbrian coast in England between 1881 and 1883. After his spell in England he swapped the Northumbrian shipping community life for that of Prouts Neck in Maine, where he settled. Homer stayed there for 30 years, living a reclusive existence.

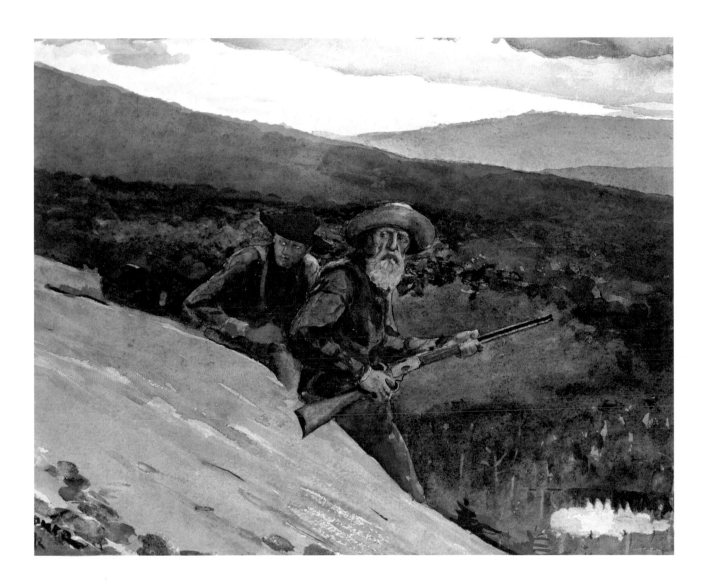

WINSLOW HOMER *(1836–1910)*

HIGH CLIFF, COAST OF MAINE 1894

Smithsonian American Art Museum, Washington, DC/Courtesy of Art Resource/Scala

"Very much of the work now being done in studios should be done in the open air. This making studies and then taking them home to use them is only half right. You get composition, but you lose freshness; you miss the subtle, and to the artist, the finer characteristics of the scene itself."
Winslow Homer, 1882

FROM 1873 Winslow Homer chose to carry out all his work outdoors, whether he was in Maine where he settled, or traveling in the Bahamas, Bermuda, Florida, or the Adirondacks. He had a desire to represent realism that was founded in the theories of William Ruskin: "When I have selected the thing carefully, I paint it exactly as it appears," he said.

Homer is one of the most famous of all American seascape painters and many of his pictures depict the coast of his adopted state of Maine. In this painting the huge cliff is being beaten by a turbulent ocean while two small figures in the upper right of the picture look on. Pioneers were still forcing their way through the wilderness of America in the nineteenth century and the inclusion of these figures reminds us both of nature's magnitude and man's powerlessness over it. Homer obviously thought that it was one of his best paintings, and when it remained unsold he said: "I cannot do better than that. Why should I paint?"

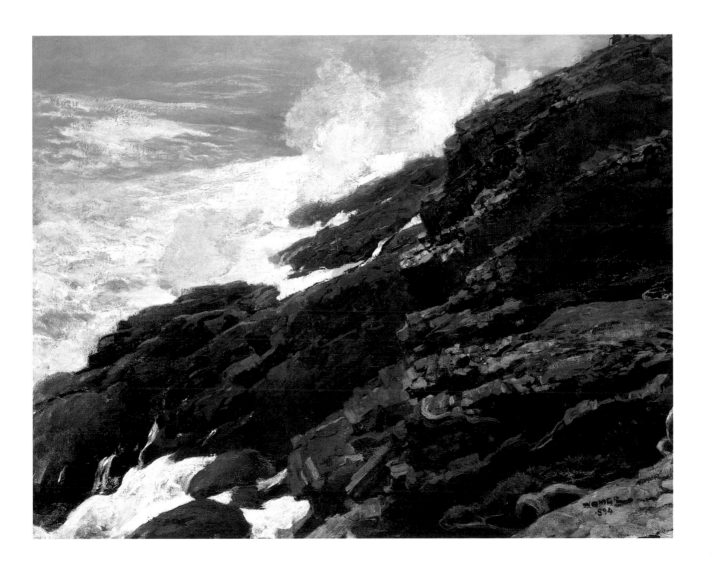

Mary Cassatt *(1844–1926)*

Girl in a Garden c.1880

Musée d'Orsay, Paris/Courtesy of Scala

MARY Cassatt was born in Pittsburgh and studied first at the Pennsylvania Academy and then in Paris at the Académie. She settled in Paris in 1866 and spent the rest of her life there. She met Edgar Degas in 1877. He encouraged her in her painting and her work has always been associated with the work of the great French Impressionist of the late nineteenth century. In fact, she became the only American to be exhibited alongside the French Impressionists in 1879–81 and 1886. In what is largely considered to be a male movement, Cassatt and Berthe Morisot (1841–95) have been called the "feminine Impressionists." In the unliberated times of the second half of the nineteenth century, women artists struggled to reconcile their roles as women, mothers, and artists.

Many artists of the late nineteenth century were extremely interested in, and greatly influenced by, Japanese art. There was an exhibition of Japanese ukiyo-e prints at the École des Beaux-Arts in Paris in 1891 and this undoubtedly provided inspiration for Mary Cassatt. As a middle-class woman in the nineteenth century, Cassatt did not have the freedom enjoyed by some of her male contemporaries and her subject matter was inevitably limited to the areas she was allowed to frequent in the city. As a result of these limitations much of her work, like that of other female artists at this time, portrays herself, her family, friends, and servants at work or at leisure in domestic interiors. Cassatt counterbalanced these restrictions with avant-garde style and techniques.

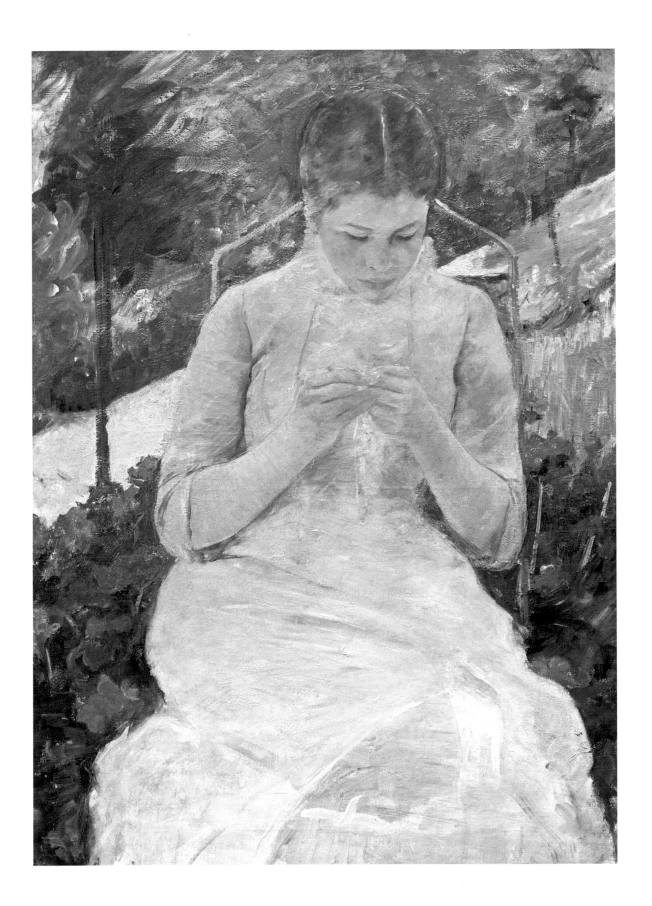

MARY CASSATT *(1844–1926)*

THE BATH 1893

The Art Institute of Chicago / Courtesy of Scala

MANY of Cassatt's pictures are of women and children, and *The Bath* is one of her most famous paintings. The painting captures an intimate moment as a mother or nurse tenderly washes a little girl's foot. Cassatt captures the complete concentration and absorption of both figures in the simple act. Cassatt was very open to the influence of Japanese art and the bold colored patterns seen here in the carpet, wallpaper, chest of drawers, pitcher, and woman's dress in this painting are reminiscent of the colors of Japanese woodblock prints.

Cassatt's work has been interpreted by some art historians as a commentary on the oppressive nature of women's lives in the nineteenth century. The women she portrays are depicted in traditional domestic roles, but often these women sit very uneasily in the interiors they inhabit. In some the figures seem too big for the picture plane and in others the surface is so flat the figures seem about to slide off the painting. This perhaps mirrors the restrictions women had to endure at this time and Cassatt's view that these should be challenged.

Despite making her home in France, Cassatt is claimed by American art scholars, dealers, and collectors alike as an American artist. This is perhaps because her work was very evident in American exhibitions in the nineteenth century. She did much to encourage American collectors to buy Impressionist works rather than Old Masters, and had a significant collection herself.

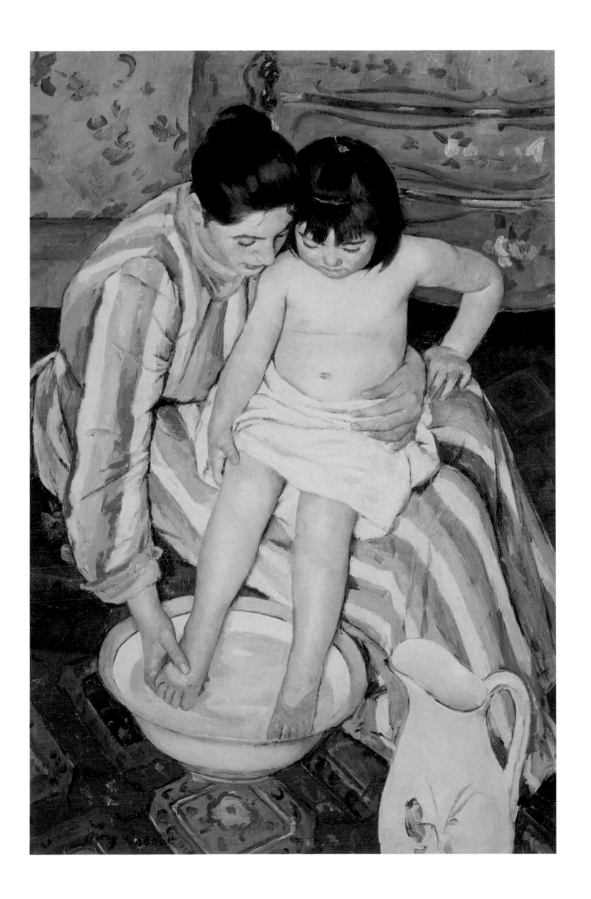

THOMAS EAKINS *(1844–1916)*

MOTHER (ANNIE WILLIAMS GANDY) 1903

Smithsonian American Art Museum, Washington, DC/Courtesy of Art Resource/Scala

THOMAS Cowperthwait Eakins was born in Philadelphia in the mid-nineteenth century and he lived there for most of his life, apart from his brief periods spent in Europe. Eakins studied in Paris at the École des Beaux-Arts from 1866 to 1869 with Gérôme and Bonnat. His French training and his appreciation of Manet are often touched on only lightly, so anxious are art historians to describe him as a leader of American Realism. He returned to Philadelphia in 1870 to teach at the Pennsylvania Academy of the Fine Arts and began painting genre scenes and portraits. He taught drawing from the nude and extensive anatomical knowledge—controversial in conservative nineteenth-century America. One of his most famous paintings is *Gross Clinic* (1875), which shows a surgeon in the operating theater and has no regard for the squeamish.

Eakins became interested in the work of Velázquez during his brief time in Spain in 1870 and it is possible to see an influence in Eakins's portraits. He mostly painted his immediate friends and family, here his mother. They are depicted in contemplation and rarely address the viewer. The faces are often bathed in light against a shadowy background. He also painted some famous figures, like the poet Walt Whitman, who said of Eakins: "I never knew of but one artist, and that's Tom Eakins, who could resist the temptation to see what they thought ought to be rather than what is."

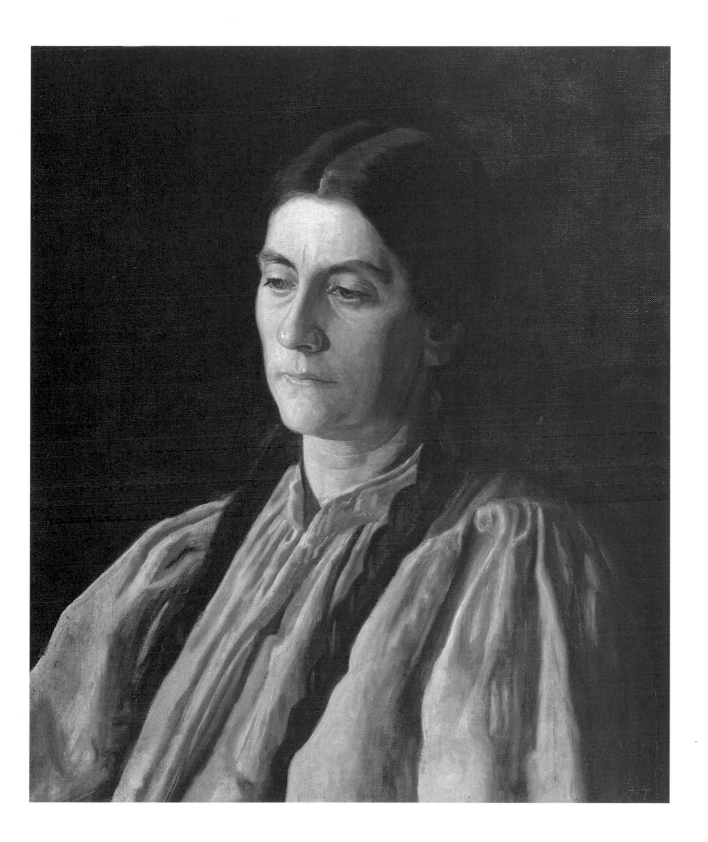

THOMAS EAKINS *(1844–1916)*

WILLIAM RUSH'S MODEL 1908

Smithsonian American Art Museum, Washington, DC/Courtesy of Art Resource/Scala

"William Rush, the Ship Carver, was the earliest and one of the best American sculptors. At the completion of the first Philadelphia waterworks at Center Square, which is now occupied by the Public Buildings, he undertook a wooden statue to adorn the square, which statue was afterwards removed to the fore bay at Fairmount, where it still remains, though very frail. Some years ago a cast of it was made in bronze for the fountain near the Callowhill Street Bridge."
Thomas Eakins

THE statue Thomas Eakins was referring to was the *Nymph of the Schuylkill* (1812) and this study was of the model used for the statue. Eakins painted an oil, *William Rush Carving His Allegorical Figure of the Schuylkill River* (1876–77). Legend has it that Louisa Vanuxem, the daughter of a respected Philadelphia merchant, posed for Eakins. Eakins's life classes at the Pennsylvania Academy of the Fine Arts had already provoked disapproval from the chattering classes and by using a lady as his model Eakins was asserting his view that working directly from the nude was essential. What particularly upset a *New York Times* critic in 1878 was "the presence in the foreground of the clothes of that young woman, cast carelessly over a chair. This gives the shock which makes one think about the nudity—and at once the picture becomes improper."

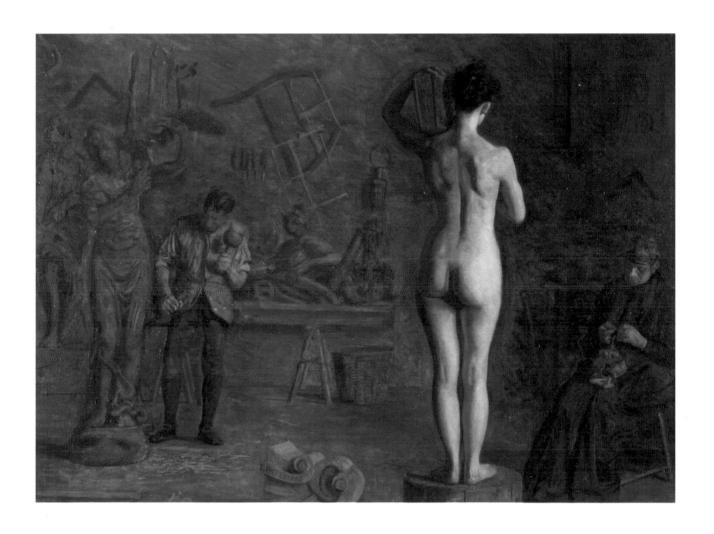

WILLIAM MERRITT CHASE *(1849–1916)*

TERRACE, PROSPECT PARK C. 1880

Smithsonian American Art Museum, Washington, DC/Courtesy of Art Resource/Scala

WILLIAM Merritt Chase was born in Nineveh, Indiana. As a child he showed an early talent for drawing. Chase's family were supportive and did not dissuade him from a career to which he was quite clearly suited. Rather than forcing his son into the family business Chase's father encouraged him in his painting and arranged classes with the artist Barton Hays. Chase went on to study at the National Academy of Design in New York and at the Royal Academy in Munich. On his return he became a teacher at the Art Students League in New York from 1878 to 1894, before opening his own school, Shinnecock Summer Art School, near Southampton, Long Island. His list of students was impressive and included names who would go on to be among the most important figures in the history of American art—Charles Demuth, Edward Hopper, Charles Sheeler, and Georgia O'Keeffe.

During the periods Chase spent traveling in Europe as a student (and during subsequent visits) he was particularly influenced by the art of the Spanish master Velázquez, as well as by that of Manet and Whistler. Their influence is often evident in his work. He was equally at ease painting landscapes, still lifes, and portraits. In the 1880s Chase and his wife lived in Brooklyn for a short time and the artist began a series of paintings of the area. At a time when most American artists were scouring Europe for subjects to paint, Chase looked in his own country and found material just as picturesque.

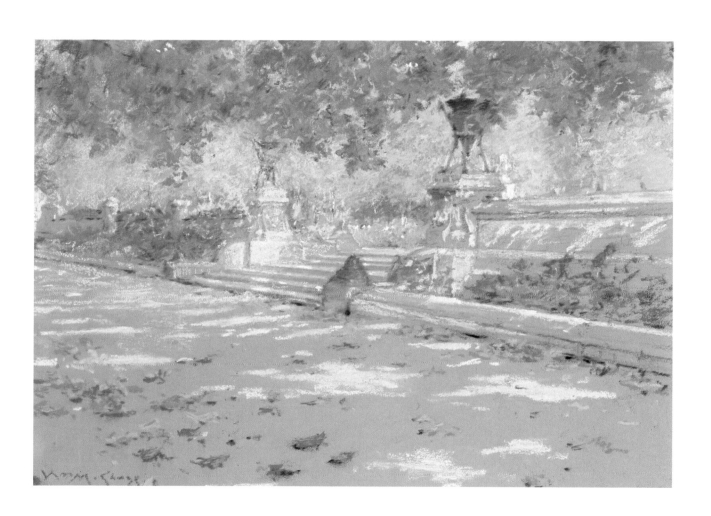

THOMAS ANSHUTZ *(1851–1912)*

THE IRONWORKERS' NOONTIME 1880

Fine Arts Museum of San Francisco, CA/Courtesy of the Bridgeman Art Library

THOMAS Pollock Anshutz was born in Newport, Kentucky in 1851 and moved to New York in 1872 to take up a place to study at the National Academy of Design. He then attended the Pennsylvania Academy of the Fine Arts and was a pupil of Thomas Eakins. Eakins maintained the only way for his pupils to learn was to draw the human body—shocking to contemporary polite society. Anshutz later became a teacher at the academy and in turn taught Robert Henri, leader of the Ashcan School—a name given to 1930s American Realist artists who painted scenes of everyday city life. They painted urban environments and the workplace and although this was the only industrial scene that Anshutz painted it may be seen as a forerunner to Ashcan works.

This painting shows the yard of a nail factory in Wheeling, West Virginia. Anshutz captures a scene during the noontime break at the yard, as the workers stretch and nurse their aching limbs. Anshutz's preoccupation with anatomy shows a debt to Thomas Cowperthwait Eakins. The industrial revolution of the 1880s had a great impact on American laborers and their conditions and while Anshutz's picture may celebrate the new age, this is balanced by the evident exhaustion of the workers, against the backdrop of an imposing factory. It was a brave subject for Anshutz, best known for his beach scenes and portraits. Not only did he show semi-nude figures, but he did so at a time when Realist pictures were at odds with the populist salon art of the time by Sargent and Chase.

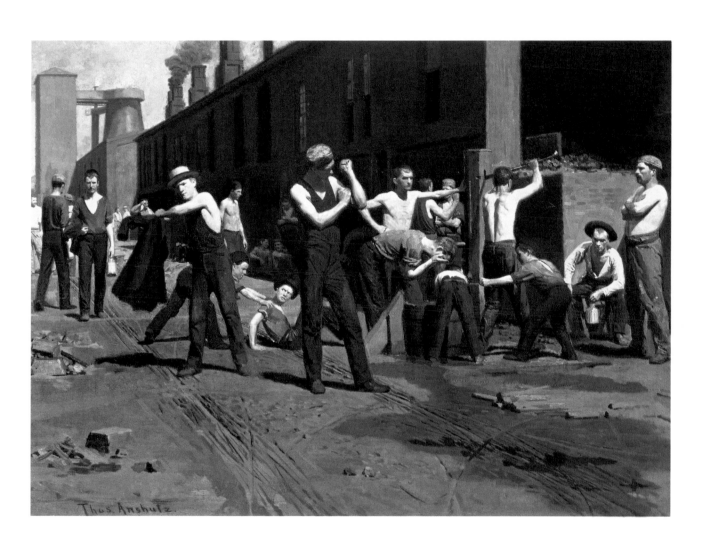

JOHN SINGER SARGENT *(1856–1925)*

ELIZABETH WINTHROP CHANLER (MRS JOHN JAY CHAPMAN) 1893

Smithsonian American Art Museum / Courtesy of Art Resource / Scala

"Every time I paint a portrait I lose a friend."
John Singer Sargent

JOHN Singer Sargent was born in Florence to American parents and although he lived in England for most of his life he visited America regularly. He maintained his American citizenship and therefore refused the knighthood he was awarded.

Sargent studied in both Florence and Paris. In Paris he studied with the portraitist Carolus-Duran and at the École des Beaux-Arts, and his early work shows a debt to Velázquez. He is best known for his society portraits and Rodin called him "the van Dyck of our times." He first exhibited at the Paris Salon in 1877 but it was not until 1884 that he really made his mark when he exhibited his portrait of Madame Gautreau. This portrait of a society lady was considered erotic and caused a sensation at the Paris Salon, and even though it was exhibited as Madame X viewers easily recognized who it was. The scandal affected his commissions and persuaded Sargent to leave Paris for London, where he lived for the rest of his life. He painted 700 portraits during his lifetime.

The artist claimed that he did not offer an interpretation of his sitters: "I never judge, only chronicle." His success at presenting the aristocracy as they wished to be seen brought him great wealth. As with many artists, he had fallen into portraiture as a good way to make money but he disliked it, calling it "a pimp's profession." After 1907 he took few commissions and preferred to do city scenes, landscapes, and more informal figurative pictures.

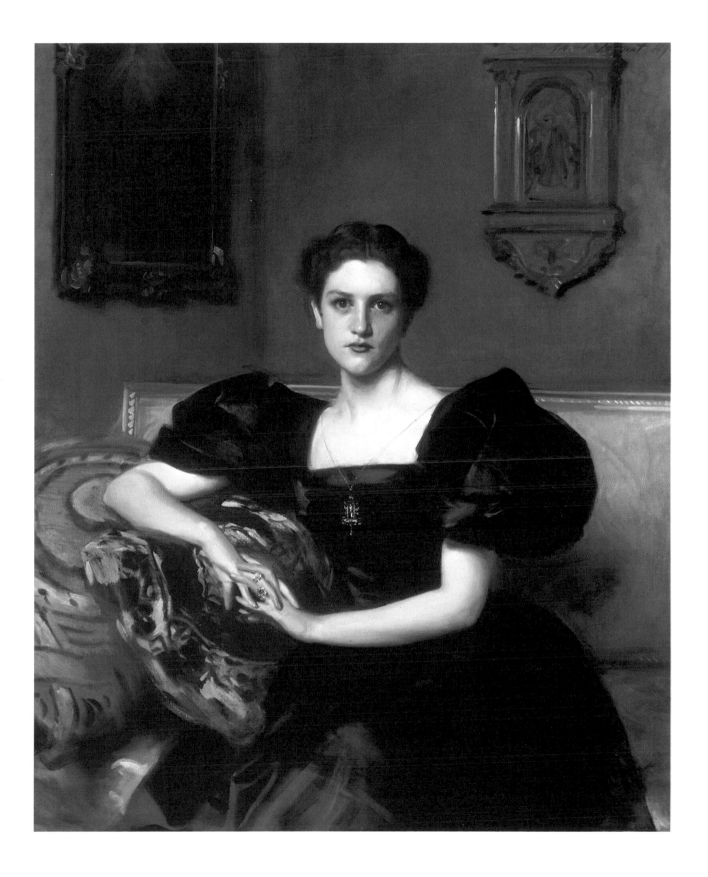

John Singer Sargent (1856–1925)

Marble Fountain in Italy (Boboli Garden) c.1910

Smithsonian American Art Museum, Washington, DC/Courtesy of Art Resource/Scala

A great many American artists traveled to Italy at the beginning of the twentieth century, but Sargent's view of the country differed from many of theirs. He tended to ignore the scenes of the canal and ceremonies and focus on the lives of the people. The Boboli Gardens are terraced gardens on a hillside behind the Pitti Palace in Florence and were completed in the seventeenth century.

Sargent painted this marble fountain in watercolor, his preferred medium after 1900. This was largely because he spent more and more time traveling, and watercolors were more portable than oils. He tended to paint gardens and garden sculpture, fountains, boats, animals, fruits, and flowers, and his light and loose style of watercolor painting suited them. These paintings lack formality and have been criticized for the image being cropped or foreshortened, but this is perhaps part of their charm and they seem to catch fleeting moments of time.

In 1918 the British government appointed Sargent as an official war artist and he spent three months working and recording scenes close to the front. His most famous painting of this time is the enormous *Gassed* (1918–19), of a scene he witnessed outside Arras of blinded soldiers marching by. After his death in 1925 Sargent's work lost popularity, but now he is much sought after, especially his portraits, which ironically he hated to paint: "Ask me to paint your gates, your fences, your barns . . . But NOT THE HUMAN FACE."

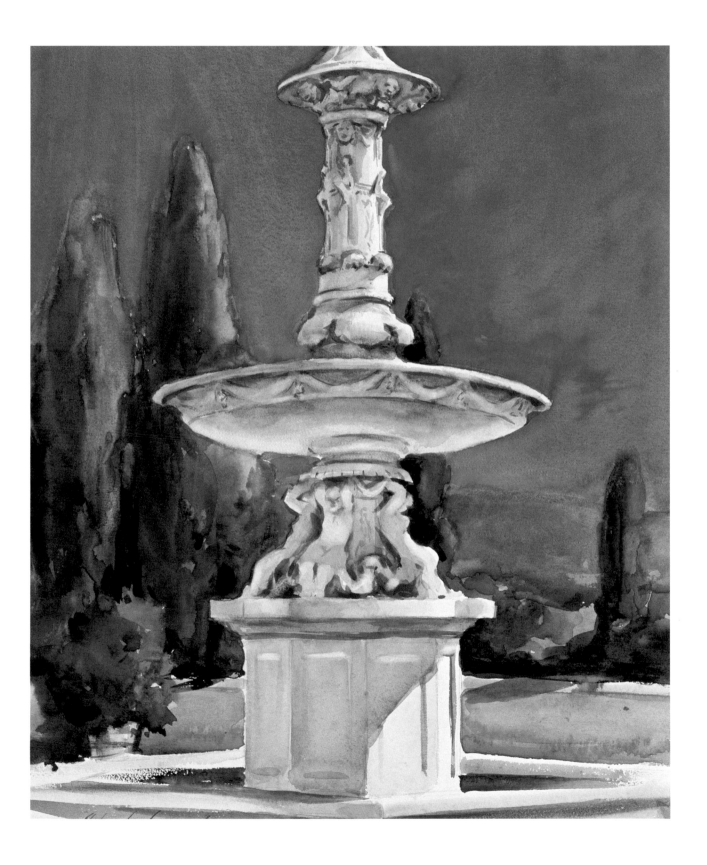

Childe Hassam *(1859–1935)*

In the Garden (Celia Thaxter in Her Garden) 1892

Smithsonian American Art Museum, Washington, DC/Courtesy of Art Resource/Scala

FREDERICK Childe Hassam was born in Dorchester, Massachusetts and first worked in a wood engraver's shop in Boston. Later he worked as an illustrator for various magazines and books. The turning point in Hassam's career came when he visited Europe, and particularly Paris, for the first time in 1883. Paris was to prove a great inspiration and he later lived there between 1886 and 1889. During his time in Paris he studied at the Académie Julian and it was there that he was first inspired by Impressionism. He and Mary Cassatt (see pages 44–7) became the leaders of the American Impressionism movement. Chase's work was recognized in France—in 1888 he exhibited at the Paris Salon and in 1889 he won a bronze medal at the Paris Exposition.

When Hassam returned to America he lived in New York, and he produced many pictures of the Empire City. He was a founding member of the so-called "Ten" (Ten American Painters group). This group joined to promote the Impressionist style, which they combined with scenes that depicted America at leisure. The "Ten" were particularly concerned with trying to persuade American collectors that there was a considerable amount of home-grown Impressionist art available on their doorstep, and that they had no need to get their examples from Paris.

Celia Thaxter was a writer and poet who loved flowers, and here she is depicted in her flower-filled garden. Hassam painted illustrations of flowers to accompany several of her books, including *An Island Garden*.

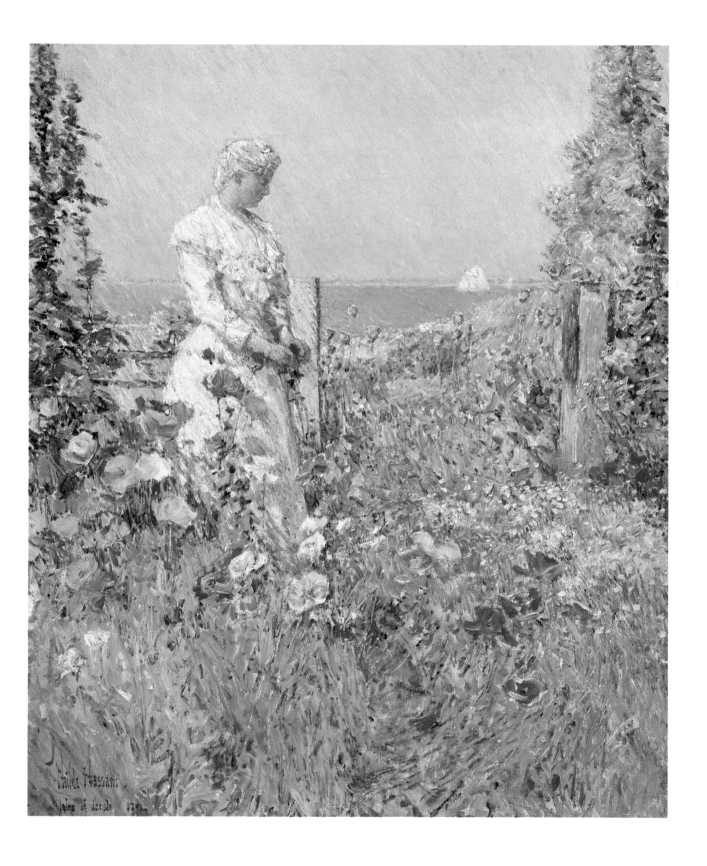

CHILDE HASSAM *(1859–1935)*

IMPROVISATION 1899

National Museum of American Art, Washington, DC/Courtesy of Art Resource/Scala

IN 1921 Childe Hassam reminisced in an interview that he had painted *Improvisation* on the Isles of Shoals and that the sitter was the niece of the poet Celia Thaxter, a young woman named Margaret Laighton. The painting shows her sitting in profile at a piano which is bathed in light. Margaret is clearly engrossed in her playing and the viewer may feel he or she has stumbled across an intimate and private scene as the girl improvises at the piano. In the background is a colonial portrait of a person playing the harp, perhaps a relative of Margaret's.

Hassam was very fond of painting flowers and the vases of flowers bring the garden, visible through the window behind Margaret, into the room. Margaret's aunt, Celia Thaxter, was a keen gardener and cut and gathered flowers from her garden for Hassam to paint.

Hassam adopted French Impressionist techniques and styles but also developed his own ways of painting. His work deftly recreates colors, light and atmosphere. A particular characteristic of Hassam's work is his use of cross-hatched lines. This technique of parallel lines crossing each other encourages the viewer's eye to move over the canvas and look at the picture as a whole.

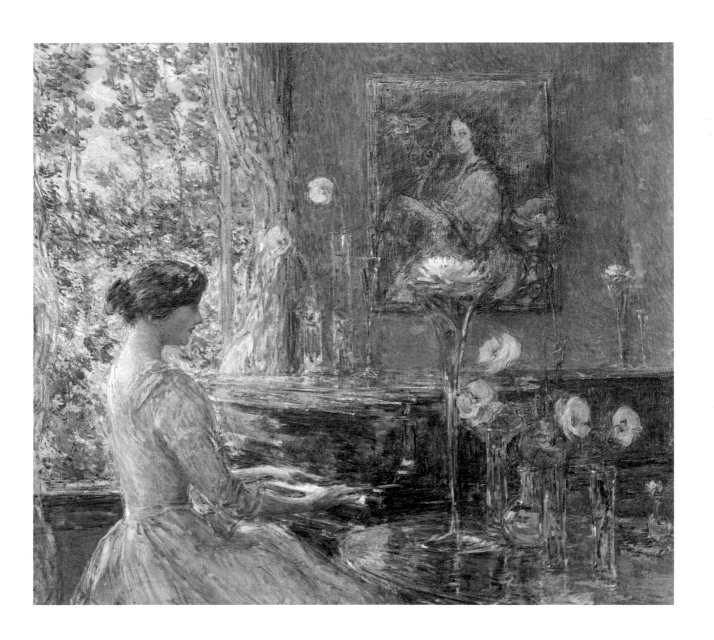

MAURICE PRENDERGAST *(1859–1924)*

PARK SCENE 1918

Smithsonian American Art Museum, Washington, DC/Courtesy of Art Resource/Scala

MAURICE Prendergast was born in Newfoundland. His family moved to Boston when he was two years old. Prendergast first worked as a card painter, but after traveling to England, Italy, and France he came back inspired by what he had seen on his travels—particularly by European Modernist art. In Paris he saw works by Whistler, Manet, and the Nabis. The Nabis (from the Hebrew word for "prophet") were a group of artists who exhibited together between 1891 and 1900 and who were chiefly influenced by Gauguin. The most famous of the Nabis were Denis, Vuillard, and Bonnard.

Prendergast was himself a member of a group known as the "Eight," which included Arthur B. Davies, Robert Henri, Ernest Lawson, George Luks, John Sloan, Everett Shinn, and William Glackens, many of whom are featured in this book. These artists formed the basis for the Ashcan School, a movement devoted to painting scenes of contemporary urban life in America. Prendergast was rather the odd man out of the "Eight," as he adopted a Postimpressionist style and depicted scenes of people at leisure, similar to those of the Impressionists. He particularly enjoyed painting park scenes like this one, which shows great sensitivity to color and lightness of touch. He produced a series of paintings of New York's Central Park, such as *Central Park* (1903), which is in the collection of the Metropolitan Museum in New York.

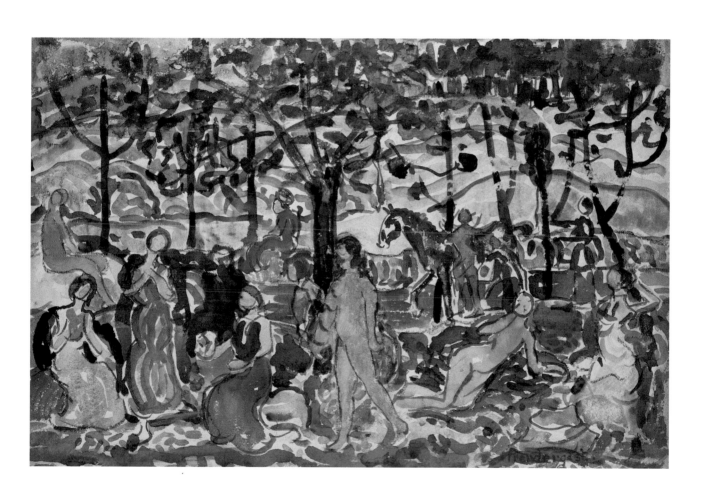

GRANDMA MOSES
(NÉE ANNA MARY ROBERTSON) *(1860–1961)*

THE OLD CHECKERED HOUSE 1944

Chisholm Gallery, West Palm Beach, Florida / Superstock

GRANDMA Moses was born to a farming family in Washington County, New York. In 1887 she married a farmer called Thomas Moses and they lived in Virginia and in New York State. The Moses family had ten children, though sadly only five of them survived through infancy. Thomas Moses died in 1927 and Grandma Moses took up painting as a hobby. Her work was included in a show at the Museum of Modern Art in New York in 1939, after she had been spotted by the collector Louis J. Calder. He saw one of her paintings propped up in a drugstore window and was impressed by what he saw. Grandma Moses had a solo exhibition the following year and proceeded to gain an international reputation.

Her work has been described as primitive, childlike, and naive. The paintings create a nostalgic snapshot of American rural life—*The Old Checkered House* is a particularly charming example. The simplicity and flatness of her paintings are reminiscent of the embroidery pieces she had done before starting to paint. She was extremely prolific and painted over two thousand paintings during her lifetime. Grandma Moses was not, however, very encouraging about her profession. In an interview in the *New York Times* in 1947 she said: "I don't advise anyone to take it up as a business proposition, unless they really have talent, and are crippled so as to deprive them of physical labor."

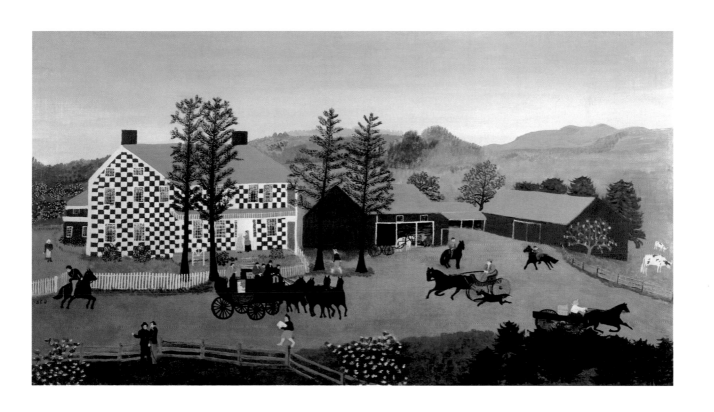

Frederic Remington *(1861–1909)*

Fired On 1907

Smithsonian American Art Museum, Washington, DC/Courtesy of Art Resource/Scala

FREDERIC Remington painted and sculpted iconic images of the Wild West: Native Americans, cavalrymen, and, most famously, cowboys. The cowboy was very much the focus of his work: "With me," he said, "cowboys are what gems and porcelain are to others."

Remington grew up in Ogdensburg, New York and studied briefly at the Yale University School of Fine Art. In 1881 the young Remington reportedly left New York and traveled through Montana to the West in search of his fortune, either in gold or cattle. The following year he began to write and provide sketches and illustrations for a number of publications, including *Collier's Weekly*, *Harper's Weekly*, and *The Century*.

The American public was enamored of the view of the Wild West that Remington presented to it. This dark, dramatic picture depicts a surprise night attack, with the startled horse made to stand out all the more by the stark contrast of light and dark. Remington's paintings represented the view of the vanishing Wilderness, and it was a view that fed Hollywood's romanticized version of the Wild West. The West had seen many changes in the 1870s and 1880s with many Native Americans gone, the cattle culled, and the landscape split by railroads. The West and the Wilderness became objects of nostalgia and myth, and Remington's paintings are the most supreme example of this in American art.

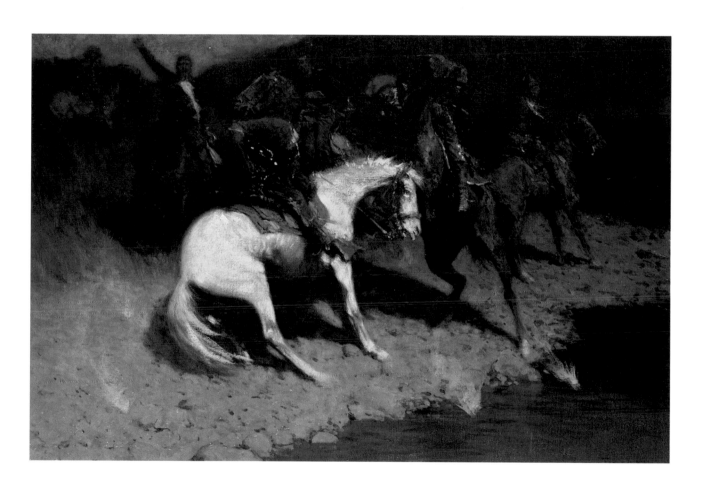

FREDERIC REMINGTON *(1861–1909)*

TROOPER OF THE PLAINS 1909

The Newark Museum / Courtesy of Art Resource / Scala

IN 1895 Frederic Remington, illustrator and painter of the Wild West and champion of cowboys, moved away from painting the American Wilderness and turned his hand to bronze sculpture instead. His first sculpture was *Bronco Buster*, of a rearing horse with its rider losing his stirrup. His second was *Wounded Bunky* (1896), which was of two troopers fleeing from Native Americans, one supporting his hurt bunky (bunkmate). Remington's first public sculpture was erected on the East River Drive in Philadelphia in 1908.

Remington went to great extremes to make his sculptures as lifelike as he could. He worked from a real horse as much as possible and his attention to detail was painstaking. He even had barn doors instaled in his studio so that he could bring the horses inside to work from. In 1883 Remington and his wife moved to a sheep ranch in Kansas, but increasing financial difficulties forced them back to New York the following year. He continued to visit the West, however, in order to find subjects to paint and sculpt.

It is perhaps for his bronze sculptures that Remington is best known. Remington seemed to realize that this was the part of his artistic output that would be his most enduring legacy—he predicted as much in 1895, saying, "My oils will all get old and watery . . . my watercolors will fade—but I am to endure in bronze . . . I am modeling—I find I do well—I am doing a cowboy on a bucking bronco and I am going to rattle down through the ages."

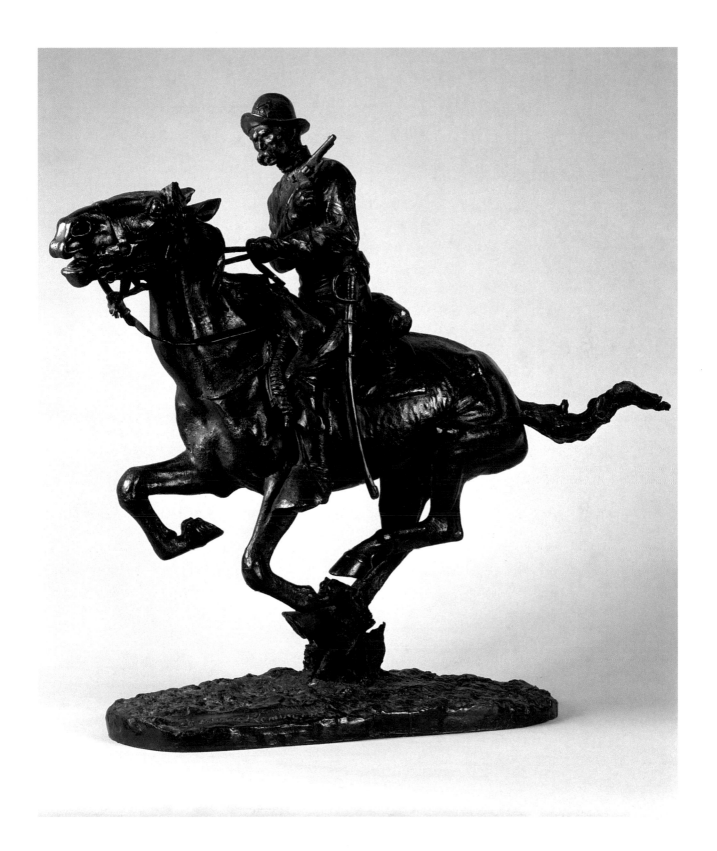

ALFRED STIEGLITZ *(1864–1946)*

THE SEINE 1894

Private collection / Courtesy of the Bridgeman Art Library

ALONG with Ansel Adams, Alfred Stieglitz is one of the most renowned and admired of American photographers. His work is in part responsible for elevating the discipline of photography to the realms of high art and demanding that viewers give it the same attention as fine art. He experimented with techniques and composition and his most famous photograph is *The Steerage* (1907).

Stieglitz was a multidisciplinary worker—he also worked as an editor, gallery owner, and as a mentor to many young photographers and artists. He was responsible for introducing elements of European Modernism to America, after spending his life as a young man in Berlin, and was an important and influential figure in the art world of turn-of-the-century New York. His "291" gallery—291 Fifth Avenue, New York—opened its doors in 1905 and Stieglitz brought an impressive array of European artists with him. He opened two other galleries during his career: the Intimate Gallery and An American Place. Henri Matisse, Toulouse-Lautrec, Francis Picabia, Constantin Brancusi, and many others held their first exhibitions in New York at Stieglitz's galleries. The endorsement of Stieglitz became a very valuable commodity in itself for many artists and he experimented with previously neglected arts; for example, he staged the first important show of African art in America at the Museum of Modern Art, New York. He also did much to promote the paintings of his wife, Georgia O'Keeffe (see pages 120–23).

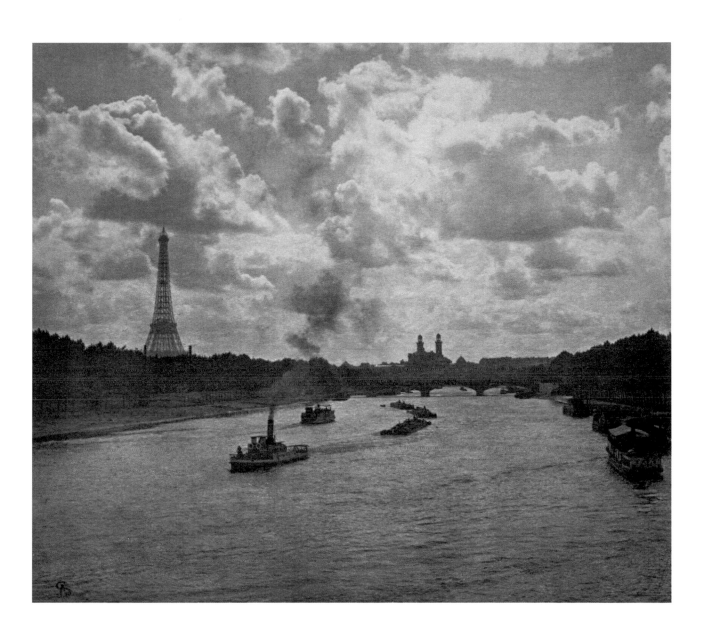

ROBERT HENRI *(1865–1929)*

BLIND SPANISH SINGER 1912

Smithsonian American Art Museum, Washington, DC / Courtesy of Art Resource / Scala

ROBERT Henri is an artist who has become almost better known for his work as a teacher and revolutionary art critic than for his actual paintings. He taught a number of painters who would go on to become some of America's leading artists, including Edward Hopper and George Bellows. Henri studied at the Pennsylvania Academy of the Fine Arts and in Paris at the Académie Julian and École des Beaux-Arts. He become one of the great American Realists, having been influenced himself by Édouard Manet and the young Thomas Eakins.

He made New York his home in 1900 and embarked upon an acclaimed teaching career: at the New York School of Art, the Modern School of the Ferrer Center, the Art Students League, and at his own school. Through his teaching Henri spawned a whole generation of famous artists who devoted themselves to modern Realist paintings. He founded the "Eight," composed of Luks, Sloan, Glackens, Shinn, Prendergast, Lawson, Davies, and himself. The "Eight" supported progressive art and sought to be independent from the academy. Out of the "Eight" came the larger Ashcan School, so called because of the gritty urban subjects they painted.

During his career Henri made several trips to Europe and produced some figurative work inspired by local people—Irish peasants, gypsies, and singers—with whom he came into contact.

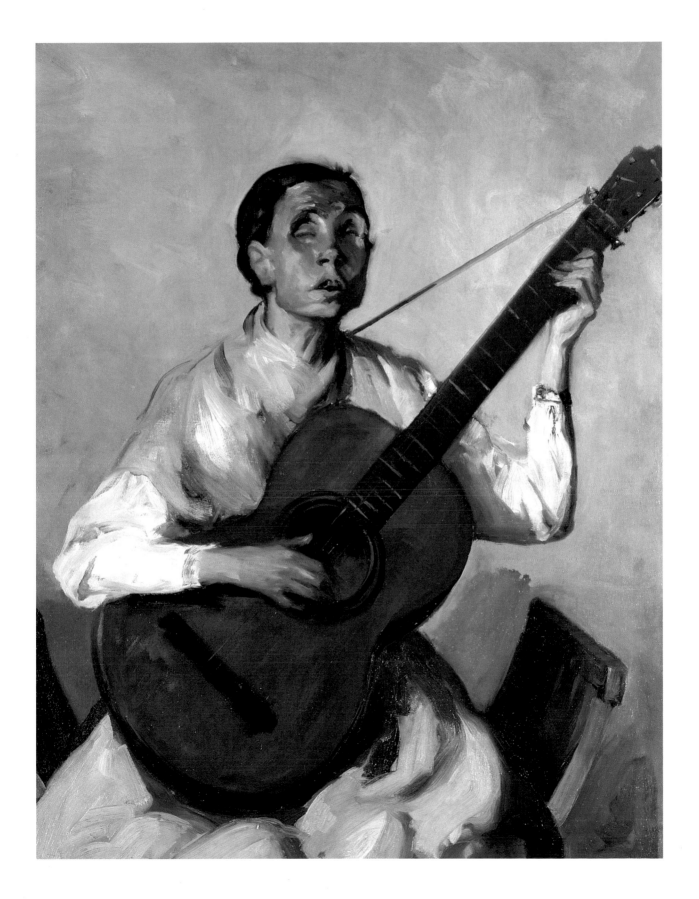

GEORGE LUKS *(1866–1933)*

THE MINER 1928

National Gallery of Art, Washington, DC/Courtesy of the Bridgeman Art Library

GEORGE Luks was born in Williamsport, Pennsylvania, the son of a physician. He studied at the Academy of Fine Arts in Philadelphia under Thomas Anshutz, whom Luks described as the best of all his teachers. Anshutz encouraged Luks in painting scenes of American Realism. He also studied at the Düsseldorf Academy and traveled to Paris and London. He was particularly influenced by Rembrandt, Goya, and Velázquez. On Luks's return to America he worked as an illustrator on the *Evening Bulletin* in Philadelphia and was sent to Cuba as an artist/correspondent during the Cuban revolt against Spain in 1896. Luks worked on his own paintings and gave up illustration when his work began to attract attention. He was one of the founding members of the Ashcan School, famous for their gritty representations of urban life.

Art history books carry many versions of Luks's biography and the uncertainty surrounding him suggests that he may well have invented and embellished various events in his life. It is therefore difficult to discover who the real George Luks was. Some accounts tell of his medals for amateur boxing, others that he posed as an ex-boxer and gave himself the name "Lusty Luks." He was certainly a mysterious and ambiguous figure in American art. Boxing was a theme that would reoccur in the work of a number of artists from the Ashcan School, and one of Luks's most famous paintings is *The Wrestlers* (1905).

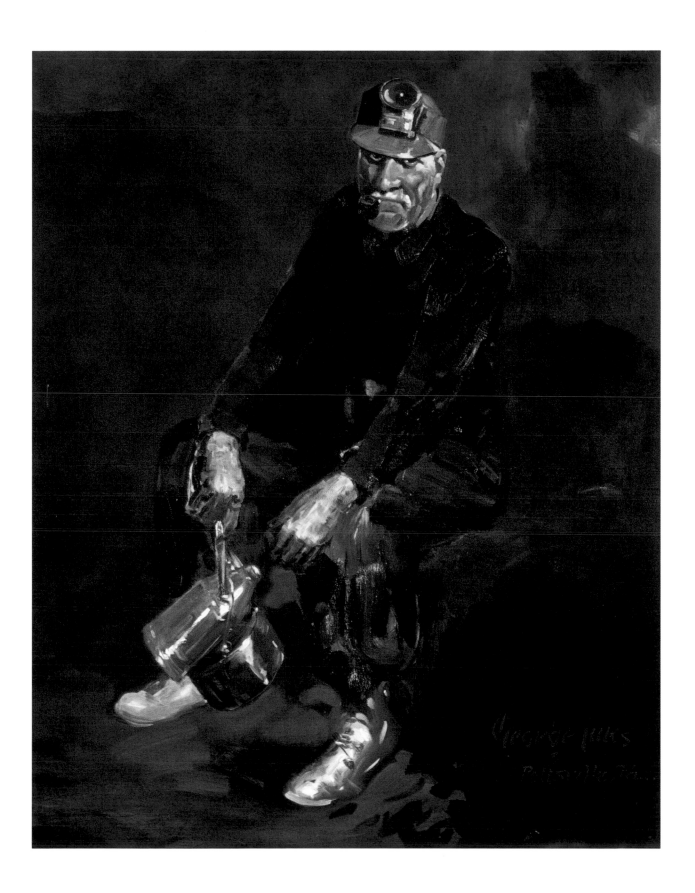

WILLIAM J. GLACKENS *(1870–1938)*

BEACH UMBRELLAS AT BLUE POINT C.1915

Smithsonian American Art Museum, Washington, DC/Courtesy of Art Resource/Scala

THE beginning of the twentieth century witnessed a considerable growth in the middle classes in America, and along with this came a focus on and enthusiasm for the pursuit of pleasure. Then, as today, Manhattanites would escape the heat and humidity of New York streets for the relief of the cool breezes and shade of the seaside and countryside. Glackens's *Beach Umbrellas at Blue Point*, set in one of the seaside towns on the south shore of Long Island, is one of the best-known portrayals of such a scene,

Glackens started as a newspaper illustrator, but took up painting in 1891, encouraged by Robert Henri. Henri was the leader of the group of artists known as the "Eight," which included Arthur B. Davies, Maurice Prendergast, Ernest Lawson, George Luks, John Sloan, Everett Shinn, and Glackens. They are more often referred to as the Ashcan School. Their aim was to paint contemporary urban life and reveal the terrible working and living conditions of working-class people in the new urban America. Several of the artists, afraid of being too realistic about the poverty and hardship of city streets, and keen to sell their works, adopted an Impressionist style and created picturesque scenes which avoided the reality of the subject matter. Glackens himself was less preoccupied with social realism and more interested in colorful scenes of leisure activities, like *Beach Umbrellas at Blue Point*, which shows how influential Renoir was on his work.

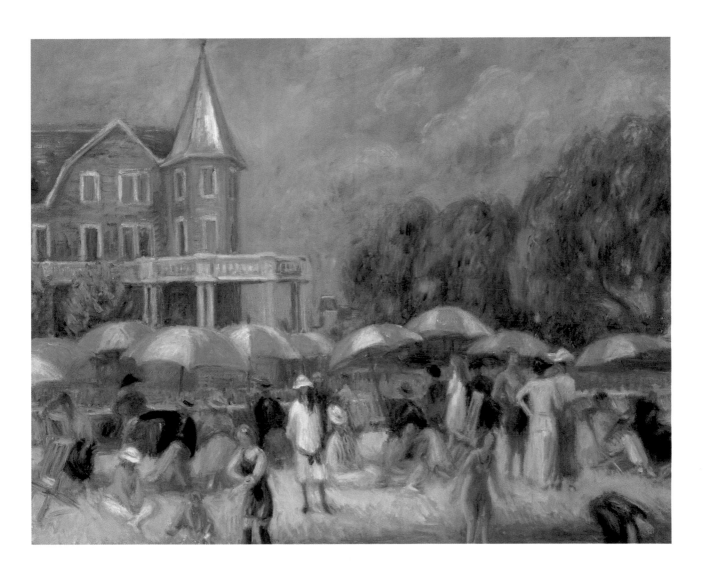

MAXFIELD PARRISH *(1870–1966)*

LUSISTI STATIS 1899

Smithsonian American Art Museum, Washington, DC/Courtesy of Art Resource/Scala

MAXFIELD Parrish studied at the Pennsylvania Academy of the Fine Arts with Howard Pyle (1853–1911) who, like N. C. Wyeth, was famous for his illustrations for children's books. Parrish's own career as an illustrator took off in 1895 when he designed a cover for *Harper's Weekly* and went on to produce a great number of illustrations, advertisements, and posters. The American art world has always, perhaps more than that of most countries, been financially driven, and as a result many American artists began their careers as illustrators for the many newspapers and magazines produced throughout the country. Parrish also produced murals, maquettes, and landscapes, but he is best known for his illustrations and color prints.

His color prints won him great success and popularity and were produced in enormous numbers and widely distributed. For example, his painting *The Garden of Allah* (1919) was a sensation, and another called *Daybreak* (1922) was an iconic image of the 1920s, selling more than 200,000 prints. The calendars he produced from the 1930s to the 1960s became collectors' items and often when the calendar became out of date people would frame the pictures. His work was less admired by museums and private collectors and more treasured by the general public. One reason for Parrish's appeal was the romantic nature of his work—he invited the viewer to escape to a land of Arabian Nights or the glamor of Hollywood. He incorporated elements from classical antiquity, with landscapes, elaborate gardens, and pretty maidens. He had a very precise technique and applied layer after layer of thin oil paint to his paper, with coats of varnish in between. This method created luminous and highly detailed pictures. He was particularly famous for his painting of skies and "Parrish blue" entered into popular parlance.

Parrish, like Norman Rockwell, enjoyed enormous popularity with the general public but has received a mixed reception from art historians and critics. In the hierarchy of painting, illustration is often disregarded or placed low. Later in his career Parrish's work went out of style and he turned to landscape. His lengthy career lasted 68 years and he worked up to his death at the age of 95.

JOHN SLOAN *(1871–1951)*

GWENDOLYN 1918

Smithsonian American Art Museum, Washington, DC/Courtesy of Art Resource/Scala

JOHN Sloan was born in Lock Haven, Pennsylvania, the son of a traveling salesman. In 1876 the Sloan family moved to Philadelphia and the young Sloan had to get a job to help support his family. Initially he worked designing greetings cards, calendars, advertisements, and so on and attended drawing evening classes at the Spring Garden Institute. Then in 1890 Sloan began working as a graphic journalist illustrator on the *Philadelphia Enquirer*. Many artists began their careers as illustrators, and so Sloan soon became part of an artistic group. He was particularly influenced by Robert Henri. As well as working on the newspaper, Sloan enrolled at the Pennsylvania Academy of the Fine Arts and attended between 1892 and 1894. Sloan was unusual in that he did not travel to Europe to complete his art education and made a conscious decision to stay in America and take advantage of the teaching there.

In 1904 Sloan moved to New York with his wife Dolly, and was greatly encouraged by Henri to pursue his painting. In 1908 Sloan exhibited with a group called the "Eight"—comprising Henri, Glackens, Luks, Shinn, Davies, Prendergast, Lawson, and Sloan. The "Eight" were the foundation for the Ashcan School, who painted gritty scenes of urban life. The group were also great friends and they drank, played poker, and argued about art together. The "Eight" and the Ashcan School celebrated the ever-changing and frantic pace of New York City, the poverty, the impact of immigration, and the differentiations between social classes. They strove to represent reality and appreciated it in the work of other artists. When Sloan met the Irish painter J. B. Yeats, the father of the poet, he praised him, saying: "His vest is slightly spotted; he is real."

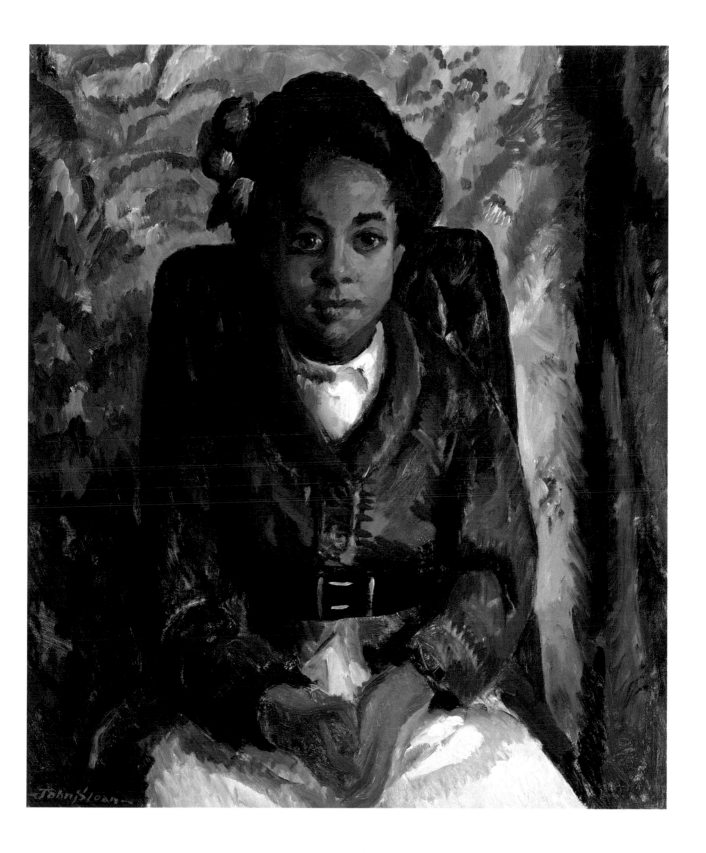

John Sloan (1871–1951)

Agna Enters 1925

National Portrait Gallery Smithsonian/Courtesy of Art Resource/Scala

SLOAN was the most political member of the "Eight" and as well as his pictures of underprivileged New York life he did illustrations for *The Masses* and other socialist periodicals. His paintings tended to be less politically didactic and satirical than his illustrations but he was very committed and went on to become the editor of *The Masses* from 1912 to 1916.

Much of Sloan's work contains a voyeuristic element. It is as if he has caught his subjects unawares and it is often the access Sloan gives the viewer that makes his work particularly compeling. He enters behind the scenes of ordinary people's lives, whether it be a woman hanging out her washing, girls going to a dance hall, lovers kissing on a fire escape, or bathers stretched out on Staten Island. This sense of voyeurism is very similar to the work of Edward Hopper, where the viewer feels uncomfortable with the subject matter but all the same feels forced to look. Sloan continued to paint these everyday scenes because, he said, "the subject matter was right under my nose," but in 1925 his subject matter changed. He began to focus his attention on painting women and nudes and he experimented with his brush techniques.

He taught at the Art Students League between 1914 and 1938, and his past students make an impressive list, including Alexander Calder, Barnett Newman, and David Smith. In 1939 he published *The Gist of Art,* which was part art criticism, part autobiography. Sloan was president of the Society of Independent Artists from 1918 until his death. He was elected to the National Institute of Arts and Letters in 1929 and made director of the Art Students League in 1931.

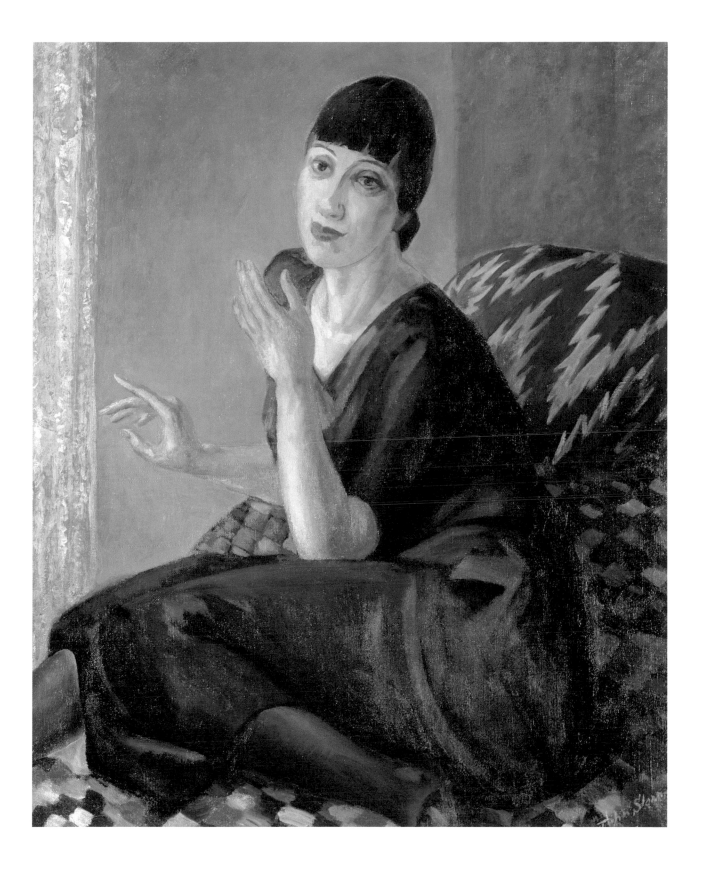

MARSDEN HARTLEY *(1877–1943)*

FISHING BOATS 1935–36

The Newark Museum / Courtesy of Art Resource / Scala

"For wine, they drank the ocean—
for bread, they ate their own despairs;
counsel from the moon
was theirs
for the foolish contention."

"Fisherman's Last Supper," by Marsden Hartley

MARSDEN Hartley was born in Maine and studied in Cleveland and New York. As with Arthur Dove, one of the greatest influences in his life was the photographer and gallery owner Alfred Stieglitz. Stieglitz staged Hartley's first solo exhibition in 1909 and with the proceeds Hartley embarked on an extensive tour of Europe. After stopping briefly in Paris, which was gripped at the time by Cubist fervour, Hartley traveled to Germany, where he lived for a time. He became interested in German Expressionism and Kandinsky's color theories. On his return to America he continued to experiment with abstraction and his work was included in the Armory Show of 1913. One of his most famous paintings is *Painting No. 5* (1914–15), painted during the First World War in an Expressionist manner and containing German military motifs.

In the 1920s Hartley led a mostly nomadic existence, traveling to France, Italy, Germany, and New Mexico. In 1934 he returned to his native Maine and spent most of his time there painting landscapes and seascapes and writing poetry.

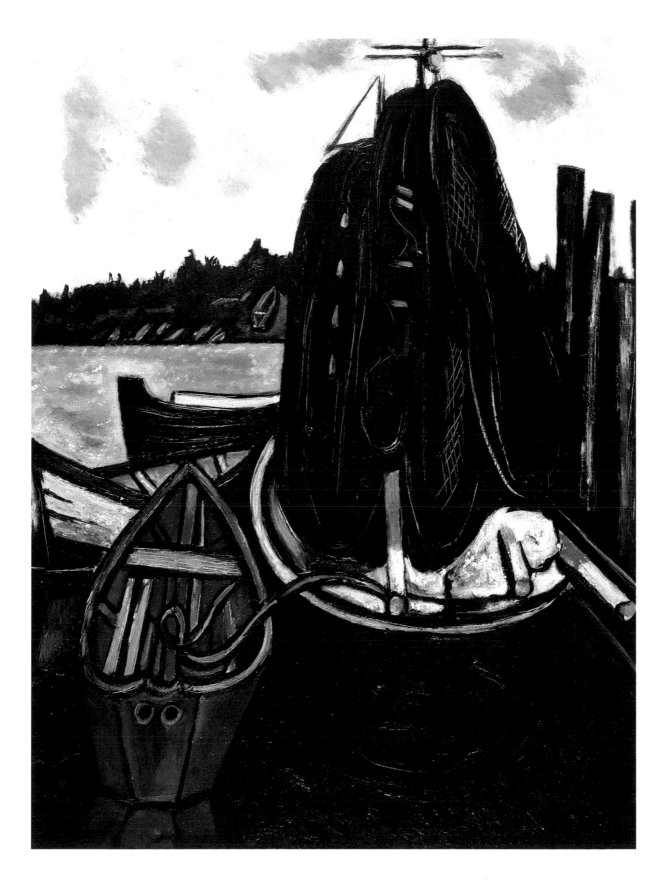

ARTHUR DOVE *(1880–1946)*

COWS AND CALVES 1935

The Newark Museum/Courtesy of Art Resource/Scala

ARTHUR Dove was born in Canandaigua in the region of the Finger Lakes in New York State in 1880. His father owned a successful brick factory, and such prosperity gave him great hopes that his two sons should similarly make their mark. However, little could have been further from his expectations than a career in art— Mr Dove Sr dearly wanted Arthur to become a lawyer, and was initially disappointed when, upon graduation from Cornell University, his son embarked on a career as an illustrator.

However, it was not long before Dove Jr gave his father something to be proud of, as he was soon hired by several high-profile magazines and papers such as *Life* and the *Saturday Evening Post*. The *Post* was a particularly fortunate place to be, as it served as a starting point for many young artists. In fact it was so highly thought of that some—such as Norman Rockwell (1894–1978)—continued to produce illustrations for it throughout their careers. Dove was ambitious and was looking for an opportunity to start experimenting with his own work.

This opportunity came when, in 1907, Dove left America for Europe and lived for two years in France. It was here that he was introduced to works by the Fauves and in particular by Cézanne. He arrived in Paris but much preferred the countryside to the city and spent time in Cagnes in the south of France. He began to paint Impressionist landscapes and took much of his subject matter from nature. The picture he submitted to the Paris Salon in 1909 was *The Lobster* and he was inspired by other animals during his career, as in this painting, *Cows and Calves*.

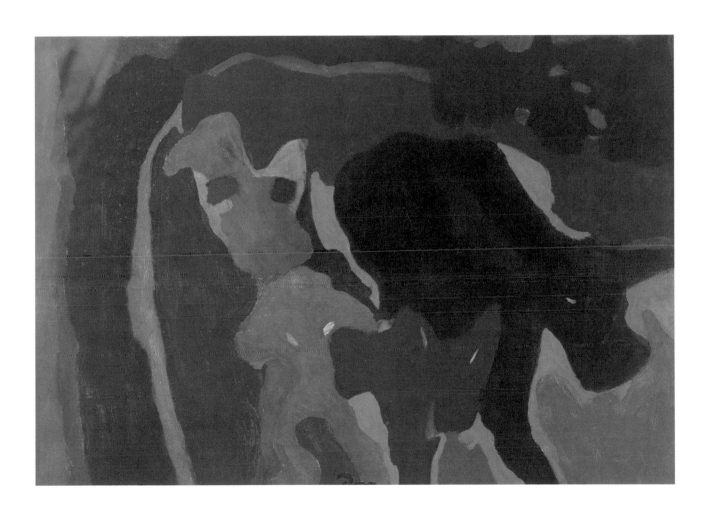

ARTHUR DOVE *(1880–1946)*

SUN 1943

Smithsonian American Art Museum, Washington, DC/Courtesy of Art Resource/Scala

DOVE returned to New York at the end of 1909, having lived and worked in France for two years, and by the time he arrived back in his native land his approach to the entire art spectrum was changed. It was vastly expanded through continued first-hand contact with contemporary and historical European art, and the knowledge that he brought home with him resulted in a burning desire to advance the American art scene by creating something that was genuinely new.

This ambition manifested itself in works he called "extractions," which, when compared with what was being done around him at that time, are widely acknowledged as the first abstract pictures to appear in American art. Interestingly though, at this stage the geometric abstractions contained references to forms from nature such as the sun and the moon, landscapes, animals, and the weather. This was a theme that was to continue throughout Arthur Dove's career, as he maintained an acceptance of nature as an important part of his work, although he was to reduce it to progressively more abstract forms.

Alfred Stieglitz was a great supporter of Dove, and the artist had his first solo exhibition at Stieglitz's "291" gallery in New York in 1912. Dove's work has been likened to the work of Georgia O'Keeffe (Stieglitz's wife), as both artists developed their own kinds of shorthand for depicting landscape.

Despite Stieglitz's involvement, Dove did not achieve financial success until late in his career. He did not sell any of his works until he was 50 years old, but is now accepted as one of the fathers of abstraction in American painting.

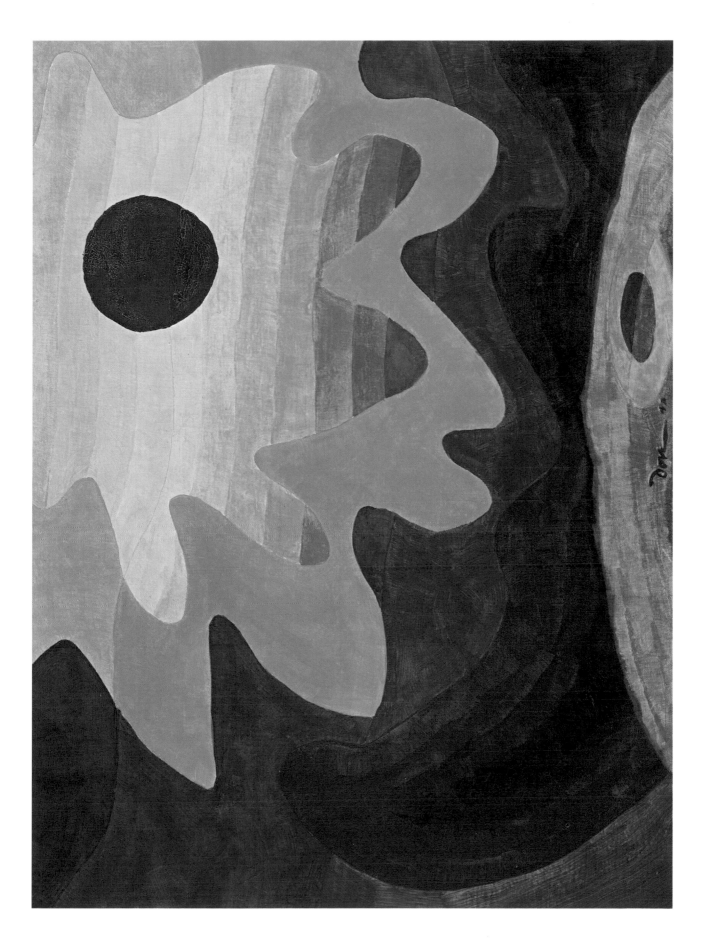

HANS HOFMANN *(1880–1966)*

STILL LIFE 1939

New Orleans Museum of Fine Art, Louisiana / Courtesy of the Bridgeman Art Library

HANS Hofmann was born in Bavaria in 1880 and became a key figure in the abstract art movement and a highly influential art teacher. He began his own art education in Munich and, after receiving sponsorship from a Berlin department store owner, he went to Paris in 1904 to continue his studies. He met Matisse, Delaunay, Braque, Pascin, and Picasso while in Paris, and showed his work at the Paul Cassirer gallery. Paris was in the grips of Fauvism and Cubism at the time and artists there were sympathetic to Hofmann's belief that "the whole world, as we experience it visually, comes to us through the mystic realm of color."

Owing to ill health Hofmann was unable to fight in the First World War and returned to Munich to open his first art school in 1915. Some would argue that he revolutionized art teaching. His word spread even further when in 1932, unhappy with the political situation in Munich, he closed his art school and moved to America. After teaching at the University of California, Berkeley, and the Chouinard School of Art in Los Angeles, he moved to New York. There he began teaching at the Art Students League and went on to open the Hans Hofmann School of Fine Arts in 1933. Between 1935 and 1958 he also organized a series of summer art schools in Provincetown, Massachusetts. Hofmann was partly responsible for introducing Cubism to American artists. To him painting was "forming with color" and nature was the best teacher. His teaching methods were controversial and he was reportedly very sexist towards his female students, believing that only men could really paint.

Hofmann's career as a teacher funded his other career as a painter. This is an example of the still lifes he painted in the 1930s. Here subject matter is still discernible, whereas his work from the 1940s became more abstract.

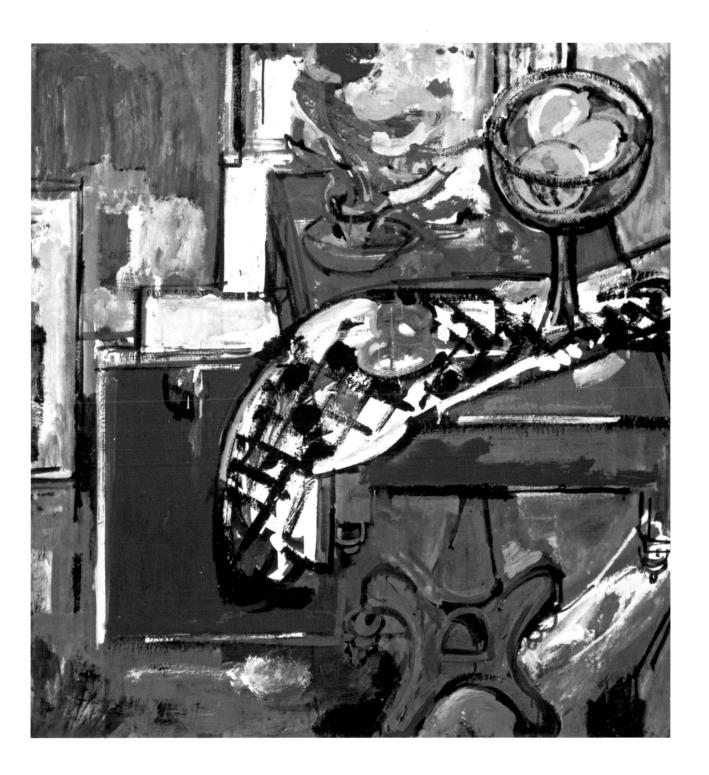

HANS HOFMANN *(1880–1966)*

THE VEIL IN THE MIRROR 1952

Metropolitan Museum of Art, New York / Courtesy of the Bridgeman Art Library

WHILE pursuing his career as a teacher Hofmann also worked on his own revolutionary style of painting. His earnings from teaching allowed him to develop his own work rather than simply concentrating on making commercially viable pictures. Hofmann's style has often been described as "painterly abstraction" and his techniques and references show a debt to the artistic movements he encountered in the different countries he lived in. He integrated into his work Parisian Fauvism and Cubism, German Expressionism, and New York Abstract Expressionism. His loose gestural style, his control of paint, and preoccupation with color characterized his work from the 1940s. Some critics have noted that his splatter and drip style predated Pollock's work.

The other important facets of Hofmann's career were his experiments with automatic drawing—it was actually a facet of Abstract Expressionism that he put his signature on. Then, at the end of his life, he painted one of his best-known series of paintings: This was *The Renate Series*, dedicated to his second wife, Renate, and for many critics it characterizes the high point of his career.

Hofmann's first show in America was at the California Palace of the Legion of Honor, San Francisco. Peggy Guggenheim admired his work and he had a solo exhibition at her Art of This Century Gallery in 1944. The artist was over 60 years old at this time and it was in the latter part of his life that he received recognition and commercial interest in his work. He also showed at the Betty Parsons Gallery and the Sam Kootz Gallery in 1947. Hofmann became an American citizen in 1941.

MAX WEBER *(1881–1961)*

SUMMER 1909

Smithsonian American Art Museum, Washington, DC/Courtesy of Art Resource/Scala

MAX Weber was born in Bialystok, now part of Poland, and his family emigrated to New York in 1891 when he was ten years old. He first studied at the Pratt Institute in New York between 1898 and 1900, and then in Paris at the Académie Julian between 1905 and 1907 under Matisse. It was during his trips to Europe that he became attracted to early Cubist pictures, and this had a great effect on his subsequent work. He returned to New York in 1909 and began producing paintings that were Fauvist and Cubist in spirit. Weber was instrumental in bringing the European avant-garde to New York.

He was a very versatile artist and worked not only as a painter but also as a sculptor, writer, and printmaker. Alfred Stieglitz admired his work, and Weber exhibited at his "291" gallery in New York in 1910. His first solo exhibition was at the Gallery Bernheim-Jeune in 1924, and the Museum of Modern Art in New York staged a retrospective in 1930. Weber's pioneering Fauvist and Cubist pictures combine attention to color with a dissection of the picture plane. Although the artist embraced European styles, he succeeded in fusing these with American subject matter and created his own distinctive work, as seen in *Chinese Restaurant* (1915).

In the 1940s Weber turned from abstraction to more representative works. He drew on his early childhood and family life in Russia for his subject matter and produced a series of works that depicted Jewish rabbis and scholars. One of the most well-known of these illustrates imagery from his own Hasidic background and is called *Adoration of the Moon* (1944).

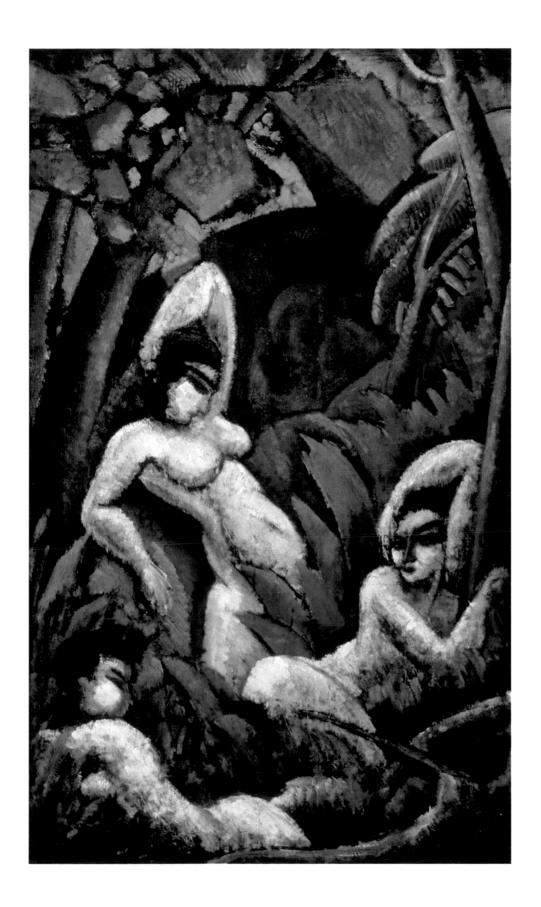

GEORGE BELLOWS *(1882–1925)*

MR & MRS PHILIP WASE 1924

Smithsonian American Art Museum, Washington, DC / Courtesy of Art Resource / Scala

GEORGE Bellows was born in Columbus, Ohio and studied under Robert Henri, founder of the Ashcan School. Bellows's approach to his art was often one of stark realism and among his best-known, best-appreciated pictures are those of the dark, brutal world of underground prizefighting—*Stag at Sharkey's* (1907) is probably the most famous. He also painted several series of paintings of New York life, such as waterfronts, street scenes, urban landscapes, and often unglamorous portraits. The results were frequently as fascinating as they were haunting, as the intrinsic beauty of the execution of pictures frequently jarred with their subject matter. In his well-known *Cliff Dwellers* (1913)—note the use of irony in the title—Bellows's eye and inherent sympathy for his subject matter make the tough reality of living in the tenement buildings somehow picturesque.

Bellows painted Mr and Mrs Philip Wase during the last summer of his life. The Wases were natives of Woodstock, where Bellows had a house, and Mrs Wase did the artist's cleaning and laundry. Reportedly the Wases' marriage was not a good one, and the figures do not interact with each other. Mrs Wase's finger holds her place in the book on her lap, giving the picture a photographic quality, as if a moment in time had been captured—a popular device with Bellows and other artists at the time. Mrs Wase told how they were paid a dollar an hour by Bellows: "And if we'd been a-willin' to set without our clothes on we'd a made twice as much; but me, I won't let down my drawers for any artists!"

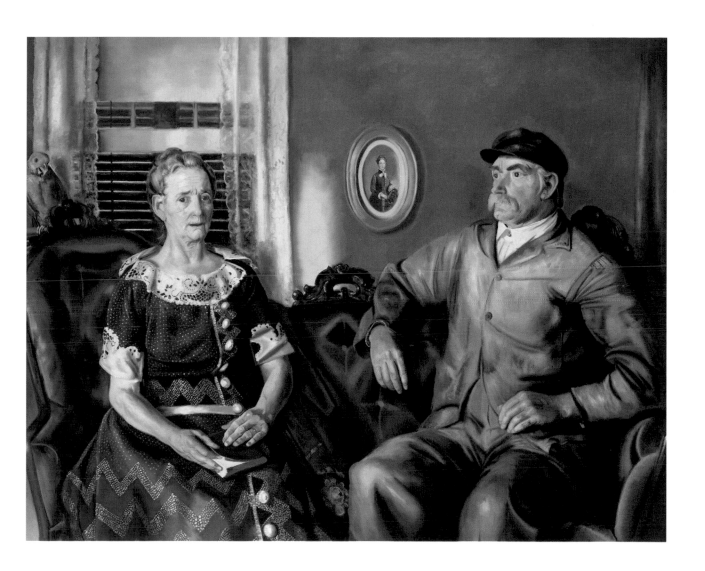

ROCKWELL KENT *(1882–1971)*

SNOW FIELDS (WINTER IN THE BERKSHIRES) 1909

Smithsonian American Art Museum, Washington, DC/Courtesy of Art Resource/Scala

"So, loving the Berkshire landscape, loving the glare of sunlight on the snow, loving the blue shadows, and the depths of space, loving that world in sunshine and under clouds, loving all the world and life . . . I painted."
Rockwell Kent

ROCKWELL Kent was one of the leaders in the printmaking scene in the 1920s and 1930s. Born in Tarrytown Heights, New York, he specialized in wood engraving, which is notoriously one of the most difficult artistic media to operate in, but his skill and attention to detail meant he exceled. Kent also worked as an illustrator and produced the illustrations for the works of such luminaries as Shakespeare, Chaucer, and Whitman. These series have since proved to be among the best examples of Kent's talents, as he was able to bring his singular flair to what was, for many, a well-trodden area, and so breathe new life into the classics.

Snow Fields is one of his works in oil, but his wood engraver's approach is what makes it so special—the effect of stark contrast that would be standard in his finished engravings is mirrored here. We are dazzled by the reflection of the light from the snow, which is counterbalanced by the shadows of the figures on the ground and the dark trees in the background. The overall appearance now becomes satisfyingly three-dimensional, as while Kent has captured the sense of playfulness of a family out walking in the snow, as dogs jump up excitedly and children are thrown up in the air, there is also a frigidity about the background that subtly undermines this sense of security.

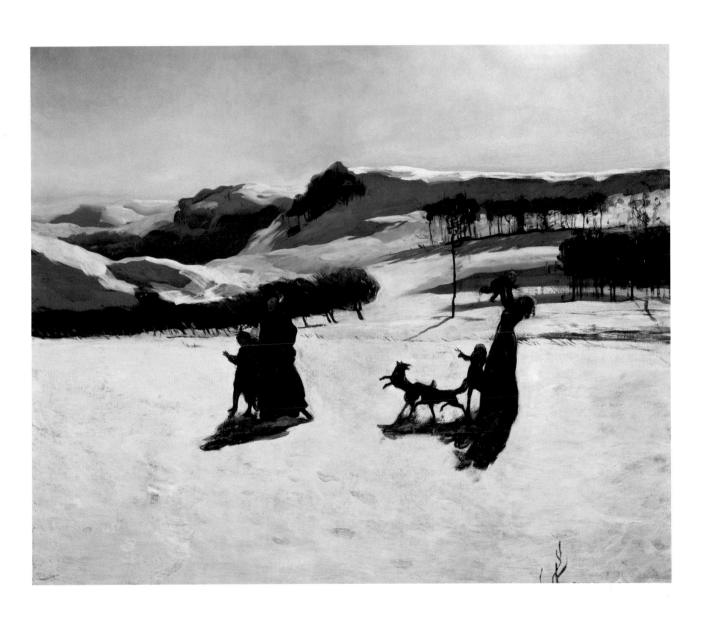

EDWARD HOPPER *(1882–1967)*

RYDER'S HOUSE 1933

Smithsonian American Art Museum, Washington, DC/Courtesy of Art Resource/Scala

HOPPER was born in Nyack, New York, and studied at the New York School of Art between 1900 and 1906, where Robert Henri was one of his teachers. He traveled in Europe as a young man and when he returned to New York he made a living by working as a commercial illustrator for various magazines until 1923. At this point he began establishing his place in US art history as one of the great exponents of American Scene painting. During the latter part of that decade he attracted serious attention and exhibited in several group shows, but it was his first solo exhibition at the Whitney Studio Club that cemented his reputation. In 1933 the Museum of Modern Art in New York staged a retrospective of his work, which represented a genuine milestone in critical acclaim for the artist.

Like those of his former teacher, Henri, Hopper's American Scene paintings specialized in urban locations and the New England countryside, and so represented the contrasts that make up so much of American life. He is particularly well known for his scenes of city life inhabited by lonely people who do not interact with each other, such as the famous *Nighthawks* (1942), set in an all-night diner. Hopper denied his paintings were social commentary. Nevertheless, one of his conscious or unconscious observations is the effect of urbanization and corporatization on American society. His landscapes and farms respond to the effect of the Depression of the 1930s and the depopulation and poverty of rural communities.

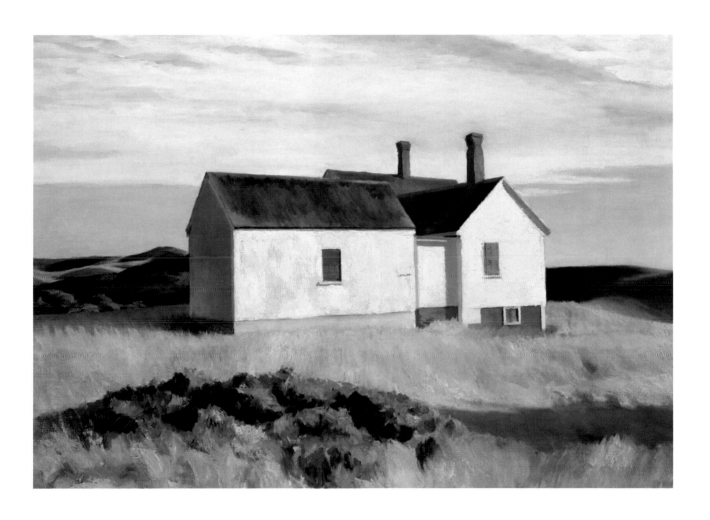

EDWARD HOPPER *(1882–1967)*

CAPE COD MORNING 1950

Smithsonian American Art Museum, Washington, DC/Courtesy of Art Resource/Scala

A young woman leans purposefully out of a bay window of a clapboard house. She seems to have seen something beyond the picture plane, or perhaps she is looking for something, even waiting for something. The viewer has no indication as to what she has or has not seen and the whole attitude of the picture seems studiously to avoid any interaction with the figure, so creating an almost voyeuristic situation. Such a relationship between subject and audience is not unusual for Hopper's work and his figures often remain detached and alone from any outside contact. Whether they are in exterior or interior settings, they frequently appear to be looking out longingly, introspective and isolated in their bleak surroundings. Occasionally the detachment from the watcher results in an almost "peeping tom" perception, since in Hopper's paintings the women in interiors are nude or scantily clad. Yet there is never a hint of a threat, as such is the self-containedness of their environments that these women remain safe.

From the 1930s Hopper experimented very little with new techniques and, as a result, his work, once seen, is quite easily identifiable. He invented his own distinctive style of American Realist painting and continued painting in the same vein all his career. He worked in watercolor as well as oil and his work was made widely known by the etchings he produced. Hopper painted his final picture, *Two Comedians*, in 1965, two years before he died. Very little of his work is obviously biographical, but the two clowns taking their final bow on a stage are recognisably Hopper and his wife, Jo.

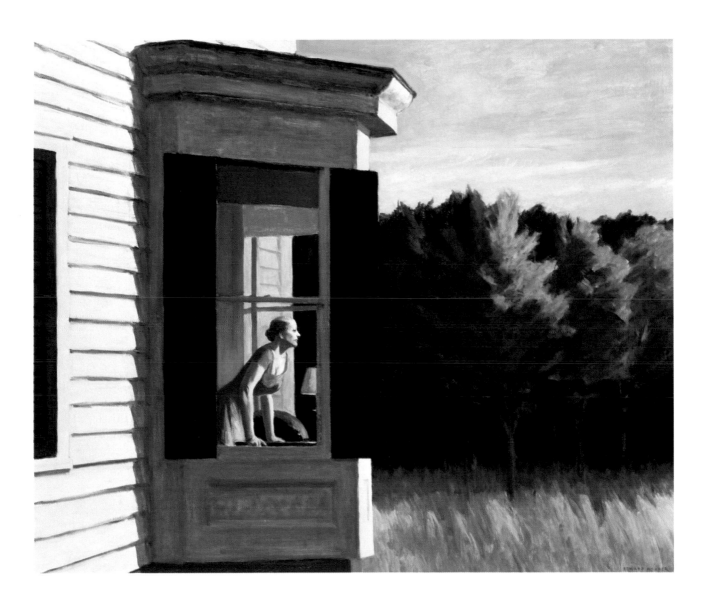

CHARLES SHEELER *(1883–1965)*

SKYSCRAPERS 1922

The Phillips Collection, Washington, DC

CHARLES Sheeler was born in Philadelphia and studied at the Pennsylvania Academy of the Fine Arts along with fellow artist William Merritt Chase. He made several trips to Europe during the first decade of the twentieth century and these had a huge influence on his thinking and approach to art. As a result, he appeared to reject the picturesque painting of his teacher, Chase, in favor of the much starker European Modernism. Another major influence on his painting was the work he did as a commercial photographer to support his own painting—the precise rendering of his oil paintings is the direct result of a photographer's eye.

In 1920 Sheeler began to paint urban subjects and was part of a group called the Precisionists. They were not a formal group as such, but they often exhibited their work together. Among the Precisionists were Charles Demuth, Georgia O'Keeffe, and Joseph Stella. The group recorded the new architecture of American cities, such as with Sheeler's *Skyscraper* here. Well-known pictures by the Precisionists include Demuth's *Incense of a New Church* (1921), O'Keeffe's *New York with Moon* (1928), and *Brooklyn Bridge* (1948). Their techniques and forms are partly Cubist and for this reason they have also been referred to as "Cubist–Realists."

The artist accepted a commission in 1927 to photograph the Ford Motor Company's plant at River Rouge, Michigan. These photographs give American industry and technology a sense of majesty and Sheeler was widely congratulated for them.

CHARLES DEMUTH *(1883–1935)*

WOMAN AND CHILD IN RED SUIT C. 1916

Smithsonian American Art Museum, Washington, DC/Courtesy of Art Resource/Scala

BORN in Lancaster, Pennsylvania, Demuth's initial environment could not have been further removed from the career he was eventually to pursue—he was the son of a tobacconist. He began his studies locally at the Drexel Institute in Philadelphia and the Pennsylvania Academy of the Fine Arts, then continued further abroad at the Académie Julian and Académie Colarossi in Paris. In fact Paris left such an impression on his thinking that he made several trips there throughout his career and lived in the city for two years between 1912 and 1914.

Charles Demuth was particularly interested in Cubism and greatly influenced by the modern artists to whom he was introduced by Gertrude and Leo Stein. The Steins held salons in their Parisian apartment for European and American artists, and were early patrons of Demuth. As a result, artists such as Duchamp, Matisse, Picasso, and Picabia became Demuth's friends and informed his work.

On his return to America he became a leading force in the Precisionist movement, along with Charles Sheeler. Precisionism was an American style of the 1920s and 1930s and the artists associated with it painted industrial and urban landscapes in a Cubist manner. It is for these that Demuth is best known, but he was also an accomplished still life and figurative painter. He was a versatile artist, comfortable working in watercolor as well as oil. He is also known as a book illustrator and produced illustrations for books by Émile Zola and Henry James, among others.

CHARLES DEMUTH *(1883–1935)*

TOMATOES, PEPPERS AND ZINNIAS C.1927

The Newark Museum/Courtesy of Art Resource/Scala

CHARLES Demuth suffered from ill health throughout his life and this somewhat dictated his lifestyle and career. Apart from the several trips to Paris he made to keep up with artistic developments in Europe, he spent most of his life in his native Pennsylvania. As a result of the physical limitations that he suffered he tended to paint subjects that were easily accessible, like this still life of *Tomatoes, Peppers and Zinnias.*

Although America's tradition of still-life painting goes back to the eighteenth century, with artists such as Raphaelle Peale, it has seldom received the acknowledgement it deserves. In fact, throughout history still-life painting has received a lot of often unfair criticism. It has, for instance, frequently been dismissed as a "feminine" art and therefore of less value than other forms of painting. Quite understandably, feminist art historians have demanded a reappraisal of this view, and as a result still-life paintings previously neglected by "serious" art critics have more recently been reevaluated. Still life has also been accused of being purely imitative with no interpretative quality, but it is works like this one of Demuth's that refute this view and show the possible variations in the genre.

Demuth was a handsome man and not prone to modesty. On seeing a photograph of himself taken by one of the fathers of American photography, Alfred Stieglitz, he said that "the head is one of the most beautiful things that I have ever known in the world of art."

DIEGO RIVERA *(1886–1957)*

THE MAKING OF A MOTOR (CARTOON FOR THE NORTH WALL OF THE "DETROIT INDUSTRY" FRESCOS) 1932

Leeds Museums and Galleries (City Art Gallery), UK/Courtesy of the Bridgeman Art Library

JOSÉ Diego Maria Rivera was born in 1886 in Guanajato and became one of the most famous of the Mexican muralists. He was the son of teachers and studied under José María Velasco at the Academia de San Carlos in Mexico City. He exhibited with the Salvia Moderna, a modern art group, in 1906 and was awarded a scholarship to study in Spain. He later settled in Paris and made the acquaintance of Modigliani, Gris, and Picasso, who inspired his Modernist and Cubist works.

He returned to his native Mexico in 1921 and was commissioned to paint his first mural at the Escuela Nacional Prepatoria in Mexico City. He was an active member of the Mexican Communist Party, but was accused of being a traitor and was expeled from the party in 1929. Rivera was politically committed throughout his life and along with Siqueiros, another muralist, he founded the Union of Technical Workers, Painters and Sculptors. He was also the director of the Academia Nacional de Artes Plásticas in Mexico City. His second wife was the artist Frida Kahlo, whom he married in 1929. He divorced his first wife, Guadalupe Marin, a year before.

In 1930 Rivera and Frida Kahlo moved to America, having had to flee their native Mexico because of their politics. He was not accepted back into the Communist Party until 1954. While in America Rivera obtained work painting murals, for example at the San Francisco Stock Exchange (1930–31), the California School of Fine Arts (1931), and the Detroit Institute of Arts (1932–33). His work was often seen as controversial and his mural at the Rockefeller Center in New York (1933) was attacked for depicting Lenin. He was commissioned to paint murals celebrating Henry Ford's car production lines for the car plant in Detroit, and this is a study in charcoal on paper.

DIEGO RIVERA *(1886–1957)*

THE ASSEMBLY OF AN AUTOMOBILE (CARTOON FOR THE SOUTH WALL OF THE "DETROIT INDUSTRY" FRESCOS) 1932

Leeds Museums and Galleries (City Art Gallery), UK/Courtesy of the Bridgeman Art Library

THE trio of Mexican muralists were Diego Rivera, David Alfaro Siqueiros (1896–1974), and José Orozco (1883–1949). They advocated engaged political art and believed that art should be public and revolutionary. As Mexicans in the United States they also wished to be recognized for their nationality and their cultural and social heritage. Rivera, Siqueiros, and Orozco were the pioneers of a new contemporary social art with a social conscience, which they hoped would reach the masses.

The muralists were influenced by Renaissance frescos and pre-Columbian art. The subject matter varied, but the murals are filled with political references and praise for modern civilization and for the Mexican people. Rivera's sympathy with Marxism is often evident in his work, and in several of the murals Karl Marx's figure is included in the composition. There is a certain paradox in Rivera's murals that should not be overlooked. One of Rivera's themes was the celebration of technology, mass production, and industrialism, as seen in this study for a fresco for Henry Ford's car plant. The workers are presented as part of a machine and some of the machines take the form of Mexican gods. Here was an artist who had recently returned from the Soviet Union and was publicly committed to Marxism, yet he was willing to take commissions from American industrialists like Rockefeller and Ford, and this apparent contradiction creates a certain tension in his work.

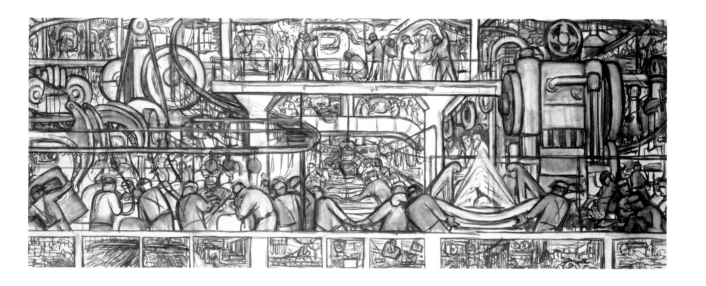

MARCEL DUCHAMP *(1887–1968)*

NUDE DESCENDING A STAIRCASE, No. 1 1911

Philadelphia Museum of Art: The Louise and Walter Arensberg Collection

MARCEL Duchamp was one of the most influential figures in twentieth-century art and was instrumental in defining what we consider art to be today. Born in France, he moved to America in 1913, and he led the New York Dada movement with Picabia and Man Ray.

Although the Dada movement was primarily concentrated in European art, it had definite manifestations in New York between 1915 and 1922. Dada was characterized by a rejection of the traditional values of art, with an emphasis on the ridiculous and an appreciation of the element of chance and accident in all artistic production. Even the word Dada (French for "hobby-horse") denotes nothing more than a random choice of a name. The basic premise of Dada endures today, with contemporary artists continually challenging people's perceptions of what is art and what is beautiful.

Duchamp's *Nude Descending a Staircase* was inspired by chronophotography and the picture attempted to emulate motion in painting. It contains around twenty static positions of a figure descending a staircase and shows a debt to both Cubism and Futurism. In 1913 the picture appeared at the Armory Show in New York (officially called the International Exhibition of Modern Art). As with many of Duchamp's pieces, it was subject to ridicule and anger from some, yet gained tremendous support from others, who saw the 1913 Armory Show as the beginning of an interest in progressive art in America.

MARCEL DUCHAMP (1887–1968)

FOUNTAIN 1917

San Francisco Museum of Modern Art

DUCHAMP is most famous for introducing the concept of the ready-made object to the realm of art, whether it be a bicycle wheel, a bottle rack or a urinal. The idea behind these works is that the object in question would be something that would, in its usual context, be considered the absolute antithesis of conventional high art. This is something that has been at the center of many controversies in the art world since then. What Duchamp was trying to do with works such as *Fountain* and *Urinal* was physically to illustrate the concept that any object becomes a work of art if the viewer declares it to be so. In addition, he often said that the ready-mades were not art at all but anti-art, thereby implying that all art is junk.

The first exhibition of the Society of Independent Artists took place in 1917. It was revolutionary in terms of its effect on the perception of art within the art world. The objective of the exhibition was to give European and American artists the opportunity to exhibit without a jury. Duchamp submitted his work entitled *Fountain*, which was a ready-made urinal set the wrong way up and signed R. Mutt. The urinal is a mass-produced receptacle of waste, but by choosing a particular urinal, placing it in an art exhibition, giving it a title and signing it, Duchamp was asking several questions, both serious and humorous. What is an artwork? Who is the artist? Who has the power to decide? The work was rejected from the show as people declared it "not art" and "indecent." This served Duchamp's purpose well, as it demonstrated the notion that a work of art is designated and has to fulfil certain criteria to be accepted.

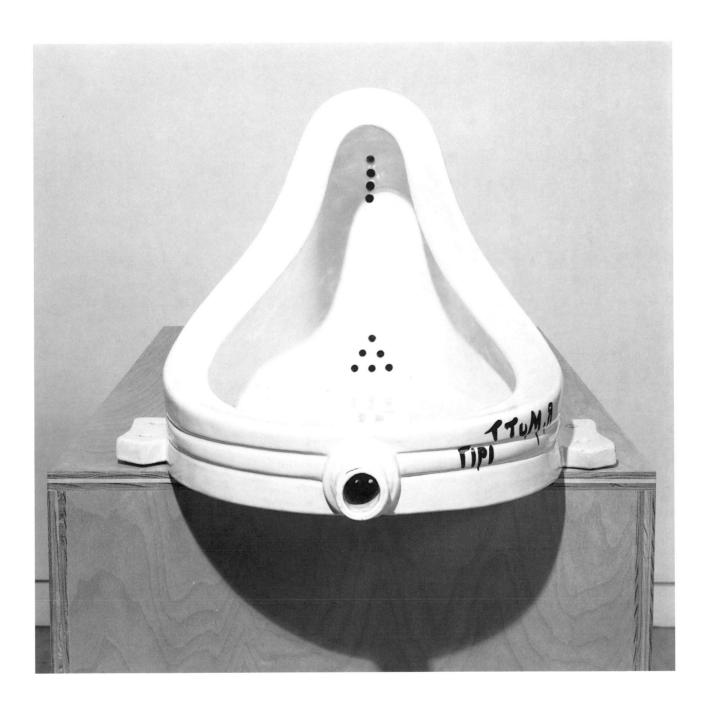

GEORGIA O'KEEFFE *(1887–1986)*

PURPLE PETUNIAS 1925

The Newark Museum/Courtesy of Art Resource/Scala

GEORGIA O'Keeffe is one of America's best-loved artists, both nationally and internationally. She grew up on a farm in Wisconsin and went on to study at the Art Institute of Chicago and the Art Students League in New York. She worked for a time as a commercial artist in Chicago and taught art at several schools. In 1916 she met the photographer and gallery owner Alfred Stieglitz and he began showing her work at his gallery "291" in New York. They married in 1924. Although O'Keeffe always believed the marriage helped her grow as an artist, it had a negative effect as far as the rest of the art world was concerned. How her work would be perceived would be severely blighted by constant references to Stieglitz and a widely held assumption that he exerted a Svengali-like influence on her development. In fact it is only relatively recently that her work has been reexamined in its own right.

She is best known for her semi-abstract paintings of flowers and plants, which critics often claim are sexually suggestive. O'Keeffe always denied such implications and strenuously maintained that critics drew such conclusions only because she was a woman. She was so unhappy with these Freudian interpretations of her work that she even threatened to give up painting altogether if these critical interpretations continued. The flower pictures are very carefully painted, with great attention to color and depth, and their large scale gives them an abstract quality. Her inspiration came from traveling in the American Southwest and New Mexico. O'Keeffe first visited New Mexico in 1929, but returned again and again and finally settled there after her husband's death in 1946.

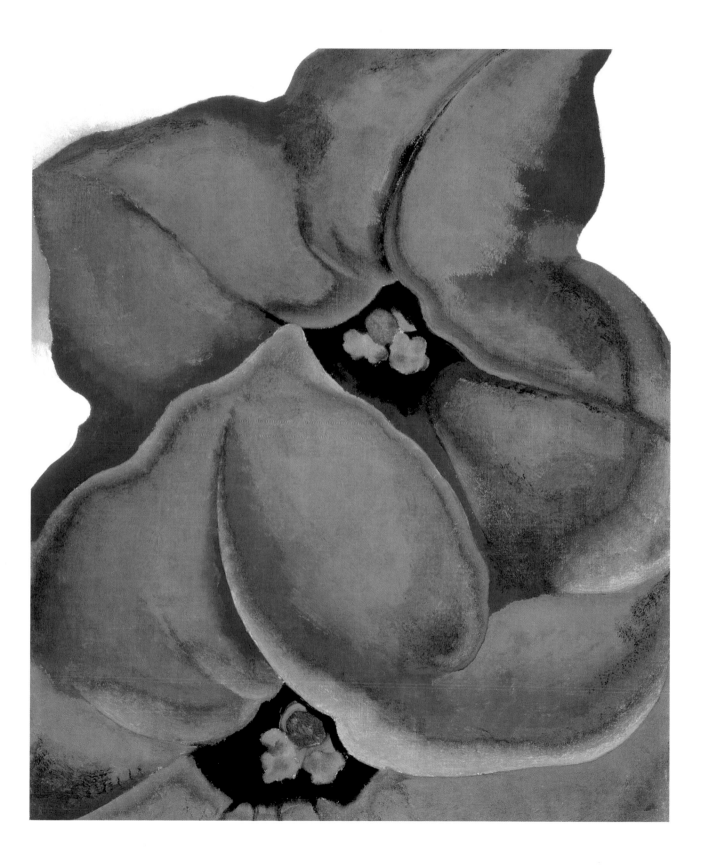

GEORGIA O'KEEFFE *(1887–1986)*

NEW YORK WITH MOON 1928

Carmen Thyssen-Bornemisza Collection

THE skyscraper in the 1920s and 1930s was a true icon of modern America. These fantastic new buildings became shorthand for the future—for technology, prosperity, and glamor, a clear metaphor for America moving forward as a nation. Unsurprisingly, all art forms embraced the skyscraper—artists painted them, Cole Porter wrote songs about them, and one of the most famous cinematic moments of the period featured them when King Kong sat astride the Empire State Building with Fay Wray in his hand, frightening audiences across the world.

Although O'Keeffe is probably better known for her flower paintings, she produced several urban landscapes during her career and was identified with a group called the Precisionists. It comprised artists such as Charles Sheeler, Charles Demuth, and Joseph Stell. The Precisionists all celebrated technology and the new urban architecture in paint. Bridges and skyscrapers provided the main inspiration for this new generation of artists. They produced images with clean lines and abstract patterns that were reminiscent of some of the work of the Futurists.

The skyscraper had an almost religious hold over urban America. People were so impressed by the skyscraper that they declared it to be the new cathedral. O'Keeffe's works are characterized by her photographic perspective, extreme verticality, stark contrast between light and dark, and the absence of human figures. Other pictures by O'Keeffe of New York buildings and skyline include *The American Radiator Building* (1927) and *New York Night* (1928–29).

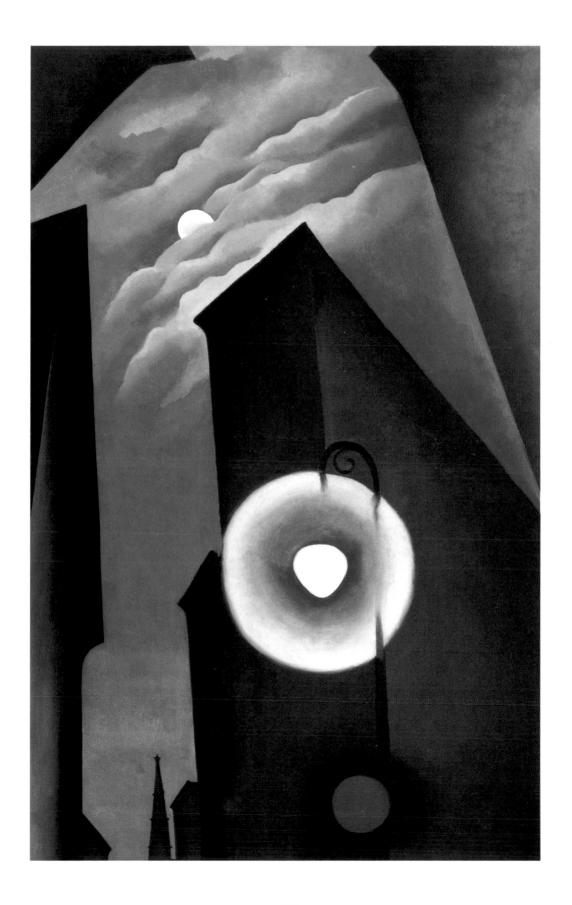

JOSEF ALBERS *(1888–1976)*

HOMAGE TO THE SQUARE

Haags Gemeentemuseum, Netherlands/Courtesy of the Bridgeman Art Library

JOSEF Albers, a Dutchman by birth, first studied and later taught at the Bauhaus and worked as a painter and a designer. The Bauhaus movement was founded in Germany in 1919—a school for arts and crafts—and it fast became a hothouse for avant-garde designers from all over Europe. Bauhaus valued form, texture, color and economy, and aimed to design objects that were beautiful and available to all through mass production. In 1933 the Nazis closed Bauhaus but this was not the end of the story. The school had been around for fourteen years and all the architects, designers, and artists it spawned continued to spread the word. Within a few years it had become a bona fide movement.

Among those who took Bauhaus principles and ideas across the Atlantic was Josef Albers, who moved to America in 1933. By retaining some of the Bauhaus traditions that were ingrained in his way of doing things, and absorbing influences from his new environment, he quickly developed his trademark geometric abstract style. It captured American imagination to such a degree that it was to have a huge influence on painters in his adopted homeland. Color was the focus of his work, and in 1963 he wrote the seminal work *The Interaction of Color*, which was to have a great influence on the Op Art movement at the time. His *Homage to the Square* series of paintings are single-color squares, often overlapping each other. The overlapping colored squares create optical illusions, giving the impression of an additional perspective to the flat picture plane.

GRANT WOOD *(1892–1942)*

LANDSCAPE

Smithsonian American Art Museum, Washington, DC / Courtesy of Art Resource / Scala

AS a nation of enormous geographical diversity, America has always celebrated regional differences in its decorative and fine arts. A particular Regionalism in American art emerged between 1930 and 1935 in response to the rapid advancement of the industrial age. The three artists who are most associated with this particular branch of Regionalism were Thomas Hart Benton from Missouri, John Steuart Curry from Kansas, and Grant Wood from Iowa. They were also keen to establish a specific and clearly definable American art denoting nationalist and parochial values. This was in response to the increasing populist view that European art was somehow superior to its counterpart across the Atlantic, since European art had a richer history to draw on and had more established traditions. The paintings of these Regionalists presented a nostalgic view of rural life in the preindustrial era, but what they neglected to show was the poverty and famine suffered during the years of the Great Depression.

Grant Wood, the son of Quaker and Puritan parents, spent almost his whole life in Iowa. He founded an art commune outside Stone City and his manifesto, called *Revolt Against the City,* encouraged artists to paint Regionalist works. His most famous work is *American Gothic* (1930), which depicts a Midwestern couple standing in front of a white cottage, the man holding a pitchfork. His pictures are sentimental about the loss of a way of life. This landscape shows Wood's idealized, almost childlike depiction of the countryside, with its decorative patchwork fields and rolling hills.

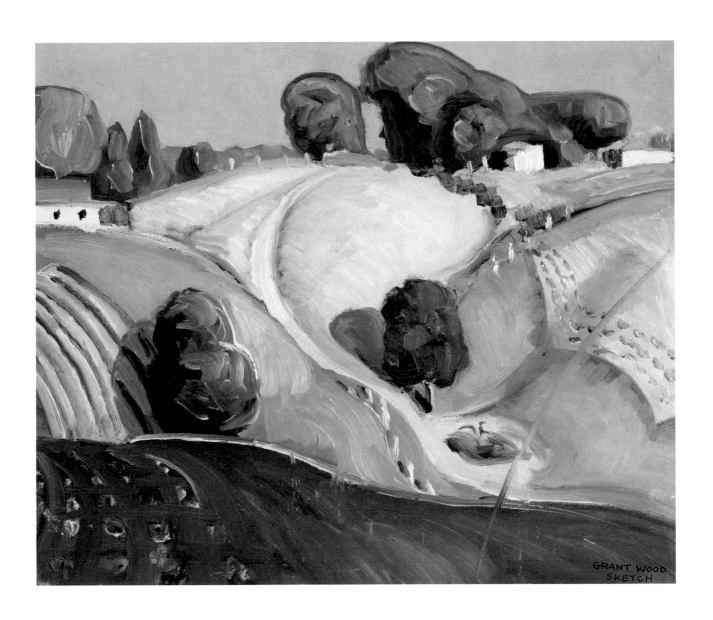

CHARLES BURCHFIELD *(1893–1967)*

NIGHT OF THE EQUINOX 1917–55

Smithsonian American Art Museum, Washington, DC/Courtesy of Art Resource/Scala

CHARLES Burchfield grew up in Salem, Ohio, and although he moved to Buffalo, New York, as a relatively young man, it was his childhood that had the greatest influence upon his work. Indeed, when he first arrived in Buffalo in 1921 he was unable to support himself as a painter and accepted a job as a designer in a wallpaper factory until he was able to take up painting full time in 1929.

Much of his early work is of nature scenes, which were clearly inspired by memories of his childhood in rural Ohio. He is best known for his American Scene paintings of the 1920s and 1930s, in which he combined his nature scenes with views of small-town America. Many of these pieces represent classic Americana of the period, and provide fascinating historical documents. In the 1940s Burchfield rejected this Realism and returned to his earlier approach of focusing on the wonders and beauty of nature. In the 1950s Burchfield became a teacher and taught at the Buffalo Fine Arts Academy and the University of Buffalo.

Night of the Equinox took Burchfield an extraordinary 38 years to complete. The painting combines some of the contrasting artistic phases of his career. It features the small town of the American Scene, but this is secondary to the depiction of the weather. This is a picture about the forces of nature; the drama is created by the limited palette of blues and grays and the streaks of paint conjure up an image of driving rain.

CHARLES BURCHFIELD *(1893–1967)*

ORION IN DECEMBER 1959

Smithsonian American Art Museum, Washington, DC / Courtesy of Art Resource / Scala

"Charles Burchfield loved the soil of his native land. From childhood, he found romance in the commonplace creatures of nature. In his paintings of the American Scene, his brush endowed the ordinary with universal greatness. During a period of urbanization and industrialization, he focused our vision on the eternal greatness of living things. He was artist to America."
Lyndon B. Johnson

THIS great posthumous tribute by Lyndon Johnson, President of the United States between 1963 and 1969, goes some way to capture the essence of one of the best American Scene painters.

In his watercolor *Orion in December*, Burchfield paints a picture of sparkling stars in the sky above a forest. Quite deliberately, the title calls to mind the myth of Orion, the hunter, who was loved by Artemis, the huntress, but was tragically and accidentally killed by her. On his death Orion rises to a heaven where eternal remembrance is achieved in the constellations. The star in the bottom center of the picture has been said to resemble a butterfly—the butterfly is a symbol often used in paintings to represent resurrection. If this is indeed what Burchfield intended to portray with the butterfly this would tie in with the idea of Orion rising to take his place in the heavens.

As with much of his work, in this painting Burchfield investigates man's interaction with the magnitude of the natural and spiritual world.

STUART DAVIS *(1894–1964)*

GASOLINE TANK 1930

The Newark Museum/Courtesy of Art Resource/Scala

STUART Davis was born in Philadelphia in 1894 to an artistic family: his father was the art director of the Philadelphia Press and his mother was a sculptor. They later moved to New Jersey and Davis was taught by Robert Henri in New York. He was one of the artists included in the controversial Armory Show of 1913, which had a great influence on Davis's subsequent work, as it did with many other young artists at the time.

Davis was inspired by the work of the French artist Fernand Léger, and by that of the other European Cubists. He was particularly struck by their experiments with collage, color, and form. His signature style combined these elements with symbols of modernity and popular culture: "I paint what I see in America, in other words I paint the American Scene," he claimed. Like Duchamp, Davis was concerned with the perception of everyday objects. He took something as mundane as an egg beater or a gas pump and celebrated it by examining its design and geometric patterns.

In his early career he also used references from advertisements and billboard posters and was a forerunner to the Pop artists of the 1960s. He worked for the Federal Art Project during the 1930s, and as his career progressed his work became more abstract. Davis, like Jackson Pollock, loved jazz and said that it had a great influence on his work. Such an assumption makes enormous sense, as the technique in jazz of expanding on more straightforward melodies and figures by stripping them down to their component parts for examination is mirrored in much of the painter's approach to his work.

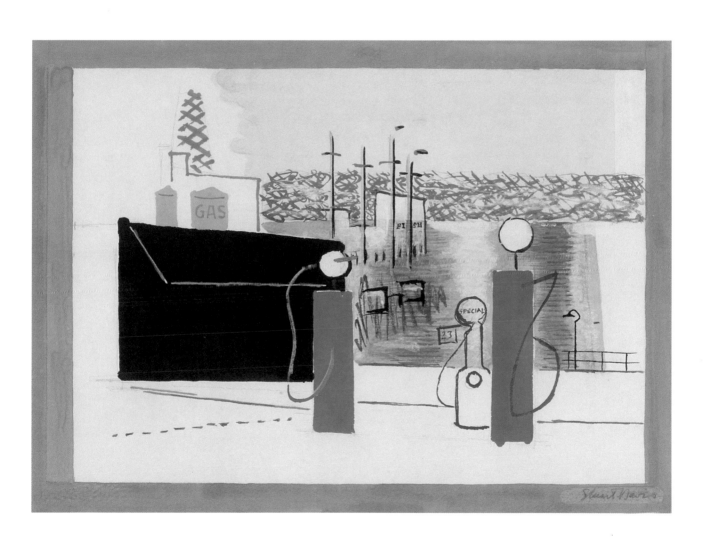

STUART DAVIS *(1894–1964)*

INTERNATIONAL SURFACE, NO. 1 1960

Smithsonian American Art Museum, Washington, DC/Courtesy of Art Resource/Scala

IN 1956 *Fortune* magazine asked seven artists to paint modern still lifes based on goods that could be purchased from a supermarket. Davis took on the commission and spent a long time figuring out how best to represent the rich, celebratory consumer society that his country had become. In his own words: "I bought a lot of groceries from the store and laid them down there on the floor and looked at them and made several compositions over a number of days until I found something in a drawing that looked like a painting, or was paintable."

This was a time when America was famed for its wealth and selection of consumer goods, especially packaged food. Other artists included these goods in their works, such as Andy Warhol with his Campbell's soup cans or his reproduction boxes of Brillo.

Davis produced two paintings inspired by the groceries. The first was *Package Deal*, and this is the second, called *International Surface, No. 1*. He took a section from the first painting and enlarged it for the second. He also changed the colors, but kept the shapes and words the same. This paring-down of subject matter is an example of Davis's transition to a more abstract style. The artist's love of jazz shows up in this particular work too, as he arranged the labels on the packages of food to reveal particular words like "CAT" and "JUICE," both vernacular musical terms from the hipster jazz idiom.

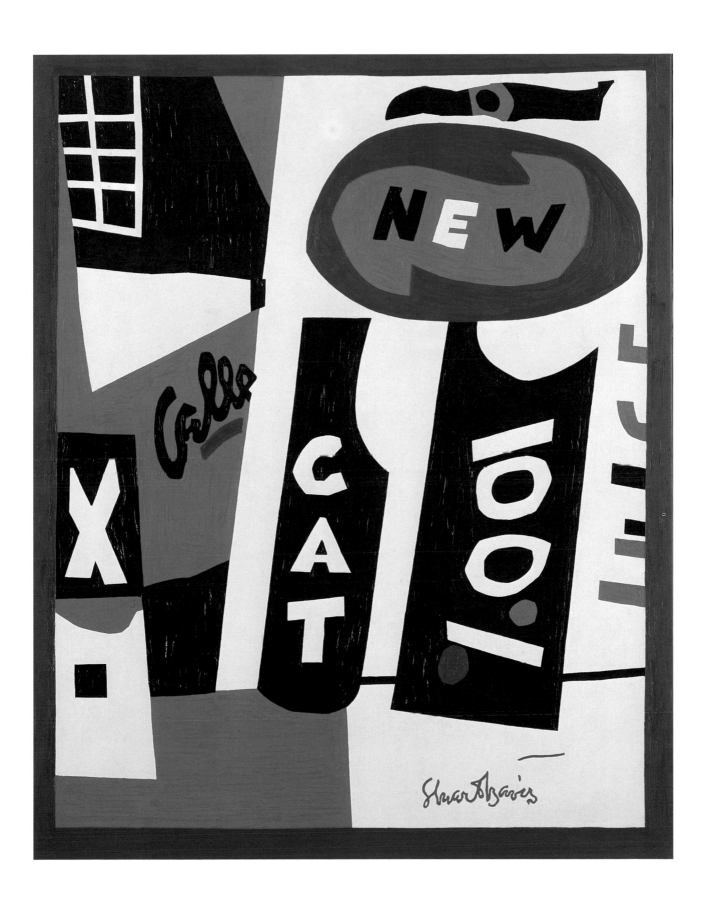

NORMAN ROCKWELL *(1894–1978)*

PORTRAIT OF RICHARD NIXON 1968

Smithsonian American Art Museum/Courtesy of Art Resource/Scala

ROCKWELL is one of the most popular American artists of the twentieth century. In fact so highly does he figure in popular perception that to many outside the country Norman Rockwell is American art itself. He studied at the Art Students League in New York and became a professional illustrator. He will surely always be most well known for his covers for the *Saturday Evening Post*, which had a deep and lasting impact on popular culture. His first picture hit the newsstands in 1916.

Through his career Norman Rockwell produced hundreds of covers, and they provide a comprehensive record of culture, society, and history in America. Rockwell has been criticized for being sentimental—he even described his art as "this best-possible-world, Santa-down-the-chimney, lovely-kids-adoring-their-kindly-grandpa sort of thing"—but this is to neglect the power of the images. He found a common ground in his subjects: "You have to think of an idea which will mean something to all of them. And it's darned hard to be universal, to find some situation that will strike the farmer, the housewife, the gossip and Mrs Purdy." Although many of his images are lighthearted, Rockwell did not shy away from gritty social commentary and a significant proportion of his work addresses patriotism, civil rights, racism, and poverty.

Nixon is the only American president to have resigned from the presidency, having been implicated in the Watergate burglary, when his supporters raided the Democratic headquarters during his reelection campaign. He led the country between 1969 and 1974.

DAVID ALFARO SIQUEIROS *(1896–1974)*

CHRIST 1922

Collezione d'Arte Religiosa Moderna, Vaticano / Courtesy of Scala

Siqueiros was one of the leading Mexican muralists, along with Diego Rivera and José Orozco. He first studied at the Escuela des Artes Plásticas in Mexico City. He served as a soldier in the Mexican Revolution, in which one million people died.

Siqueiros went to Europe and worked as a military attaché. While in Paris he met Diego Rivera. He found a sympathetic compatriot in Rivera, who cared as much as he did about the future of Mexican art. Like Rivera, Siqueiros was attracted to a social art that could easily reach the masses and as a result they both rejected easel painting in favor of murals. They believed that the reception of easel painting was too limited and too easily commodified. His relationship with Rivera was long-lasting. Together they founded the Union of Technical Workers, Painters and Sculptors and edited the magazine *The Machete*. Siqueiros formalized their ideas in his *Manifesto to the Artists of America*, published in 1921.

The following year the artist returned to his native Mexico and began work on a series of murals, although between 1925 and 1930 he put his political duties before his art and produced very little. He took up painting again while in prison for political activities and proceeded to paint murals throughout the 1930s in North and South America. Siqueiros fought in the Spanish Civil War between 1937 and 1939, but after 1944 he focused more on his painting and less on his political activities. Siqueiros's strong, brightly colored murals celebrated twentieth-century technology, his native Mexican culture and religion.

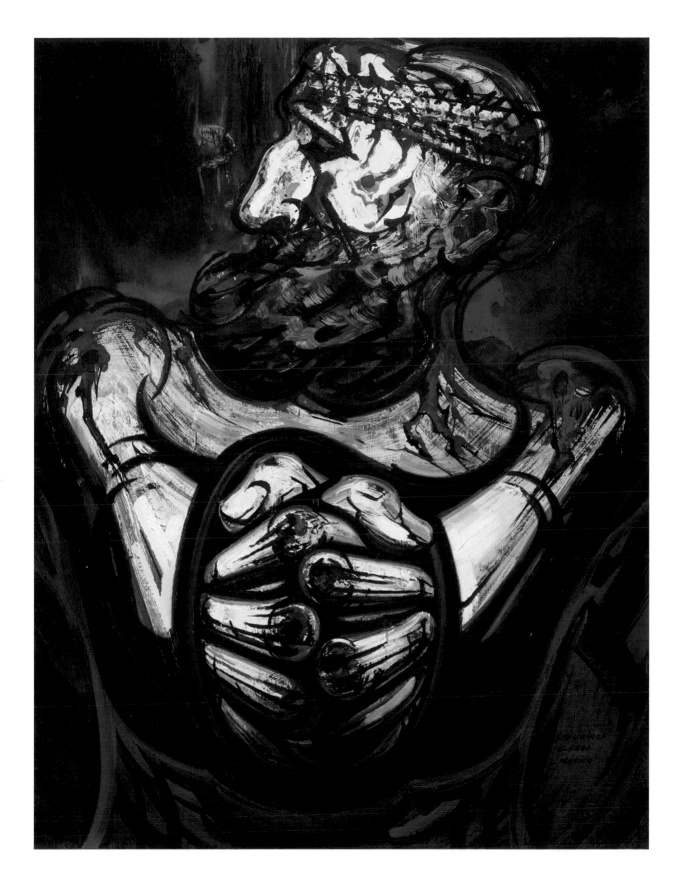

JOHN STEUART CURRY *(1897–1946)*

STATE FAIR 1929

The Huntington Library, Art Collections, and Botanic Gardens, San Marino, California/
Superstock

JOHN Steuart Curry was born on a farm near Dunavant, Kansas, and the Midwestern landscape of this childhood forms the theme of much of his work. At the age of nineteen Curry went to study at the Kansas City Art Institute, before moving to Chicago and then to New York, where he worked as a magazine illustrator. He completed his education in Paris, where he was inspired by paintings by artists such as Rubens, Delacroix, and Géricault. Curry felt homesick for his native land, however, and he returned to settle in New York.

Curry was part of the Regionalist school of painting, together with Thomas Hart Benton from Missouri and Grant Wood from Iowa. They wished to create a purely American art that celebrated nationalism and the culture of their homeland. Their pictures are often sentimental depictions of rural life in a preindustrial time, such as Curry's most famous work, *Baptism in Kansas* (1928). In *State Fair* Curry records rural customs and traditions in an effort to preserve them. In the 1930s the artist was given several commissions for the Federal Art Project, but the murals he started for the Kansas State Capitol remained unfinished. Yet Curry's paintings struck a chord with others who held similar views on the treatment of rural communities—Curry was not the only man with an idealistic view of how his beloved Kansas should look and his scenes of the rural Midwest proved very controversial.

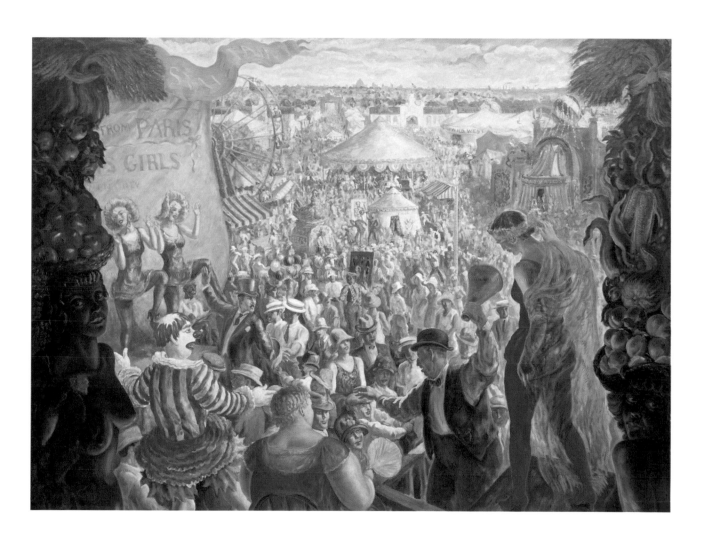

JOHN STEUART CURRY *(1897–1946)*

PARADE TO WAR 1938

The Cummer Museum of Art and Gardens, Jacksonville / Superstock

IN John Steuart Curry's *Parade to War* a pretty young woman walks alongside a marching army, her arms around one of the soldiers. The soldier looks out of the painting towards the viewer—his face is the skull of a dead man. Streamers flutter above the heads of the soldiers and young boys collect them and play in the street. Far from being a band of young and hopeful men marching to battle, the soldiers are a parade of skeletons carrying a star-spangled banner. A woman in the bottom left corner of the painting is bent over crying into her handkerchief—an emblem of the aftermath of war.

It is a grisly scene that leaves us with a clear insight into what war is really about—death, loss, and futility on a massive scale—and how the artist felt about it. There can be no doubt that in this most macabre and dramatic painting Curry is expressing his anti-war sentiments, and rather than depicting the pageantry and tradition of war he concentrates on the imminent loss of lives. Curry felt very strongly about both World Wars and America's involvement in them, as war was something that threatened the countryside and challenged the rural life that he loved. Indeed, he was expressing his objections to the huge strain the war effort was putting on farming communities as a result of manpower being used for war and not agriculture. Many farming families fell into penury after the war as sons were lost. Curry's free and painterly style gives the impression of movement and this mirrors the inevitable progress of war as the men march to their deaths.

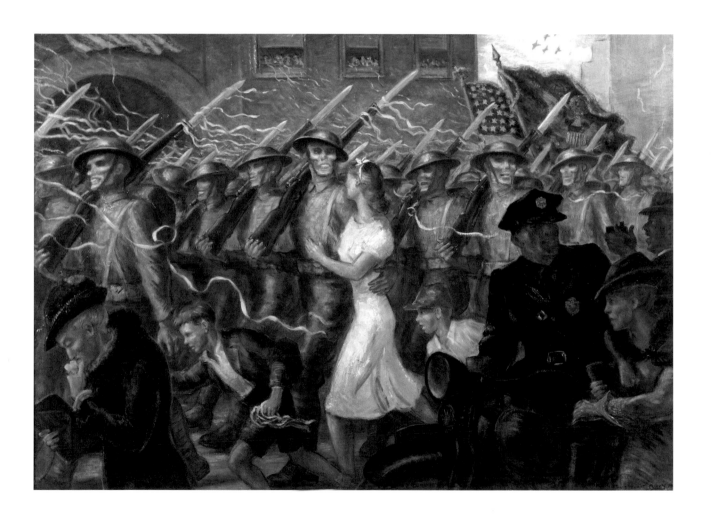

WILLIAM GROPPER *(1897–1977)*

CONSTRUCTION OF THE DAM 1939, AUTOMOBILE INDUSTRY 1940

Smithsonian American Art Museum, Washington, DC/Courtesy of Art Resource/Scala

AFTER a poverty-stricken childhood on the Lower East Side of Manhattan, William Gropper used his considerable talent as an artist to political ends. He studied art at the Ferrer School in Manhattan and his teachers were artists from the Ashcan School, Robert Henri and George Bellows. The young artist's first job was as a cartoonist on the *New York Tribune* in 1917. He also later contributed to the *New Yorker*, *Vanity Fair*, *New York Post*, and *New Masses*. He began producing paintings in 1921 and his first solo exhibition of paintings was in 1936 at the ACA Galleries in New York.

Gropper is particularly known for the murals he produced for the Federal Art Project (FPA), of which this is one. The FPA was an American government project active between 1935 and 1943. Its aim was to provide work for the enormous number of artists who had been affected by the Depression as the sharp economic downturn had a knock-on effect across the arts in general—with so little money about, spending on culture and the arts was one of the first things to be cut back. The FPA also had the secondary purpose of creating public art to celebrate American art and America's achievements. It was part of the larger Works Progress Administration (WPA) developed by President F. D. Roosevelt in his New Deal, which attempted to reduce unemployment. The FPA employed more than five thousand artists and most American artists of the time were involved in the project in some way.

Construction of the Dam (opposite, above) and *Automobile Industry* (opposite, below) are two paintings in which Gropper addresses America's transition from an agricultural nation to an industrial one. The coming of the Machine Age and its effects on American society is something that fascinated him socially as well as artistically. In his famous picture *Migration* (c.1932) he shows prairie farmers having to leave their farms to search for work. *Automobile Industry* is a study for a mural at the Michigan Post Office, Detroit and depicts men working on a car assembly line. While this may be a celebration of technology, viewed in the context of Gropper's other work it may be seen to comment on industrialization and society.

The American government was suspicious of Gropper for his outspoken criticism of social injustice and in 1953 he was attacked by Senator Joseph McCarthy who cited Gropper's picture *Pictorial Map* as an example of propaganda and anti-Americanism. The fact that he had spent a year in Moscow working for the Communist Party newspaper *Pravda* did him no favors with McCarthy. Gropper believed passionately in artistic and political freedom and invoked the Fifth Amendment, which prohibits self-incrimination. As a result he was ostracized by the newspapers and magazines that had once employed him and the galleries that showed his work.

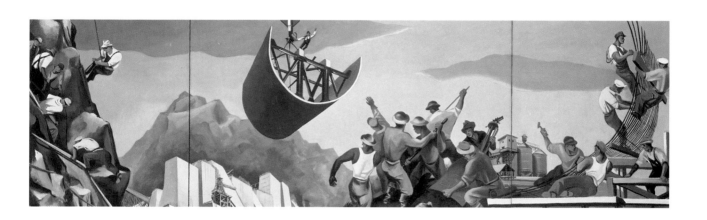

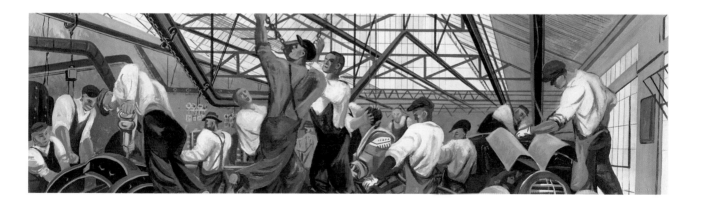

RAPHAEL SOYER *(1899–1987)*

ANNUNCIATION 1980

Smithsonian Americam Art Museum, Washington, DC/Courtesy of Art Resource/Scala

RAPHAEL Soyer and his twin brother Moses (1899–1974) were Russian-born painters who emigrated to America in 1912 to escape persecution for political reasons in Russia under the Tsars. They lived as exiles, and in 1914 were joined by another brother, Isaac, also an artist. Understandably for somebody whose life has been so affected by politics, Raphael Soyer is best known for his social realist subjects. Among the best known are those painted during the Great Depression of the 1930s, and because of some of this work Soyer has also been referred to as an American Scene painter. Soyer was a writer as well as a painter—among his published works are an autobiography and a book on the painter Thomas Eakins.

The artist once said: "If art is to survive it must describe and express people, their lives and times." His best-known picture is *Office Girls* (1936), which depicts two women in a crowd coming out of their office. It is a familiar urban scene, but the blank expression on one of the women's faces and the lack of interaction between the two figures may be seen as a commentary on the alienation that is so much a part of modern life. This picture, *Annunciation*, painted 44 years later, is also of two contemporary women, and they stand in quiet contemplation. It is only the title that gives any clue as to what has been said or is about to be said. It refers to the occasion that the angel Gabriel informs Mary that she will bear the Messiah.

ALICE NEEL *(1900–84)*

SELF-PORTRAIT 1980

Smithsonian Americam Art Museum, Washington, DC/Courtesy of Art Resource/Scala

"I love to paint people torn by all the things that they are torn by today in the rat race in New York."
Alice Neel

ALICE Neel is best known for her portraits, although they were so often portraits of unknown subjects. In fact it is actually because her subjects were unknown, rather than in spite of it, that her portraiture are so fascinating. Not only do her subjects offer a record of the anonymous and the celebrated, but they also serve as an analogy for the ambitions and anxieties of America during the middle part of the twentieth century. Her work has been described as New Realism—a term used to describe the artists who reacted against Abstract Expressionism in favor of the figurative. Alice Neel and the English painter Lucian Freud are often categorized together under the New Realists' umbrella.

Born in 1900 in Merion Square, Pennsylvania, Neel grew up in Colwyn before attending the Philadelphia College of Art and Design. She settled in New York in 1927 and began painting New Yorkers, using friends, family, and neighbors as sitters. The realism of her work can be shocking because she makes no attempt to flatter or embellish her sitters, but rather concentrates on creating their life stories in paint. She called herself a "collector of souls." Her own life was happy and tragic in parts and she treated herself in this self-portrait in the same way.

PHILIP EVERGOOD *(1901–73)*

WOMAN AT THE PIANO 1955

Smithsonian American Art Museum, Washington, DC/Courtesy of Art Resource/Scala

BORN Philip Howard Blashki in New York in 1901, Evergood was the son of a Polish immigrant who rather than simply Americanize his name opted to change it completely. One of the best-educated artists of his generation, Evergood was schooled at Eton, Cambridge, and the Slade School of Art in England. He also studied at the Art Students League in New York and the Académie Julian in Paris. He traveled extensively in Europe and settled in New York in 1931.

Yet what many would see as a rather privileged background did not prevent the painter from being aware of the world around him and in tune with how it was changing. On his return to New York Evergood was horrified by the effects of the Depression. He became involved in the Social Realist movement—a group who used art for political protest and propaganda and addressed the issues of political oppression, racism, and poverty. He also produced religious pictures and Surrealist works, like the well-known *Lily and the Sparrows* (1939).

Woman at the Piano is an example of Evergood's lighter and more satirical side. At first glance it seems to be a portrait of an elegant woman about to sing a song. On closer inspection, the woman stares blankly out of the canvas holding a chaotic music score. Evergood has manipulated the perspective of the picture plane to create an almost vertical surface, thereby giving the viewer the uneasy sense that the woman might slide off the canvas at any minute.

ANSEL ADAMS *(1902–84)*

NORTH DOME, BASKET DOME, MOUNT HOFFMAN, YOSEMITE C.1935

Smithsonian American Art Museum, Washington, DC/Courtesy of Art Resource/Scala

ANSEL Adams's contributions to the genre of landscape photography and his pioneering photographic techniques have made him one of the most famous photographers of all time.

Born in San Francisco, the son of a businessman, Adams began taking photographs at the age of fourteen when he and his family visited the Sierra Nevada and the Yosemite National Park. He joined the Sierra Club, a society concerned with education and conservation issues. One of his mentors was the photographer Paul Strand (1890–1976) and Adams adopted Strand's techniques to produce sharply focused images with a sense of perspective. This was groundbreaking work at a time when most photographers favored a soft-focus look.

In 1936 another father of photography, Alfred Stieglitz, organized Adams's first solo show in New York. Adams was also keen to educate photographers of the future and founded the photography department at the California School of Fine Arts, which placed photography in the academic register.

In 1937, Ansel Adams moved to the Yosemite Valley, the area seen in this photograph taken two years earlier. He used his immediate surroundings in his work again and again and is best known for these landscapes of the American Wilderness. Through his photographs of landscape he has helped bring conservation issues to public attention.

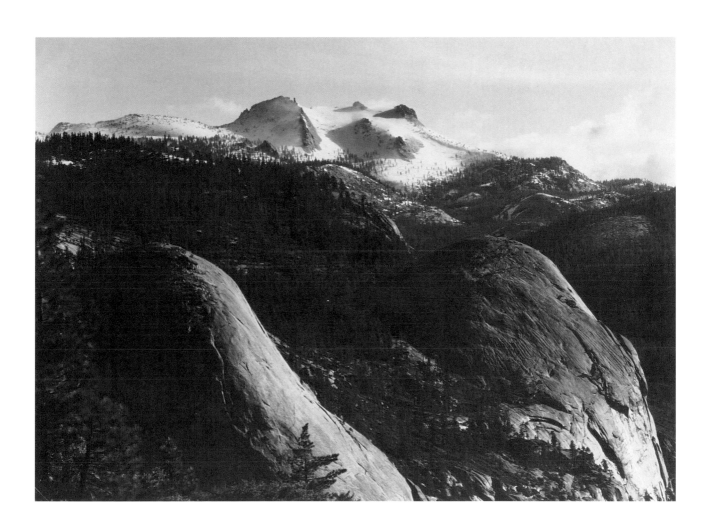

WALKER EVANS *(1903–75)*

TENGLE CHILDREN, HALE COUNTY, ALABAMA 1936

AKG, London / Courtesy of Image Select

"Stare. It is the way to educate your eye, and more. Stare, pry, listen, eavesdrop. Die knowing something. You are not here long."
Walker Evans

WALKER Evans, along with Ansel Adams and Alfred Stieglitz, is one of the most famous American photographers. He was educated at Andover Academy and briefly at Williams College before moving to live in New York and Paris. He began his photographic career in New York when, in 1927, he started to record the city and the people who lived in it. He took photographs during the day and supported himself by working on Wall Street at night, as a clerk.

Evans worked for the Federal Resettlement Administration and is best known for *Now Let Us Praise Famous Men*, a series of photographs of Appalachian sharecropping families taken during the Depression. These farming images were produced in collaboration with the author James Agee. It has been said that Agee was a perfectionist, but it seems that Evans was just as much a perfectionist himself—he would spend hours or even days waiting for the perfect photo opportunity.

In 1938 Evans began photographing New Yorkers in the subway. He used to travel around for hours with a concealed camera tied to his chest and peeping out of his coat. These subway works, which were entitled *Many are Called,* were published to great acclaim.

WALKER EVANS *(1903–75)*

FLOYD BURROUGHS AND THE TENGLE CHILDREN 1936

AKG, London / Courtesy of Image Select

"With the camera, it's all or nothing. You either get what you're after at once, or what you do has to be worthless. I don't think the essence of photography has the hand in it so much. The essence is done very quietly with a flash of the mind, and with a machine. I think too that photography is editing, editing after the taking. After knowing what to take, you have to do the editing."
Walker Evans

DURING the Second World War Evans worked as a magazine photographer, where he was able to bring his distinct style and approach to composition to reportage work and, as a result, high art to news and editorial portraiture. Unsurprisingly, he went on from there to work for the influential magazines *Fortune* and *Time*. In 1938 Evans had a solo exhibition of his work at the Museum of Modern Art in New York, and it is a mark of how seriously the art world was taking him, as this was the first one-man show of photography at the museum.

Like Ansel Adams, Walker Evans was interested in nurturing the following generation of photographers and was very keen on photography education. To this end, he taught photography and photographic technique at the School of Graphic Design at Yale. Although his photographs command large prices today, Evans seemed unaware of his own commercial worth, as he sold all his prints and negatives near the end of his life for a mere $150,000.

MARK ROTHKO *(1903–79)*

UNTITLED (RED) C. 1958

National Gallery of Victoria, Melbourne, Australia / Courtesy of the Bridgeman Art Library

MARK Rothko was born to a Jewish family in Dvinsk, Russia; his father was a pharmacist. The family emigrated to Portland, Oregon in 1913. Born Marcus Rothkowitz, he changed his name in 1940, two years after becoming a naturalized American citizen. His education started with great promise when he won a scholarship to Yale University at the age of eighteen, but he did not complete his degree and he moved to New York looking for work. He began to paint and studied at the Art Students League and was part of the Federal Art Project.

The artist's early works were of the Ashcan School and he favored urban scenes containing solitary figures. During the 1940s he experimented with a Surrealist style, influenced by Miró. By the late 1940s Rothko was starting to produce abstract and color-field painting, and his interest in the work of Matisse affected his use of pure color. Rothko had his first solo exhibition in 1945 at Peggy Guggenheim's gallery, but sold very little of his early work and preferred to keep it stored in his gallery.

During the 1950s Rothko developed his signature Abstract Expressionist style— large canvases with squares of color in a limited palette. The soft edges of these "floating" squares, their scale and the absence of a point of focus, create a vehicle for meditation and spirituality. For this reason an oft-quoted comment by one viewer described Rothko's paintings as "like television sets for Zen Buddhists."

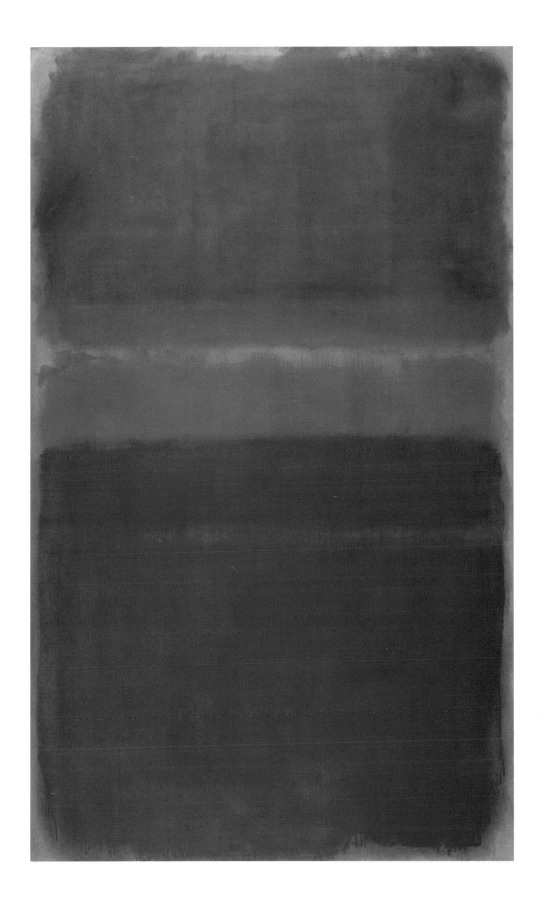

MARK ROTHKO (1903–70)

BLUE, GREEN, BLUE ON BLUE GROUND 1968

The Newark Museum / Courtesy of Art Resource / Scala

ROTHKO'S abstract work progressed from the rich reds, pinks, oranges, blues, and greens of the 1950s to the brown and maroon paintings of the late 1950s and 1960s. His final works were gray and black, and the transformation of his palette has been attributed to the artist's increasing bouts of depression, with the body of his work reflecting the passage of his life.

Throughout his career Rothko worried a great deal about the reception and interpretations to which his paintings might be subject. He claimed to hate art critics and art historians and feared their analysis might destroy the mystery surrounding his work. Reportedly he attended exhibitions of his work and listened to the comments of the museum-goers, who were oblivious to the fact that the eavesdropper next to them was the artist himself. He also tried to curtail analysis of his work by offering explanations of his own, saying that his work was about universality, timelessness, and tragedy.

Rothko received several commissions through his career, most famously the so-called "Seagram Murals" from the late 1950s and the Rothko Chapel in Houston (1965–67). The former was a series of nine paintings in maroon and black that he produced for the Seagram Building in New York, but that were never installed. Instead Rothko made an incredibly generous gesture and presented them to the Tate Gallery in London in 1970. The artist was a friend of Sir Norman Reid, director of the Tate in the late 1960s, and it was partly because of their relationship that the paintings were given. Reid made a little cardboard model of the gallery he proposed to hang them in and he and Rothko discussed the hanging. Rothko carefully staged the delivery of the paintings and was anxious to ensure that they were moved from his studio in New York to London under a veil of secrecy. As the paintings arrived at the Tate and were being unpacked from their crates, a telegram also arrived telling of Rothko's suicide.

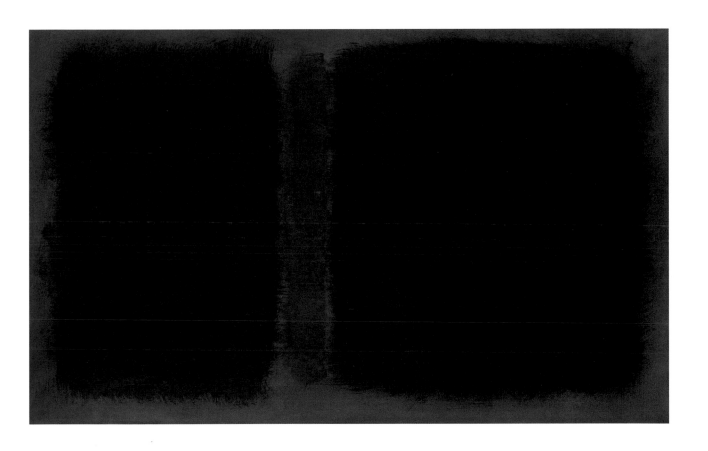

WILLEM DE KOONING *(1904–97)*

THE WAVE c.1942–44

Smithsonian American Art Museum, Washington, DC/Courtesy of Art Resource/Scala

DESPITE his Dutch origins, William de Kooning is fêted as one of the greatest of all American painters. Abstract Expressionism is a broad term applied to a style of painting produced in America in the 1950s and 1960s that valued individualism and spontaneous expression. Paint was dripped and smeared on to the canvas as moods and emotions would be expressed in texture and almost physical movement as well as in more conventional methods. In 1952, Harold Rosenberg said of the movement: "The big moment came when it was decided to paint … just to PAINT. The gesture on the canvas was a gesture of liberation, from Value—political, aesthetic, moral."

Contemporary critics were keen to categorize the Abstract Expressionist movement as a home-grown mode of painting and to celebrate what they saw as America's first artistic innovation of its own. The government saw the movement in political terms and believed that at last it had a unique and valuable export that would place America firmly to the fore on the cultural world stage.

De Kooning settled in America in 1926; his work was influenced by the Dutch Expressionists, De Stijl, and Arshile Gorky. He first worked as a decorator, and this undoubtedly influenced the painterliness of his subsequent pictures. Some critics dispute de Kooning's inclusion in Ab-Ex, as many of his works are not purely abstract and have recognisable subject matter in them, as seen in *The Wave*.

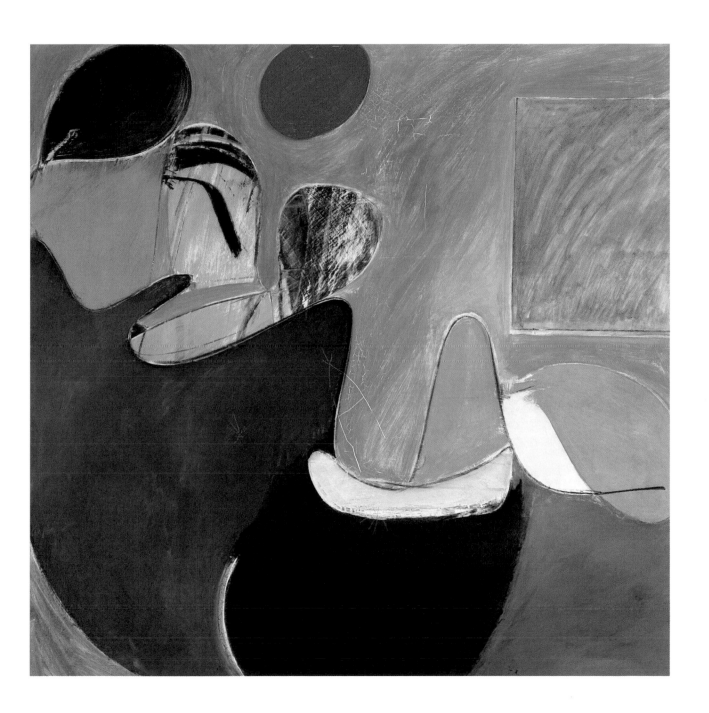

ARSHILE GORKY *(1904–48)*

UNTITLED 1946

*Private collection, Manza / Courtesy of the
Bridgeman Art Library*

ARSHILE Gorky was born in Turkish Armenia and he emigrated to America in 1920. He deemed his Armenian name too difficult for the average New Yorker to pronounce so on his arrival he adopted the name Arshile Gorky, taken from the Greek Achilles and the Russian writer Maxim Gorky. He was first a student and then a teacher at the Grand Central School of Art in New York. Reports say that Gorky employed a Hungarian violinist to play to his students during classes to make their painting more emotive.

Gorky's own work shows the influence of European Cubism and Surrealism, particularly that of Cézanne, Picasso, and Miró, and his anticipation and role in the evolution of the Abstract Expressionist movement. Unlike that of many of his contemporaries, Gorky's work shows a variety that makes him hard to pin down stylistically. Some critics claim him a Surrealist, others as an Abstract Expressionist. Few, however, contest his part in the creation of an American school of abstract art.

The story of Arshile Gorky's life is an extremely tragic one—few men can have suffered quite so many misfortunes piled on top of each other: a fire in his Connecticut studio destroyed a large number of his paintings, he developed cancer, he was involved in a car accident, and his wife left him. As a result of this sucession of personal disasters the artist hanged himself in 1948, two years after this painting was completed.

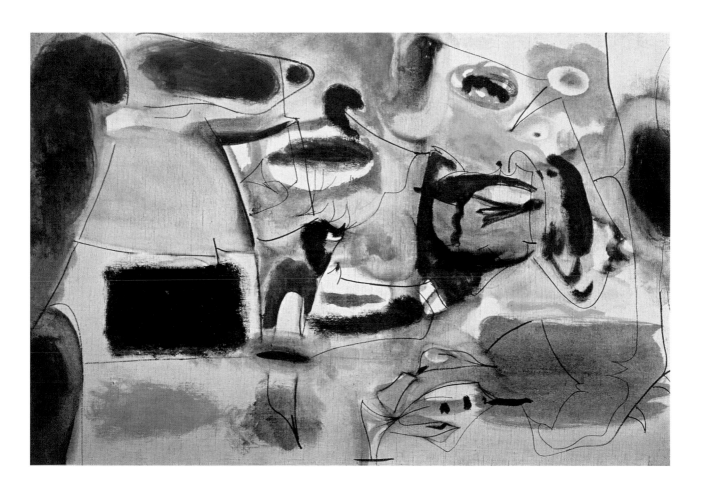

CLYFFORD STILL (1904–80)

INDIAN RED AND BLACK 1946

Smithsonian American Art Museum, Washington, DC / Courtesy of Art Resource / Scala

ALTHOUGH he was an early member of the Abstract Expressionist movement, Clyfford Still is generally better known for his transition to color-field painting, which came later during that movement's chronology. Other color-field artists working during the late 1940s and through the 1960s were Barnett Newman and Mark Rothko. Like Still they also rejected the often aggressive, supremely gestural style of true Abstract Expressionism and looked to move in the opposite direction by reducing the art of painting to its very essence.

Born in North Dakota, Still studied at Spokane University and Washington State College and became a teacher himself, working in colleges in Washington, California and New York. Still's early work was figurative, but he soon turned to abstraction and began to develop his own style of color-field painting. During his time in New York he held a solo exhibition at Peggy Guggenheim's Art of This Century gallery in 1946. Still settled in Maryland in 1963, anxious to get away from the at times stifling art scene of New York and create the right atmosphere for what he considered to be his visionary and spiritual paintings.

His typical works contain blocks of color, mostly reds, blacks, yellows, and purples. They have jagged, unfinished edges, and give the sense that the paint has almost bled down the canvas.

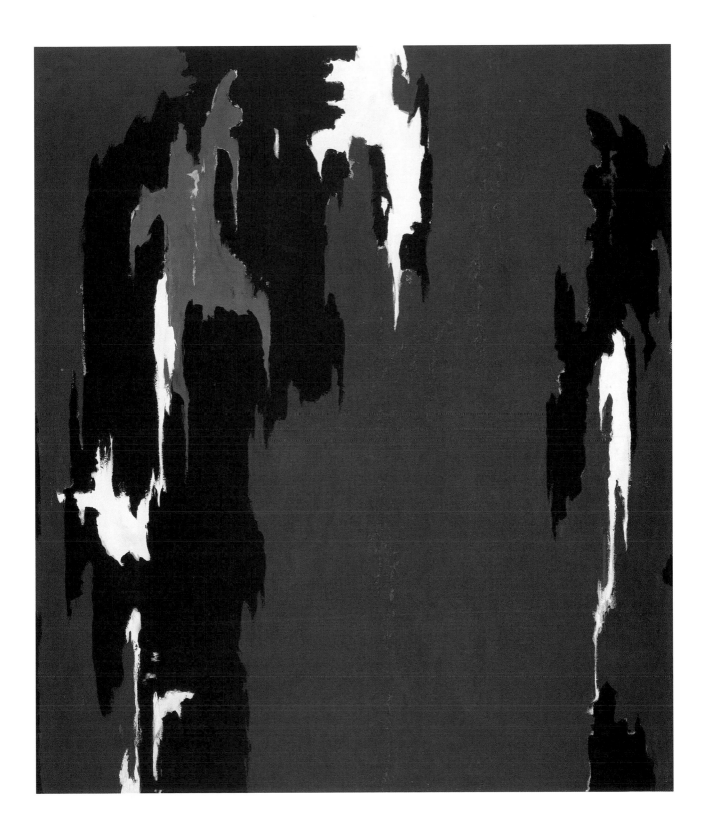

BARNETT NEWMAN *(1905–70)*

BE I 1970

Courtesy of the Detroit Institute of Arts / Bridgeman Art Library

BARNETT Newman is considered the chief exponent of the technique of color-field painting, a style of American abstract painting produced between the late 1940s and 1960s. Other artists producing paintings in this vein were Mark Rothko and Clyfford Still. Color-field was considered to be a part of the larger Abstract Expressionism movement.

Born in New York to a Polish Jewish family, Barnett Newman studied at the Art Students League and the City College. A man of stongly held political principles, in the 1930s he was one of the few artists not to work for the Federal Art Project, which provided work for struggling artists. His first influence was Surrealism, but he destroyed much of his early work and few of these Surrealist works survive. From his Surrealist beginnings he turned to more abstract works and in 1948 created his first so-called "zip" paintings—a canvas painted with a single color and a lighter-colored "zip" line running vertically down the canvas. These "zip" paintings became his signature works and are what he is best known for today.

Newman's first solo exhibition was in 1950 at the Betty Parsons gallery in New York; it did not receive the praise he had hoped for. His precise style was too different from the fashionable gestural painting of the Abstract Expressionists so in vogue at the time. In the 1960s, however, he finally gained the respect he deserved when he produced a black and white series and the American art press claimed him as their own.

FRIDA KAHLO *(1907–54)*

DAMA DE BLANCO (WHITE LADY) 1928

Private collection / Courtesy of the Bridgeman Art Library

FRIDA Kahlo was born Magdalena Carmen Frida Kahlo y Calderón in Coyoacán, Mexico City. Her mother was Mexican and her father, who was born in Germany, had settled there. She began painting almost by chance, as her parents hoped that she would study to become a doctor. However, her fate was sealed when she was involved in a serious traffic accident in 1925. As a result Frida spent long stretches of time, throughout her life, in hospital and she underwent numerous operations. It was during one of her periods of convalescence that she began to paint and discovered that she had a remarkable talent.

Her immobility limited her access to a wide variety of subject matter and as a result many of her paintings are self-portraits. They are often autobiographical, for instance the works *My Birth* and *Henry Ford Hospital* (both 1932). She married the Mexican muralist Diego Rivera in 1929 and their relationship was reportedly a tempestuous one. This intense relationship was also represented in her paintings.

Kahlo was greatly influenced by native Mexican folk art, and by André Breton and Surrealism. She met Breton in 1938 and he and Marcel Duchamp promoted her work in Paris and in America. Interestingly, it was not until 1953, a year before she died, that an important exhibition of her work was staged in Mexico. For many people Frida Kahlo embodies Mexican art; her home was donated to the country after her death and serves as a museum.

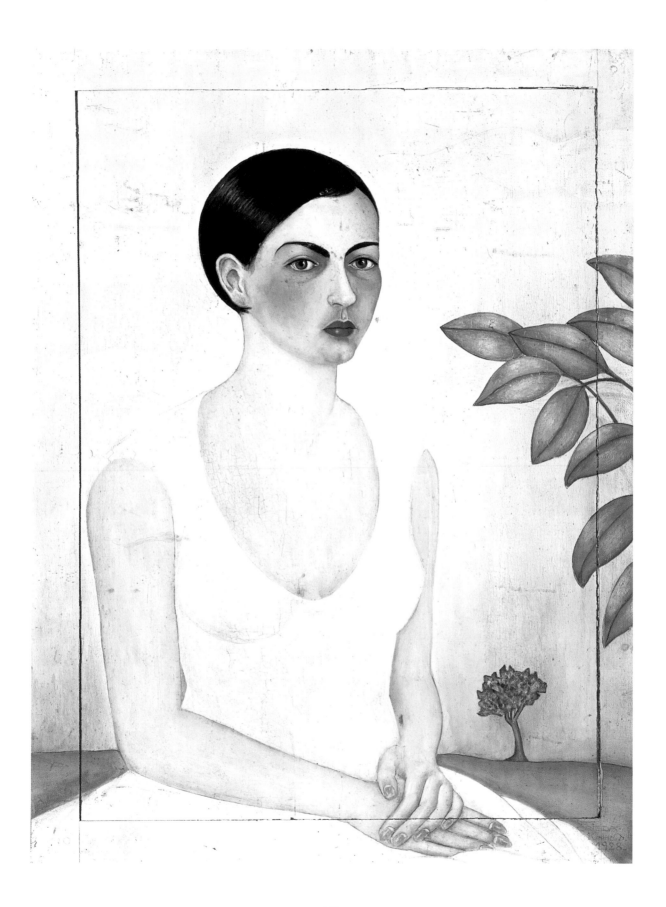

FRIDA KAHLO *(1907–54)*

THE FRUIT OF THE EARTH 1938

Colección Banco Nacional de Mexico, Mexico/Courtesy of the Bridgeman Art Library

FRIDA Kahlo and her husband Diego Rivera lived in America, having been forced to flee their native Mexico because of their politics. They were both members of the Mexican Communist Party for a time and then part of the Fourth International, led by Leon Trotsky.

Kahlo has since become acclaimed as something of a feminist icon. This is less for her direct involvement in feminist issues—there was little feminism as such at the time she was working—but more as an example of a strong woman who worked through great physical limitations. She produced remarkable paintings, despite living for most of her life in great pain, and suffered considerable persecution for her involvement with political causes. As with other wives of famous painters, her work has often been sidelined or compared ungenerously with that of her husband. Rivera himself did much to support Kahlo's work, however, and described her as "the first woman in the history of art to treat, with absolute and uncompromising honesty, one might say with impassive cruelty, those general and specific themes which exclusively affect women."

The autobiographical nature of Kahlo's work can be sad, confusing and inspiring, and she conceals very little. Rivera praised her for being "the only example in the history of art of an artist who tore open her chest and heart to reveal the biological truth of her feelings."

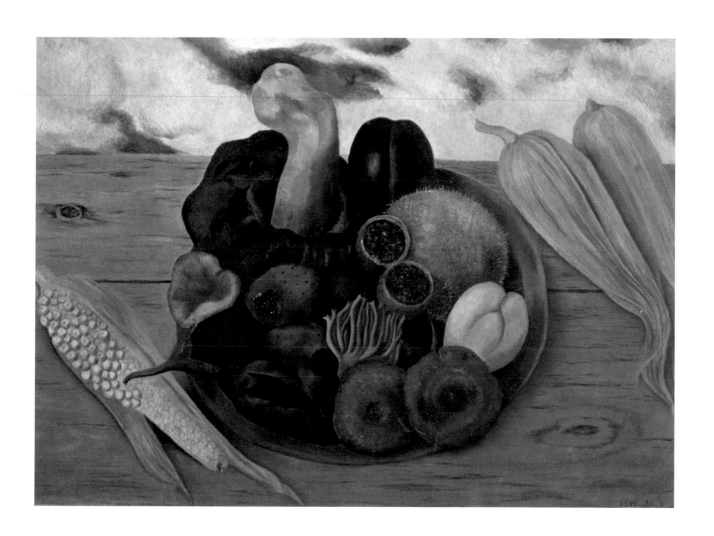

LEE KRASNER *(1908–84)*

COMPOSITION 1943

Smithsonian American Art Museum, Washington, DC / Courtesy of Art Resource / Scala

IN an interview in 1973 Lee Krasner said: "I was not the average woman married to the average painter, I was married to Jackson Pollock. The context is bigger and even if I was not personally dominated, the whole art world was."

Krasner was born in Brooklyn, New York, and studied at the Women's Art School of Cooper Union, the Art Students League, the National Academy of Design, and under Hans Hofmann in New York. During the 1930s she worked on Federal Art Projects and had received recognition as an artist before she married Pollock in 1945. She, like Pollock, was part of the Abstract Expressionist movement and she developed her own all-over painterly style, with sensitive attention to color, shapes, and composition. The influence of Pollock is undeniably present in her work, as is that of de Kooning, Matisse, and Mondrian.

The reception of Krasner's work has been blessed and blighted by her marriage to one of the most famous and controversial artists of all time. She herself said of the relationship: "Unfortunately, it was most fortunate to know Jackson Pollock." Clement Greenberg, the eminent critic and flag-bearer for the Abstract Expressionist movement, said that Krasner had "the best eye in the country for the art of painting." Many women artists at this time suffered at the hands of the chauvinist art world. Her teacher Hans Hofmann's famous compliment for his female students was to say: "This painting is so good you'd never know it was done by a woman."

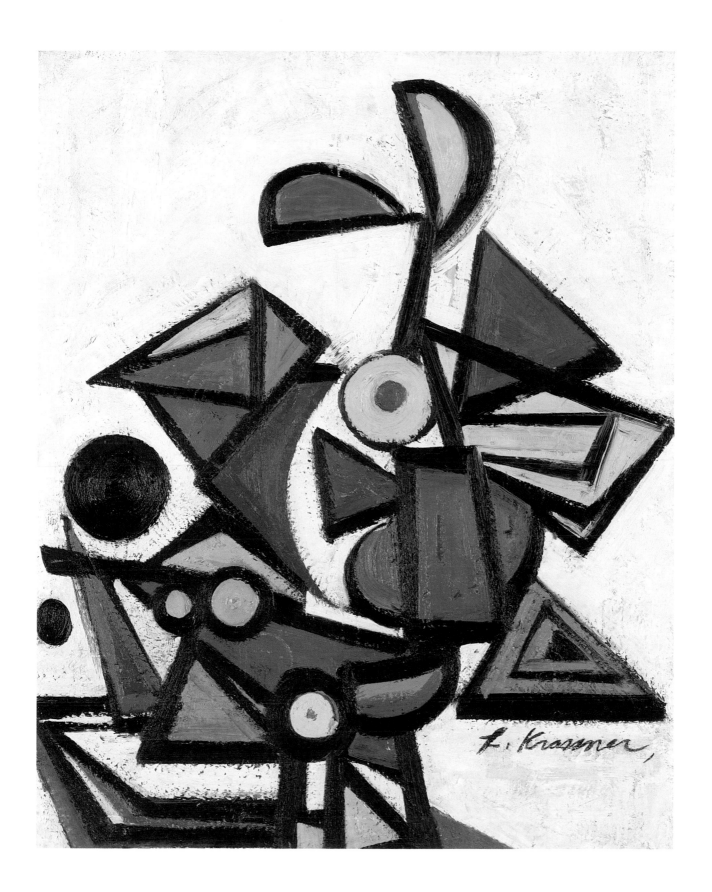

FRANZ KLINE *(1910–62)*

BLUEBERRY EYES 1959–60

Smithsonian American Art Museum, Washington, DC / Courtesy of Art Resource / Scala

FRANZ Kline was born in Pennsylvania, and studied at Boston University. He lived in London during the 1930s and on his return to America in 1939 he moved to New York. In the 1930s and 1940s he became part of the Regionalist movement, which was led by Thomas Hart Benton, Grant Wood, and John Steuart Curry. He produced urban scenes and in particular landscapes until the 1950s when he moved towards abstraction. His first solo exhibition was in 1950 at the Charles Egan Gallery in New York and he was very well received by the critics, who appreciated his innovative techniques.

The story goes that Kline developed his signature style when he saw some of his representative work enlarged by a projector. By looking at the brushstrokes of his work he saw the possibility of abstract derivations. His distinctive paintings bear a white ground and painted on the canvas are large black brushstrokes, which have been likened to Oriental calligraphy. The variety of Kline's gestural painting made each work individual and subject to chance—an important characteristic of Abstract Expressionism. The work he produced towards the end of his life sometimes contained bright colors, but the majority of his work was based on variations of the black-and-white paintings he produced in the 1950s.

Kline played a major part in developing the artistic vocabulary of Abstract Expressionism, and for this reason is often associated with Willem de Kooning. He, like de Kooning, used commercial paints and the broad brushes usually associated with house painting.

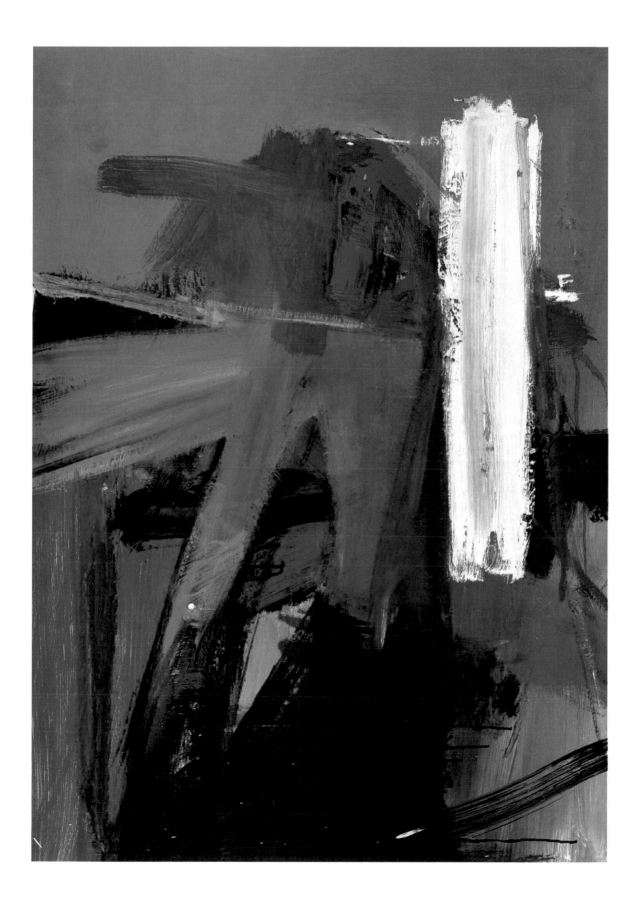

LOUISE BOURGEOIS *(1911–)*

FÉE COUTURIÈRE 1963

Solomon R. Guggenheim Museum, New York

LOUISE Bourgeois was born in Paris and moved to New York in 1938. She was married to the American art historian Robert Goldwater and together they had three sons.

As a young woman Bourgeois studied with the Cubist Fernand Léger and lived near Gravida, a Surrealist gallery in Paris. She knew some of the Surrealist artists and was a great friend of Marcel Duchamp. Despite this illustrious list of artists she associated with, Bourgeois claims her work was a type of exorcism and not the result of artistic influence. How seriously this claim ought to be taken is open to debate—indeed, how seriously she intended it to be taken is equally uncertain—but what cannot be denied is that much of Bourgeois's work contains a great deal of anger. This anger may be partly explained by the discovery of the ten-year affair that her father had with her governess, Sadie Gordon Richmond. Said Bourgeois of the affair, "I was betrayed not only by my father but by her too, dammit! It was a double betrayal—it is the anger that makes me work."

Like Duchamp, Bourgeois started as a painter and then stopped painting to become a sculptor. In the 1950s she produced abstract wooden sculptures painted black or white. She moved on to work in a variety of media, including stone, latex, metal, and textiles. Most of her work is abstract but does contain oblique references to the human figure and has sexual connotations.

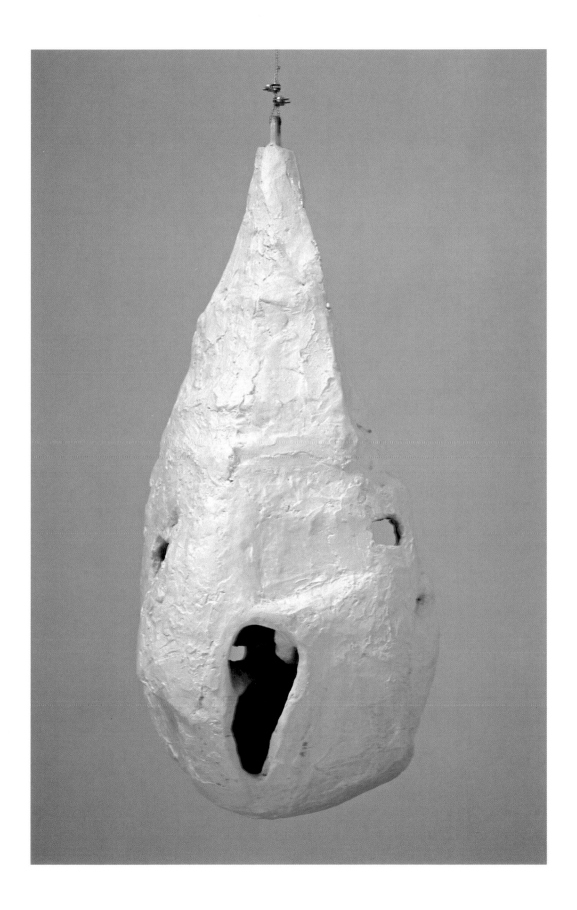

JACKSON POLLOCK *(1912–56)*

GOING WEST C.1934–35

Smithsonian American Art Museum, Washington, DC/Courtesy of Art Resource/Scala

JACKSON Pollock is undeniably one of the most famous artists that American has ever produced. He was born in Cody, Wyoming, and raised in Arizona and California. He attended the Manual Arts High School in Los Angeles and was introduced to abstract painting and theosophy by Frederick Schwankovsky. It was at this school that the controversies that were never too far away from Pollock in his later life commenced, as he began his lifetime of heavy drinking there—as a result he was promptly expeled.

Pollock moved to New York in 1930 and studied at the Art Students League under the Regionalist painter Thomas Hart Benton. He worked as both a mural and easel painter for the Works Progress Administration. The WPA was part of Franklin D. Roosevelt's New Deal, the scheme that aimed to save capitalism through the creation of extensive employment programs, including jobs for artists.

During the 1930s Pollock was greatly influenced by Regionalism and Benton, by the Mexican muralist painters (Rivera, Orozco, and Siqueiros), and by Surrealism. The influence of Thomas Hart Benton is particularly obvious in the treatment of the figures in *Going West*, which depicts a moonlit migration scene. Pollock was a model for Benton's own murals and the young painter learned much about posture and movement from his teacher. Of Benton Pollock said it had been instructive to work with him as he had given him something to react against.

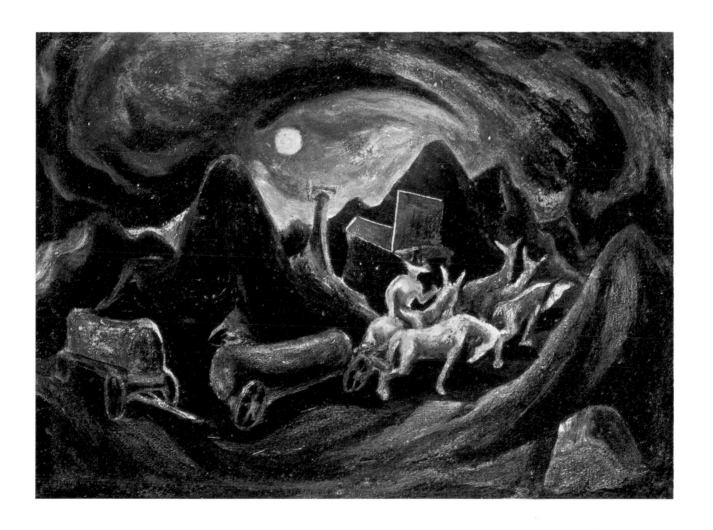

JACKSON POLLOCK *(1912–56)*

AUTUMN RHYTHM (NUMBER 30) 1950

The Metropolitan Museum of Art, George A. Hearn Fund

"On the floor I am more at ease, I feel nearer, more a part of the painting, since this way I can walk around in it, work from the four sides and be literally 'in' the painting."
Jackson Pollock, 1947

POLLOCK was a pioneer of the Abstract Expressionist movement—"He broke the ice," as de Kooning was to say later. Pollock's artistic breakthrough came in 1947 when he began his "drip" paintings by placing a canvas on the floor and dribbling and splattering paint in hundreds of web-like layers. It created his signature style of an all-over painting with no, or few, points of focus and a fantastic feeling of action that frequently bordered on the violent. It has been suggested that his inspiration came from Navajo Indian sand paintings and from jazz music. The "drip" paintings would go on to acquire an almost iconic status in the history of art.

Pollock was interested in Surrealism and the Surrealist practice of automatic writing. Pollock claimed that his Abstract Expressionist paintings were created by a process of psychic automatism, a direct expression of the unconscious—"When I am in my painting, I'm not aware of what I'm doing," he said. However, in Hans Namuth's famous documentary on Pollock in 1950 the artist said, "I can control the paint, there is no accident," so art historians are rather left wondering. Pollock has always been a controversial figure and viewers tend to love or loathe his work. Pollock even said of himself, "I am doubtful of any talent."

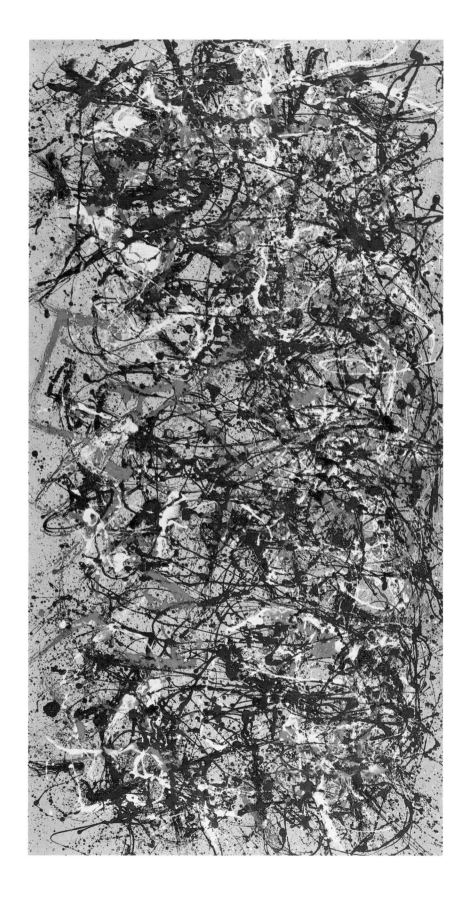

JACKSON POLLOCK *(1912–56)*

LAVENDER MIST, NO. 1 1950

The National Gallery of Art, Washington, Ailsa Mellon Bruce Fund

ABSTRACT Expressionism was a home-grown movement and it put the United States firmly on the international art map. The Abstract Expressionists were marketed as bar-brawling, macho, womanising cowboys and Pollock, in Levi's and smoking a permanent cigarette, certainly played the part to the full. As such Pollock was arguably the first American celebrity artist. As an illustration of how important he was to American culture in 1949 *Life* magazine asked, "Is he the greatest living painter in the United States?" and in 1956 *Time* magazine christened him "Jack the Dripper"—he had entered the mainstream.

Lavender Mist is ten feet long and the skeins of oil, enamel, and aluminum paint are applied so densely that a viewer's eyes can scarcely cut through the different layers. It is a delicate mesh of glistening colors and it is for this effect that Francis Bacon called Pollock "the old lace-maker."

In 1944 Pollock married Lee Krasner (see page 176), another Abstract Expressionist, and a year later they moved to East Hampton, Long Island, hoping a move away from the city might help Pollock stop the drinking that was beginning to take over his life. On 11 August 1956 Pollock, aged 44, died in a car crash, drunk at the wheel. His lover, Ruth Kligman, was also in the car and survived but her friend, Edith Metzger, died. As with James Dean and Marilyn Monroe, Pollock's talent and premature death have secured him legendary status and media interest in his life and work continues today.

ANDREW WYETH *(1917–)*

FIRST SNOW 1959

Delaware Art Museum, Wilmington / Bridgeman Art Library

ANDREW Wyeth was born in Pennsylvania and studied under his father, the celebrated muralist and book illustrator Newell Convers Wyeth (1882–1944). Andrew was the youngest of five children, many of whom became artists, and he was sick as a child and as a result was tutored at home. His first show was in October 1937 and held at the William Macbeth Gallery in New York. It was sold out on the day it opened.

The settings of Wyeth's paintings play a significant part in his work and for this he has been described as a Regionalist painter. The two places he depicts are the Brandywine Valley around Chadds Ford, Pennsylvania, where he was born, and Cushing in Maine, where he and his wife Betsy spent their summers. Throughout his work he has shown his surroundings in varying seasons, peopled by his family, friends, and neighbors. Man's interaction with the land and sea is one of the main themes of Wyeth's paintings. Even without the narrative of figures the paintings often achieve a sense of quiet isolation and sadness. Wyeth honors the innocence of rural life, with little attention given to technology and modern civilization.

Wyeth's preferred medium of tempera also harks back to a different era. It is a painting technique in which a powdered pigment is mixed with a binder, usually egg. This was first popular in European panel painting between the thirteenth and fifteenth centuries, until oil painting became more popular. The late nineteenth and twentieth centuries saw a renewed interest in tempera painting and Wyeth is often cited as the key exponent. He was also particularly interested in the work of Albrecht Dürer and was inspired to use the drybrush technique seen here.

ANDREW WYETH *(1917–)*

SEA BOOTS 1976

The Detroit Institute of Arts/Courtesy of the Bridgeman Art Library

SEA *Boots* was produced at the same time as Wyeth was painting his secret paintings of the model Helga. Wyeth's models have all achieved great notoriety, but Helga is the most controversial. For fifteen years, from 1970 to 1985, Wyeth secretly made drawings, watercolors, and tempera paintings of his neighbor Helga Testorf. He hid the work from his wife Betsy and did not release the pictures on to the art market. When the collection of paintings, some 240 works including many nudes, was revealed, it established Wyeth as one of the most famous American artists and Helga as one of the world's most famous models. Wyeth avoided Betsy's suspicion by also producing a substantial number of other paintings, including *Sea Boots*. Wyeth's use of the sea as subject matter was influenced by the work of Winslow Homer and he greatly admired Homer's use of light.

The other great work of Wyeth's career was the earlier *Christina's World* (1948), arguably the most famous painting by a living American artist. Christina Olson, alongside Helga, is also one of the most famous models in American art. Initially the painting appears to show the back view of a young girl in a pink dress sitting in a meadow looking up at a clapboard house. On closer inspection the girl's limbs are wasted and abnormally thin. It is in fact a painting of a crippled woman pulling herself along the ground back to her house. The house is a place of pilgrimage for Wyeth's fans today and they often mimic Christina's pose and take photographs of themselves in her place.

Wyeth's standing in American art has always been problematic as his own brand of Regionalism has not been in step with the cutting-edge developments in his country. Despite the criticisms Wyeth, with his nostalgic view of a simpler life, remains one of the most popular artists in America today.

RICHARD DIEBENKORN *(1922–93)*

VIEW OF OAKLAND 1962

Smithsonian American Art Museum, Washington, DC / Courtesy of Art Resource / Scala

RICHARD Diebenkorn was born in Portland, Oregon and studied at the California School of Fine Arts, San Francisco. His work went through several different stages. He tended to absorb these different stages rather than moving from one to the next, and as a result his work often sat just outside what was going on around it. It was not unusual for him to combine the modern painting of his time with more traditional styles with quite spectacular results. In the 1960s, when developments in American abstract art were being watched closely by people all over the world, Diebenkorn returned to figurative and representative art and offered a reinterpretation. This approach became a major influence on many around him and several other young Californian artists followed suit.

Always acutely aware of how he fitted into his environment, the artist created a number of cityscapes, like this *View of Oakland* and the well-known *City Scape 1* (1963). In the tradition of representational painting Diebenkorn has created a three-dimensional space. However, despite the sense of perspective in the background, the car in the foreground is flat and one-dimensional and gives the painting a modern edge. It is known that Diebenkorn was inspired by Matisse's picture *Porte-fenêtre à Collioure*—a view through an open window. Here, Diebenkorn has painted what he saw out of his own studio window. His colors are integral to the subject and the muted palette conjures up the damp, foggy air of the bay area of Oakland.

RICHARD DIEBENKORN *(1922–93)*

UNTITLED 1970

Smithsonian American Art Museum, Washington, DC/Courtesy of Art Resource/Scala

WHILE he was studying at the California School of Fine Arts in San Francisco Diebenkorn met Mark Rothko and Clyfford Still, who were members of the color-field school. They greatly influenced his techniques and use of color, but he made his work his own by incorporating subject matter inspired by his surroundings.

As mentioned before, Diebenkorn took on board previous styles and methods and incorporated them in his contemporary work. This is very clearly demonstrated through a comparison of his representational painting *View of Oakland* of 1962 with this abstract *Untitled* painting of 1970. By looking at the two works together it is possible to see how the different phases of his career affected him within the space of just eight years.

Diebenkorn's unique style as a color-field artist is best observed in the series of paintings he began in 1967. These have come to be known as his *Ocean Park* series, and in them he pared the landscape down to a grid of large geometric areas of color. Derivations of that process may be seen here.

Diebenkorn's work has become synonymous with many people's views of California and its representative art. In 1969 *Time* magazine featured an article, which many took to be inspired by Diebenkorn's work, about the mythologising of Californian life, which explored characteristics that were peculiar to the so-called "Golden State": "California people have created their own atmosphere, like astronauts," it claimed.

GRACE HARTIGAN *(1922–)*

MODERN CYCLE 1967

Smithsonian American Art Museum, Washington, DC / Courtesy of Art Resource / Scala

GRACE Hartigan was born in Newark, New Jersey, and lived for a time in Los Angeles, where she took drawing classes. She returned to New Jersey in 1942 and worked in an airplane factory as her contribution to the war effort. During this time she began painting still lifes in watercolor. Hartigan moved to Manhattan in 1945. Manhattan at the time was an extremely exciting place for a young artist to be, and it was this environment that had the greatest effect on her work.

She was involved with the Abstract Expressionist movement and practiced and developed its spontaneous and abstract mode of painting. She enjoyed the freedom she felt it offered and although Hartigan would probably not have called herself a feminist she was acutely aware of how important such a lack of constraint in painting was for a woman at the time. Most of the Abstract Expressionists were men, and as a woman Hartigan is often somewhat neglected next to the giants of Pollock and de Kooning. However, in 1959 the Museum of Modern Art, New York staged a touring exhibition called "The New American Painting" and Hartigan was the only woman out of the eight artists included.

The importance of color and its contribution to the unity of composition in Hartigan's work is evident. She used colors that would serve to complement each other, rather than conflict, such as blue and orange or green and red. There is rarely a point of focus in her works, which encourages the viewer's eye to take in the whole canvas.

GRACE HARTIGAN *(1922–)*

INCLEMENT WEATHER 1970

Smithsonian American Art Museum, Washington, DC/Courtesy of Art Resource/Scala

"There's a time when what you're creating and the environment you're creating it in come together."
Grace Hartigan

THIS painting is typical of Grace Hartigan's best-known work in its Abstract Expressionist style and relation to her surroundings. She says that "Somehow, in painting I try to make some logic out of the world that has been given to me in chaos." Hartigan's compositions have their own sense of order and by considering the proportion and color of the shapes she paints she determines their place within the picture.

As well as nature, Hartigan draws on numerous references to popular culture in her paintings. Some critics view her work of the 1950s as prefiguring the work of the Pop artists. Like Willem de Kooning, Hartigan's work was not purely abstract and she took many references from urban New York. One of her best-known works is *Billboard*, which is based on the impression a viewer might have of an advertisement as he or she speeds down a highway. The artist is still working today and sometimes she returns to rework themes she first explored in the 1950s. In the 1990s she produced works about Rudolph Valentino and Marilyn Monroe and examined the phenomena of Hollywood and society's love of celebrity. She has also taken references from the work of poets who were her friends, such as Frank O'Hara, James Schuyler, and Barbara Guest.

ELLSWORTH KELLY *(1923–)*

BLUE ON WHITE 1961

Smithsonian American Art Museum, Washington, DC/Courtesy of Art Resource/Scala

ELLSWORTH Kelly was a painter and a sculptor and is best known for his work of the 1950s and 1960s. He was born in New York and first studied in his home city before moving to Paris to study from 1946 to 1954. In France he became much influenced by the Surrealist work of Jean Arp and Joan Miró and he experimented with the Surrealist technique of automatic drawings. Kelly was also attracted to the work of Matisse, in particular to his innovative use of color.

On his return to America Kelly, along with Frank Stella, was a leading figure in a group who rejected Abstract Expressionism and advocated a so-called "hard-edge" style of painting. This new abstract painting concentrated on the expressive power of color and the paint was applied to create a flat, textureless surface. The distractions of texture and multiple colors are avoided and the edges of the painting are defined and reject the blurred and color-soaked edges of Ab-Ex and color-field painting.

His works were often made up of a canvas painted with a single color, or a number of canvas panels joined together and painted in a few uniform colors to create a grid.

Kelly also produced sculpture from the late 1950s and was influenced by Alexander Calder. Like Calder in his mobiles, Kelly used sheets of aluminum cut into geometric shapes and painted. These shapes echoed the forms found in his paintings. Kelly also worked with shaped canvases, themselves works of sculpture.

ROY LICHTENSTEIN *(1923–97)*

IN THE CAR 1963

Scottish National Gallery of Modern Art, UK/Courtesy of the Bridgeman Art Library

IN 1961 Roy Lichtenstein began to paint large-scale single frames from comic strips. They were often based on romantic scenarios and sometimes included speech bubbles. They were often overtly ironic in their approach, but this is an aspect that has become more considered in retrospect. Here, an attractive woman sits in a car alongside a man who gives her a sidelong glance, as if appraising her. It is the stuff of cheap romantic fiction—the icy glamor-puss and the handsome cad. Lichtenstein created images with dots, which reflected the technique used on the pages of a comic. He took the techniques from mass media production and applied them to fine art. These large, emotionally loaded figures and situations are familiar to us today—they have inspired countless imitators and the term "Lichtenstein-style" has become the accepted description for such paintings.

Lichtenstein was one of the key figures in the Pop Art movement and like Warhol, Wesselman, and Rosenquist, Lichtenstein used banal references from popular culture and elevated them to high art. Lichtenstein was a native New Yorker and studied at the Arts Students League and Ohio State University. He, like Jasper Johns, served in the army, before returning to Ohio and reading for his masters degree in fine art in 1949. He worked as a commercial artist during his early career in order to support himself, and his graphic design training is evident in the meticulousness and precision that he continued to apply to much of his own work.

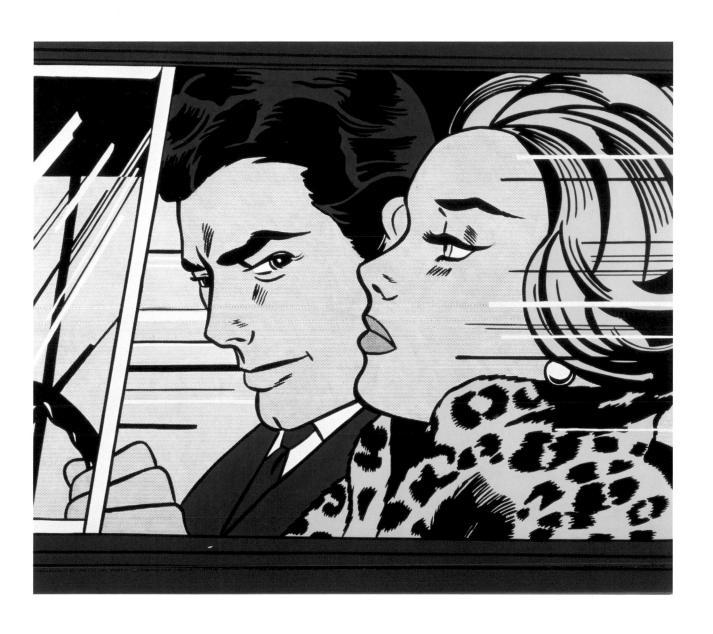

ROBERT RAUSCHENBERG *(1925–)*

RESERVOIR 1961

Smithsonian American Art Museum, Washington, DC/Courtesy of Art Resource/Scala

BORN in Port Arthur, Texas, Rauschenberg began by studying pharmacy at Texas University before serving in the Second World War. He then studied art under Josef Albers at Black Mountain College, North Carolina and at the Art Students League in New York.

Rauschenberg, along with Jasper Johns, was responsible for the move away from Abstract Expressionism, which had monopolized American art in the late 1940s and early 1950s. Rauschenberg and Johns were pioneering members of the Pop Art movement, which reevaluated fine art by focusing on objects of popular culture, thereby bringing art to the people and elevating popular culture to the status of high art. Consumer goods, advertisements, movies, and so on were the substance and subject of artworks and usually approached with a sense of irony and no little humor.

Throughout the 1950s and 1960s Rauschenberg created "combined paintings" in order to "act in the gap between art and life." These works merged painting with an assemblage of "found" objects and are his best-known works. The most famous is *Monogram* (1959), in which a stuffed goat bears a rubber tire around its girth. It is covered in splashes of paint, reminiscent of Abstract Expressionism. In *Reservoir* Rauschenberg created a multidimensional picture plane with tin cans, clocks, wheels, and pieces of wood—perhaps dredged from a reservoir—attached to a painterly canvas.

HELEN FRANKENTHALER *(1928–)*

SMALLS' PARADISE 1964

Smithsonian American Art Museum, Washington, DC/Courtesy of Art Resource/Scala

BORN in New York City, Helen Frankenthaler studied art with Paul Feeley at Bennington College, Vermont and read art history at Columbia University. She attended the Art Students League in New York and was taught there by Hans Hofmann (see pages 92–5). She was married for a time to the painter Robert Motherwell.

Frankenthaler is associated with Abstract Expressionism and the influence of Jackson Pollock on her work is undeniable. She is, however, credited with taking that movement in a slightly different direction when, in the 1950s, she developed her own derivative style. Rather than almost physically attacking the canvas as so many of her contemporaries appeared to do, Frankenthaler adopted a far more gentle method, which involved soaking or staining an unprimed canvas with diluted oil paint. The effect is one of ghostly transparent color, as is usually seen in watercolors. Often the canvas shows through, which creates very different textures and, as a result, promotes another spectrum of moods entirely.

Frankenthaler also experimented with acrylics, as in *Smalls' Paradise.* The artist described it as: "a play on interiors, shapes within shapes." While the painting marked a departure from her landscape abstractions, it is still rooted in the theme of "place." Once again this work shows Abstract Expressionism's links to the world of jazz as the title refers to the famous jazz club in Harlem that Frankenthaler visited.

CY TWOMBLY *(1928–)*

BOLSENA 1969

Christie's Images, London, UK

CY Twombly was born in Lexington, Virginia, and received his training at Boston Museum School, the Art Students League, New York, and Black Mountain College. At Black Mountain College he was particularly influenced by the work of Franz Kline.

Although his very distinctive style developed from his association with Abstract Expressionism, it is obviously an interpretation of what was going on around him rather than an actual involvement. Twombly's style is characterized by the unique works he called "written images" paintings—a sort of random scribbling on large white or black grounds. Twombly rejected the traditional ideas of representation and composition and produced an all-over style of painting, in a similar way to Jackson Pollock. In all-over painting the orientation of the picture is unclear and Twombly's pictures are even more disorderly than Pollock's.

Twombly's work represented a move away from Abstract Expressionism to a more post-painterly abstraction, associated also with the works of Jasper Johns and Robert Rauschenberg. Twombly includes both painting and writing in his creations. Here, in Bolsena, he uses a mixture of oil, colored chalk, and pencil. This work, as with Twombly's other pieces, divided critics, who read various meanings in the words and symbols he includes. As such it is a mark of how complex his work could be.

In 1957 Twombly settled in Rome and in the summer and autumn of 1969 produced a series of Bolsena pictures when he was staying at the Palazzo del Drago, a house set on a hill above the town of Bolsena.

ANDY WARHOL *(1928–87)*

CAMPBELL'S SOUP CAN 1962

The Andy Warhol Foundation / Courtesy of Art Resource / Scala

ANDREW Warhol was born to Roman Catholic Czech immigrant parents at the beginning of the Depression in 1928. He grew up near Pittsburgh and was a graduate of Carnegie Institute of Technology. In 1949 Warhol moved to New York and during the 1950s he worked as a very successful commercial illustrator. In 1960 he began to produce paintings based on mass-produced images such as advertisements and comic strips.

In 1962 he struck upon the Campbell's soup can and his series of these soup cans made Warhol the leading figure in the Pop Art movement. Warhol's skills were many and he embraced a range of artistic disciplines: he was a painter, graphic artist, filmmaker, and writer. Asked why he painted soup cans he replied: "I used to drink it. I used to have the same lunch every day for twenty years, I guess, the same thing over and over again."

Warhol famously declared that "Pop Art is for everyone" and in order to reach the masses he looked to instantly recognisable objects from mass culture and made them into the subjects of his art—like the soup can. The seriality of the images echoes the very nature of the commodity. They contain references to mass production, mass consumption, and technological progress. Warhol painted his first serial paintings by hand, but he soon developed a silk-screening process that enabled him to produce multiple identical images easily and quickly. These works were produced in his studio in Greenwich Village, which was appropriately named The Factory.

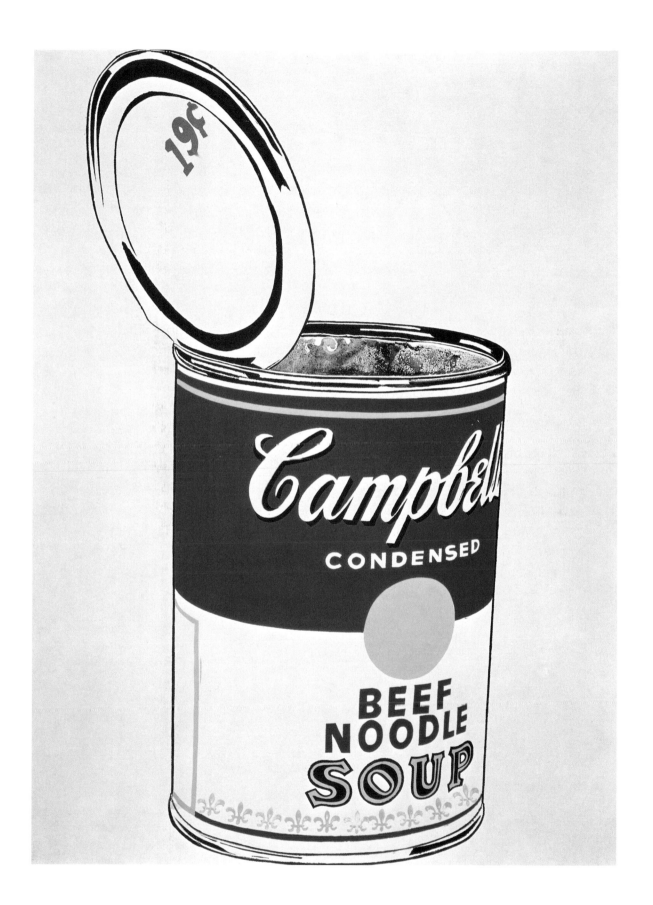

ANDY WARHOL *(1928–87)*

MARILYN 1962

The Andy Warhol Foundation/Courtesy of Art Resource/Scala

WHEN Marilyn Monroe died from a drug overdose in 1962, Warhol produced a series of pictures that commemorated her death. He chose a publicity still taken from her film *Niagara* (1953). In the early 1960s Warhol had perfected the process of silk-screen printing and used it to reproduce the same image over and over again on a canvas. Some of the paintings bear one print of Monroe's face; in others it is repeated up to 50 times. He produced the silk-screens in several different colors and even gold in *Gold Marilyn Monroe*. This transforms the movie star into a gilded Byzantine icon and perhaps comments on her commercial value.

Warhol understood celebrity—he was a celebrity himself—and he addressed the issue in his series of celebrity portraits, which included Elvis Presley, Elizabeth Taylor, and Jackie Kennedy. In his art Warhol used elements of popular culture, but was he elevating low culture to high art, or dropping high art to low culture? Was he merely selling a psychedelic picture of a beautiful woman and icon of the twentieth century, or illustrating the power of the media and popular culture?

He also took commissions for portraits, understanding the public's interest in celebrity and their desire for the opportunity to become "famous for fifteen minutes." Department stores and museums were his favorite places to go and he tried to combine the two. A Neiman Marcus (a department store) advertisement read: "Become a legend with Andy Warhol . . . You'll meet the Premier Pop Artist in his studio for a private sitting. Mr. Warhol will create an acrylic on canvas portrait of you in the tradition of his museum quality pieces."

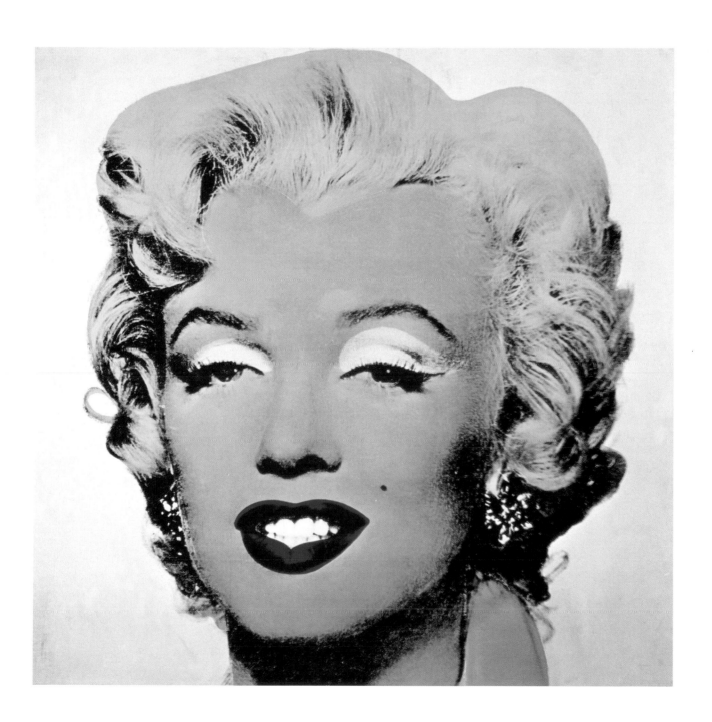

ANDY WARHOL (1928–87)

TUNA FISH DISASTER 1963

The Andy Warhol Foundation / Courtesy of Art Resource / Scala

IN the 1960s Warhol produced a series of pictures called *Tunafish Disaster*. They were based on a news story about two women from Detroit who, having eaten sandwiches made with tinned tuna fish, died a few hours later of botulism.

The paintings consist of multiple images of the two tragic women and of the offending tuna fish tin, with the batch code of the tin clearly displayed. In a far more obvious way than with the Campbell soup can or his other images of everyday objects, which seemed merely to draw attention to consumerism, the *Tunafish Disaster* series was a clear comment on the dangers that came with it. At the time it was felt that such an overt statement was needed to prove that this current art movement had all the social statement teeth of its predecessors and was not just fluff.

Warhol often extolled the virtues of a machine-made art bringing culture to the masses, but his true intentions were never very clear. Far from selling to the masses, his pictures, with their often high price tags, were accessible only to the rich. His serial paintings look at commodities and the spoils of consumerism. In his *Campbell's Soup Can* series Warhol may be seen to be celebrating the industrial age of mass production. The story here is very different—Warhol observes the downside of mechanical food production. Warhol loved to throw all the possible interpretations of his work into the air at the same time and ask the viewer to choose.

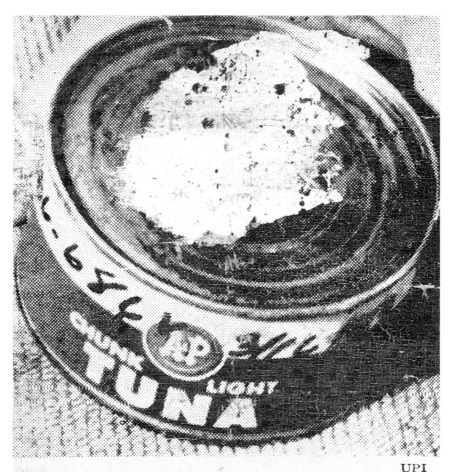

UPI

Seized shipment: Did a leak kill . .

. . . Mrs. McCarthy and Mrs. Brown?

ANDY WARHOL *(1928–87)*

DOLLAR SIGNS 1981

The Andy Warhol Foundation/Courtesy of Art Resource/Scala

IN 1965 Andy Warhol announced that he was giving up painting in order to devote himself to film directing and to managing the rock band the Velvet Underground. Nevertheless, the lure of money that he was able to make from commissioned portraits of wealthy society meant that Warhol could never quite give up art.

While the subject matter of his art may seem to comment on the greed of modern society, he was never above pandering to it and profiting from it. He even went so far as to refer to himself as an "art businessman" and a "business artist," and this probably was not another example of Pop Art irony. Later Jeff Koons would take up the mantle. It was no secret that by this time art was indeed a business and that when a collector hung a picture on his wall he was at the same time making a declaration of his worth and of what he could afford. Before Warhol, few artists had admitted to manipulating the situation to the degree that he was prepared to. Indeed, *Dollar Signs* does rather sum up this aspect of what he did.

Warhol was a tireless self-promoter and invented a public persona that intrigued the media. He was the leader of the "movers and shakers" of a generation and his lifestyle has become folklore. Warhol loved to shop and his spending is now legendary. He amassed an enormous fortune and on his death in 1987 (from a routine operation on his gall bladder) Warhol left an estimated $100,000,000. Most of this went to found the Andy Warhol Foundation, an arts charity.

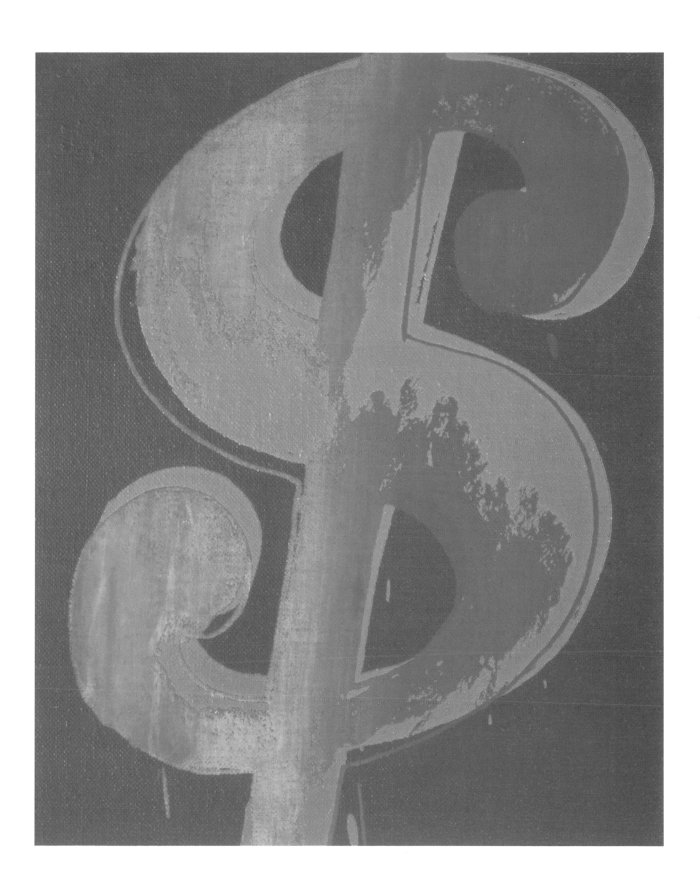

CLAES OLDENBURG *(1929–)*

FLOORBURGER 1962

Art Gallery of Ontario, Toronto, Canada/Courtesy of the Bridgeman Art Library

OLDENBURG followed his installation *The Store* (1960–61) with a series of "soft sculptures," which took their inspiration from junk food and everyday items from popular culture. He created giant hamburgers, ice-cream cones, slices of pie, typewriters, and other disposable items. Although these soft sculptures created what was initially an entertaining and ironic commentary, they were essentially one-line jokes: as soon as the viewer had viewed the objects and experienced the novelty they simply became just another artistic convention.

These Pop sculptures were made of canvas or vinyl, stuffed to make them three-dimensional. Oldenburg saw soft sculpture as a way of drawing in space and enjoyed the medium's malleability. Every time a sculpture was moved and set up it was slightly different. He set it up against a metal frame and thumped it to get the shape just right.

From the 1970s Oldenburg, with the help of his wife, Coosje van Bruggen, produced large-scale public sculpture works. Some are unrealized plans, like their idea to replace the Statue of Liberty with an electric fan; others were realized, like the giant baseball bat erected in Chicago (1977), a giant clothespin in Philadelphia (1976), a flashlight in Las Vegas (1981), and a matchbook in Barcelona (1992). The novelty of these sculptures is matched by the quality of their production, and they also show Oldenburg's superb draughtsmanship.

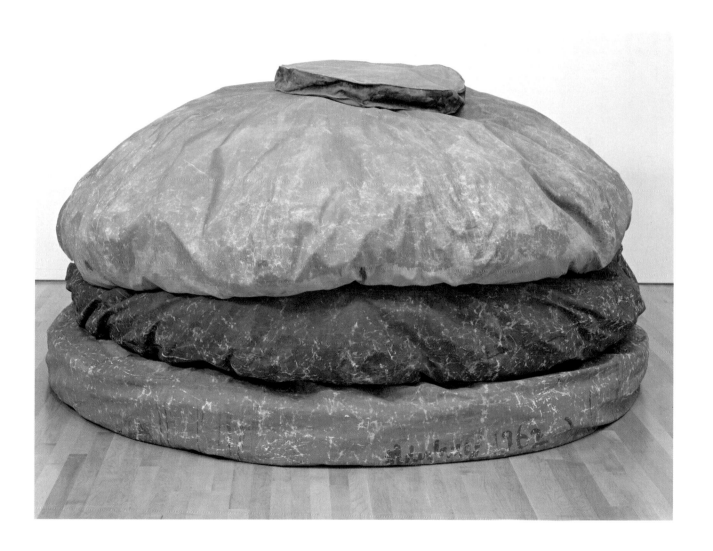

CLAES OLDENBURG *(1929–)*

CHEESECAKE FROM JAVATIME 1963

Private collection / Courtesy of the Bridgeman Art Library

"Art should not sit on its arse in a museum."
Claes Oldenburg

CLAES Oldenburg was born in Stockholm in Sweden, but his family emigrated to Chicago in 1934. Before emerging on to the New York art scene, Oldenburg studied at Yale University and worked as a newspaper reporter and illustrator while attending evening classes at the Chicago Art Institute. He moved to New York in 1956 and became involved in the Happenings and the Pop Art movement.

Oldenburg staged a Happening in his installation The Store (1960–61). He created an environment of an ordinary store, filled it with plaster replicas of consumer goods such as food and clothes, and invited people to come in and buy. The artist succeeded in taking art out of the galleries and museums and created The Store in an actual store in a neighborhood. The plaster objects were painted with great energy and covered in drips and splashes, perhaps a critique of the painterly style of Abstract Expressionism. Oldenburg was one of a group of artists who rejected Ab-Ex and reintroduced the figurative. The objects Oldenburg made for Happenings, like this slice of cheesecake, were often shown as sculpture after the event.

The Store is a good example of Oldenburg's infectious humor and his keen sense of the ridiculous. James Rosenquist went to The Store in 1961 and saw Oldenburg. Rosenquist said of the young artist that he "looked as if he was having an immense amount of fun."

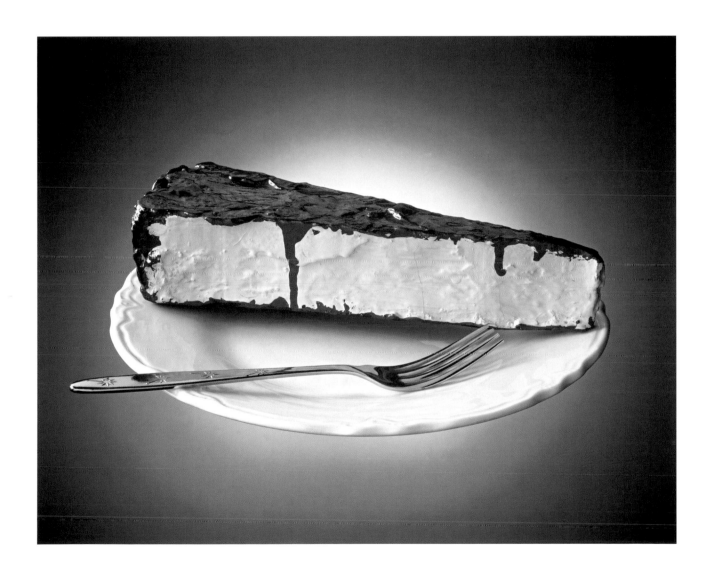

JASPER JOHNS *(1930–)*

THREE FLAGS 1958

Private collection / Courtesy of the Bridgeman Art Library

JASPER Johns, along with Robert Rauschenberg, is often described as a forerunner to the Pop Art movement. The work that Johns and Rauschenberg produced in the 1950s certainly contains a number of references to popular culture. However, there is another dimension to their work—in particular their painterly techniques show a clear debt to the Abstract Expressionism movement.

Jasper Johns produced a series of paintings based on the American flag, the Stars and Stripes, which has confused critics and viewers ever since. The first flag picture was immediately bought by the Museum of Modern Art, New York, but put in storage and not shown for some time. The museum staff realized it was important in the history of American art, but perhaps too controversial to show.

Johns has not provided an explanation for the series and numerous issues have been raised and readings applied. Some ask if they are flags or paintings, true representations or abstractions. Some see them as a figurative reaction to Abstract Expressionism. The flag is an abstract design and a sacred object in America. It is to be saluted with respect and to burn it as a political statement is a criminal offense. Some see significance in the fact that the series was produced during the McCarthy era—a time of hysterical patriotism. Johns's silence allows each viewer his or her own interpretation. It also gives the works a timelessness, as different people at different times will apply different meanings to it.

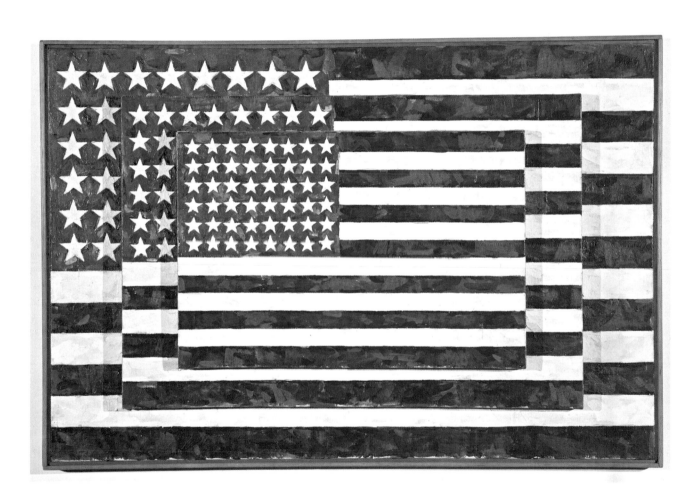

JASPER JOHNS *(1930–)*

DIVER 1962

Private collection / Courtesy of the Bridgeman Art Library

JASPER Johns grew up in South Carolina and attended the University of South Carolina. He served in the army before moving to New York in 1952 and he managed to support his own painting through his day job of creating designs for department store displays.

His first solo exhibition was in New York in 1958, where he showed his paintings of targets and flags. A section of a target is visible in this painting in the top left corner. Johns produced numerous collages and constructions that employed everyday objects, for example *Beer Cans* (1960). Developing alongside the Pop Art movement, these so-called ready-mades are cast in bronze and painted to look like originals. They play on the notion that any object can be claimed as an artwork. This illustrates the undeniable influence of Marcel Duchamp on Johns. Indeed, the work of Johns, along with that of Robert Rauschenberg, is often referred to as "neo-Dada."

Johns experimented with mixed media and his painterly canvases often incorporated "found" objects like rulers and brushes. Some of his paintings are collage, made up of layers of newspaper covered with encaustic paint (a wax medium). The objects and paint textures encourage the viewer to observe the action of painting. This can also be read another way: Johns and Rauschenberg reintroduced the figurative into painting and this is simply a critique of Abstract Expressionism. As with *Three Flags*, the meanings are ambiguous and the viewer is invited to decide.

JAMES ROSENQUIST (1933–)

THE MARGIN BETWEEN 1965

Smithsonian American Art Museum, Washington, DC/Courtesy of Art Resource/Scala

IN the 1950s Rosenquist worked as a painter of billboards and gasoline signage and at the end of the decade he began using similar techniques in his own paintings. His use of popular culture imagery linked him with the Pop Art movement.

One of his most famous works is *F-111* (1965), which is owned by the Museum of Modern Art in New York. The images Rosenquist chooses often create unusual juxtapositions, as in *F-111*, where pictures of consumer objects are placed alongside military pictures. One of the most striking things about Rosenquist's art is its sheer scale. After working as a billboard painter, Rosenquist was never frightened of working on large formats and his artistic creations were often monumental in scale. Sometimes the same size as those billboards, paintings would take up whole walls, some of them extending even further to take over other walls or wrap themselves around entire rooms.

Again with a nod to the precision required from his work with billboards, Rosenquist's works are finished to an extremely high standard and the gloss is reminiscent of media images designed to be alluring. Through his work Rosenquist asks the viewer to examine the power and effect of advertising on the viewer and as a result questions the manipulation of the masses made possible by modern media. His images of women explore the presentation of women in mass media, often with red glossy painted nails and suggestively applying lipstick to their open lips.

JIM DINE *(1935–)*

THE VALIANT RED CAR 1960

Smithsonian American Art Museum, Washington, DC/Courtesy of Art Resource/Scala

JIM Dine is best known for his Happenings and for the Pop Art objects and pictures he produced alone and with Claes Oldenburg in the 1950s and 1960s. Happenings were impromptu performances or events by artists which sometimes invited the participation of onlookers. Their aim was to blur the boundaries of "art" and "life" as the producer and the consumer became merged. It was these that formed the blueprints for the happenings, love-ins, and festivals that were an integral part of the hippie culture of the second half of that decade.

Happenings mostly took place in galleries, as with Dine's *Car Crash* (1960) at the Reuben Gallery in New York. Dine, dressed in a silver suit and a bandaged head, described a car accident he had experienced and kept interrupting his story with pleas for help.

He was a leading figure in the American Pop Art movement and also produced Pop in England, where he lived from 1967 to 1971. His Pop canvases, like this one, were aggressive and painterly with obvious similarities to Abstract Expressionism, but he often incorporated "found" objects too. These were household utensils and appliances and belonged to Dine himself, so had an autobiographical element. The use of writing and graffiti in art was particularly strong at this time and common in the work of Dine and Jean-Michel Basquiat.

FRANK STELLA *(1936–)*

FLIN FLON 1968

Private collection / Courtesy of the Bridgeman Art Library

FRANK Stella was born in Maiden, Massachusetts and studied at Philips Academy under John Pierpont Morgan. He went on to study at Princeton University between 1954 and 1958. On the completion of his studies he moved to the artistic center of New York and the first pictures that he produced were simple canvases on which the picture plane was divided by stripes of black or metallic paint, as seen, for example, in *The Marriage of Reason and Squalor II* (1959).

During the 1960s Frank Stella produced a series of abstract works in bright primary colors and it is these for which he is best known. Stella was one of a group of artists at this time who were building a new movement that rejected the gestural painting of Abstract Expressionism. They believed that Abstract Expressionism had pretty much run its course and that the artists had said all they were going to say. They felt that art had become more about attitude than substance, and as that attitude was now almost mainstream it was counting for less and less.

Stella's approach was almost diametrically opposed to Abstract Expressionism, as he painted pure shapes with clean lines and even went to the extreme of using industrial paint to create solid blocks of color and reduce the effect of painterliness. In a further move away from convention, he sought a detachment from his work, believing that the pictures should be able to stand alone, and he did not sign them and was loathe to explain them.

FRANK STELLA *(1936–)*

GREEN BORDER 1968

Private collection / Courtesy of the James Goodman Gallery, New York / Bridgeman Art Library

MANY critics have reacted in a rather negative manner to the work of Frank Stella, and have proclaimed it derivative of op art (optical art). Op art was a term that evolved in the 1960s, and which referred to abstract art that produced optical illusions, influenced by artists such as Josef Albers. As patterns converge, the canvases often seem to move in front of the viewer's eyes. Stella's work can often have this effect, but his aim was not merely to create an illusion. In the mid-1960s he started to produce paintings that played with shapes and colors and sometimes gave the impression of an extra dimension to the picture plane and sometimes left the spatial qualities ambiguous.

Stella's work was greatly influenced by that of Jasper Johns (see pages 222–5) and in particular by Johns's paintings of flags and targets. Stella responded to the notion that a painting was an object in its own right, and not simply a metaphor for something else. He rejected the idea that a painting should create an illusion, should represent something other. He declared that a painting was, quite simply, "a flat surface with paint on it—nothing more." Stella further explored the picture plane by using hexagonal, chevron, and X-shaped canvases that correlated with the shapes he painted on them. These shaped canvases also gave the paintings a sculptural aspect. As a result he has been an influential figure on many artists, and on the evolution of Minimal sculpture.

DAVID HOCKNEY *(1937–)*

PACIFIC COAST HIGHWAY AND SANTA MONICA 1990

Courtesy of David Hockney / Steve Oliver

THERE can be few schoolboys from the north of England who grow up to create art that embodies the Californian way of life quite as David Hockney has done. Because of his substantial depiction of American life and landscape the English artist is included in this history of American art. His contribution to American art is undeniably substantial.

Hockney was born in Bradford, England, and studied at the Bradford School of Art between 1953 and 1957. He then went on to the Royal College of Art and was a student there alongside R. B. Kitaj between 1959 and 1962. He was associated with the Pop Art movement in London and exhibited at the famous "Young Contemporaries" show in 1961.

Much of Hockney's work is clearly autobiographical and his life in the Golden State has provided him with a enormous amount of subject matter on which to draw. He first visited Los Angeles in 1963 and in 1976 he decided he would make it his permanent home. Hockney is probably most famous for the work he produced in the mid-1960s, particularly a series of paintings of swimming pools, such as *A Bigger Splash* (1967). The composition in these famous pictures of pools, modern houses, and gardens creates geometric patterns. There is very little perspective in them and this is enhanced by the solid blocks of acrylic color—predominantly the blue of the skies and pools of the state of California.

ED RUSCHA (1937–)

ART 1970

Courtesy of the Los Angeles County Museum of Art, Museum Acquisition Fund

ED Ruscha was born in Omaha, Nebraska, and grew up in Oklahoma City. In 1956, he moved to Los Angeles and had a number of jobs including working in a printer's shop setting type and layouts. His art education began at the Chouinard Art Institute, which he attended between 1956 and 1960, and he was also influenced by a trip to Europe and his study of the work of Jasper Johns. Ruscha began producing his own work and by the early 1960s was known for his paintings, collages, and prints. He was part of a group of artists who showed at the Ferus Gallery, together with Edward Moses, Ken Price, and Edward Kienholz.

Critics struggle to categorize Ruscha's work and the terms Pop Art, process art, conceptual art, photorealism, and media art have all been applied. Throughout his career he has incorporated elements of graphic design and references to popular culture. Ruscha's cutting-edge work of the 1960s used symbols from roadside signs and buildings and incorporated words and phrases. This illustrated the power the inclusion of a word could have over the viewer, for instance in *The Los Angeles County Museum of Art on Fire* (1965–68).

In the late 1960s Ruscha also produced so-called "liquid word" paintings, which gave the impression that the words were made of clear fluid, rather than paint. He often experimented with different and unusual media, including a series that he produced using gunpowder and another using pigments from vegetables.

The artist also used the more traditional medium of oil, most notably in his sunlit panoramic stereotypical views of Los Angeles like *The Back of Hollywood* (1977). In the mid to late 1980s Ruscha began working in acrylic applied with an airbrush to give a highly glossy effect. His most recent work is hyperrealist and depicts views of snow-capped mountains superimposed with unrelated words and maps of Los Angeles intersections.

CHUCK CLOSE *(1940–)*

PHIL III 1982

Smithsonian American Art Museum, Washington, DC/Courtesy of Art Resource/Scala

BORN Charles Close in Monroe, Washington in 1940, Chuck Close first attended the University of Washington in Seattle then Yale University School of Art and Architecture in New Haven, Connecticut. He moved to New York in 1967 and it was there that he began creating the highly original photorealist portraits that have made him an internationally celebrated artist. His work is so well known and so closely connected to him as an individual that, like Roy Lichtenstein, he has given his name to that style and any practitioner of it will inevitably be referred to as Close-like.

The photorealist movement evolved in America in the 1970s when a number of artists began producing paintings that resembled Polaroid snapshots. Close developed a system whereby he would reduce the photograph of his sitter to a grid of shapes and colors and copy it accurately in paint. It has been said that these images are in fact computer-generated, but Close has always denied this, and it remains something of a back-handed tribute to his precision that they are capable of fooling the eye. Some images very large and the effect is very different when seen from a distance or up close.

Close has produced many self-portraits throughout his career and has also painted the unknown and the famous. Roy Lichtenstein, Robert Rauschenberg, and even President Clinton have sat for Close. He asks sitters to wear everyday clothes so as not to detract from the focus of his painting—the human face.

BRUCE NAUMAN *(1941–)*

MY LIFE AS THOUGH IT WERE WRITTEN ON THE SURFACE OF THE MOON 1968

Sammlung Ileana and Michael Sonnabend/Courtesy of AKG Photo

BRUCE Nauman was born in Fort Wayne, Indiana and between 1960 and 1964 he attended the University of Wisconsin, and in 1966 the University of California in Davis. He is renowned for his teaching as well as his own art, and has taught in a number of institutions, including the San Francisco Art Institute and the University of California in Irvine. His first solo exhibition took place in 1972 at the Whitney Museum of American Art in New York, and was entitled "Bruce Nauman: Work from 1965–1972." Subsequently the show toured other locations.

Nauman's work ranges from sculpture, neon, film, and video, to performance and environment arts. The extent and breadth of his work makes him extremely difficult to categorize, but there are common themes in his work to which Nauman returns again and again, and these provide a continuity in what can otherwise seem a fairly random body of work. These common themes are social, sexual, political, and ethical subject matter and references.

America began the 1960s a rich, optimistic and confident country, but the effect of the Vietnam War had a huge impact on every aspect of American life. By the end of the decade the country had been divided in its beliefs, much as it had been by the Civil War. This anxiety was reflected in the work of many of the artists at the time, including Ed Kienholz, Louise Bourgeois, and Bruce Nauman. Nauman's work often includes contradictory messages and instructions which may insult the viewer or make him or her feel uncomfortable.

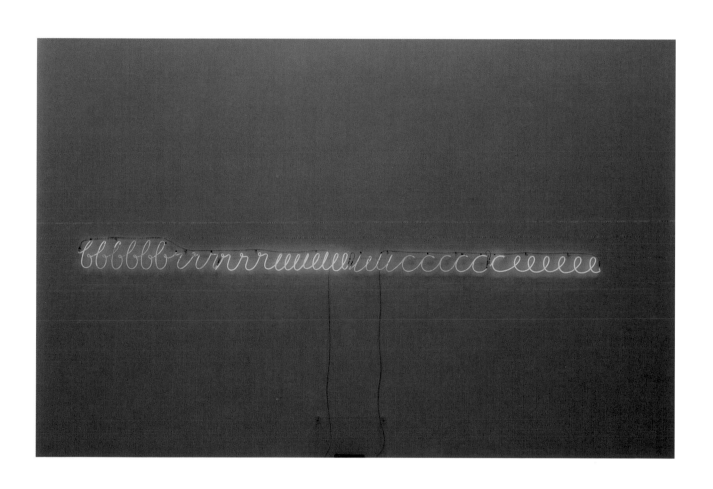

BRUCE NAUMAN *(1941–)*

RUN FROM FEAR/FUN FROM REAR 1972

Sammlung Ileana and Michael Sonnabend/Courtesy of AKG Photo

MUCH of Nauman's work is concerned with the human body and he was associated with the funk art movement. He developed his own form of body art using photography, hologram, and video. Funk art was a kind of scatological or pornographic art that came out of California in the 1960s. Funk art threatened acceptable social behavior and one of its main purposes was to upset and disturb the viewer. Like the Dada movement funk art often took the form of assemblages or performances. Even its name was rather crude as "funky" is slang for "smelly."

Nauman sometimes uses his own body as the medium in his art and was part of the body art movement. Body art was a by-product of conceptual art and performance art in the late 1960s and 1970s. These were just two of the art forms that Nauman engaged with in that time. He is an incredibly versatile artist who worked in numerous media and styles. Nauman has had an enormous influence on a new generation of video artists, and he continues to work today. His show in 1997–99 "Bruce Nauman: Image/Text, 1966–1996" at the Centre Georges Pompidou in Paris and other locations showed 30 years of his work. His art can also be violent towards the viewer, as in his 1969–70 work called *Live-Taped Video Corridor*, a performance and video installation in which he constructed a very narrow corridor that filmed the viewer's discomfort and disorientation when he or she entered it. Another is *Clown Torture: Dark and Stormy Night with Laughter* (1987), which explores feelings of alienation and anxiety. Nauman also revels in the ridiculous and his use of and plays on words can be humorous, as seen here in *Run from Fear/Fun from Rear* (1972). In 1999 Nauman won the Leone d'oro (Golden Lion) at the 48th Venice Biennale in Italy.

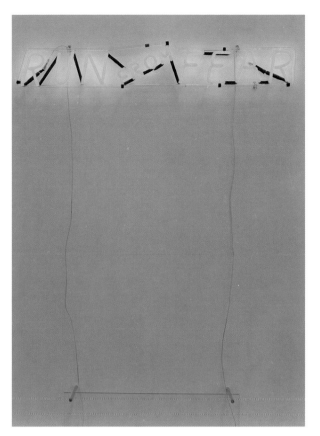

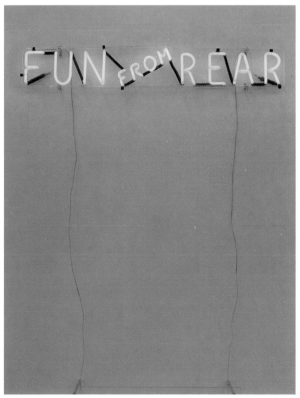

SHERRIE LEVINE *(1947–)*

FOUNTAIN (AFTER MARCEL DUCHAMP: A. P.) 1991

Collection Walker Art Center, Minneapolis T. B. Walker Acquisition Fund

SHERRIE Levine is an appropriation artist who questions the notion that the explanation and "answer" to creativity lies in who the artist is. The concept of appropriation is based around an artist taking another artist's work and claiming it as his or her own, thus exploring the notion of authorship. This is also evident in the work of Andy Warhol and Barbara Kruger.

Levine began her appropriation work in the early 1980s and has borrowed references from a number of artists, such as Walker Evans, Constantin Brancusi, and Marcel Duchamp. She has made new versions of well-known works by them and placed them in different contexts. She purposefully chooses the work of male artists to illustrate the lack of women in the established artistic canon. The work of an appropriation artist relies on the viewer identifying the model that the artist is questioning. This sculpture entitled *Fountain (after Marcel Duchamp: A. P.),* which she produced in 1991, is inspired by Marcel Duchamp's *Fountain* of 1917.

Duchamp's *Fountain* was a ready-made urinal which he turned upside down and signed "R. Mutt." He illustrated the point that any object can become a work of art if the viewer declares it to be so. Levine's *Fountain* is not a carbon copy of Duchamp's, it is cast in bronze, a traditional medium for sculpture. The medium transforms it from an everyday utilitarian object to an attractive work of art. While challenging the mystique and reverence attached to the original artist, Levine's work also highlights art history's linearity and points forward to a new generation of artists.

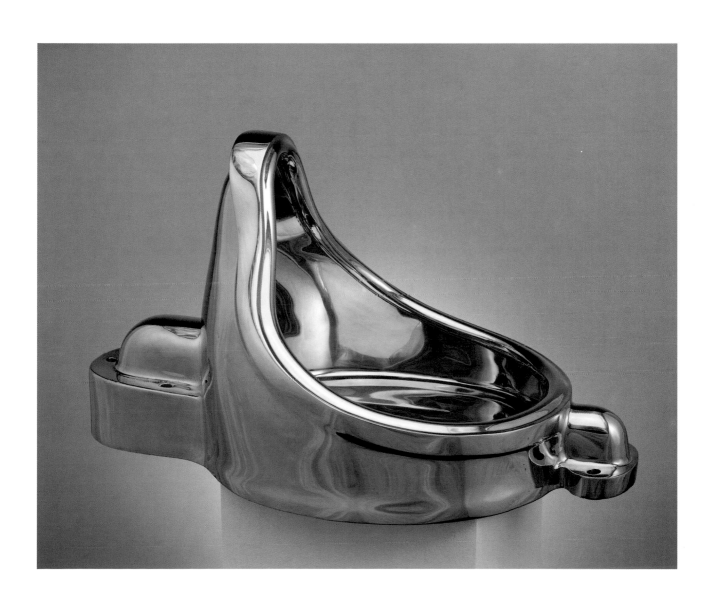

NAN GOLDIN *(1953–)*

MISTY AND JIMMY PAULETTE IN A TAXI, NYC 1991

Courtesy of the Tate Picture Library

"For me taking a picture is a way of touching somebody—it's a caress. I'm looking with a warm eye, not a cold eye. I'm not analyzing what's going on—I just get inspired to take a picture by the beauty and vulnerability of my friends."
Nan Goldin

NAN Goldin was born in Washington, DC, and grew up in a suburb outside Boston. Her interest in photography first developed when she was sixteen and attended the School of the Museum of Fine Arts in Boston. She moved to New York in 1978 and still lives and works there.

Since her arrival in New York she has kept a photographic diary of the lives of her friends, who are part of the art scene on the Lower East Side. Not only do the photographs celebrate her various friendships, but they also chart her friends' struggles with drug addiction and AIDS-related illnesses and provide a document of how the phenomenon of AIDS has wreaked devastation across certain communities. Her photographs explore a demi-monde of cross-dressers, transsexuals and a variety of sexual orientations—*Misty and Jimmy Paulette in a Taxi, NYC* is one of the most well-known portrayals of this world. Goldin's sympathy with her subjects and her nonjudgmental stance are evident in all her photographs. Her work traces the excesses of the 1970s and 1980s and the sobering effects of AIDS on society. She has said: "I used to think that I could never lose anyone if I photographed them enough. In fact, my pictures show me how much I've lost."

CINDY SHERMAN *(1954–)*

UNTITLED FILM STILL NO. 58, 1980

Solomon R. Guggenheim Museum, New York

CINDY Sherman was born in Glen Ridge, New Jersey, and grew up in Huntington Beach, Long Island. She studied art at the University College of Buffalo in New York. Sherman found fame with her first solo exhibition of *Untitled Film Stills* (1977–80), at Metro Pictures in New York in 1980.

In these *Film Stills* Sherman photographs herself dressed up in various costumes and adopts contrasting poses to recreate and to question the stereotypical images of women in contemporary mass media. In doing so she aims to examine the masquerade of femininity and present her rejection of the Western world's fictional representation of women. The artificiality of this culture is made all the more palpable by the viewer's knowledge that Sherman herself plays every role.

Feminist artists and groups in America have a history of examining the issue of artistic representation of women. One particular group dedicated to this cause is the activist group the Guerrilla Girls, who came to prominence in the 1980s when they began to attack art institutions for what they saw as a failure to include women artists in their exhibitions and collections. The humor of the Guerrilla Group caught the imagination of the press when they appeared in gorilla suits and pasted posters all over Manhattan asking: "Do women have to be naked to get into the Met. Museum? Less than 5% of the artists in the Modern Art sections are women, but 85% of the nudes are female."

Fred Wilson *(1954–)*

Mining the Museum 1992

Courtesy of Metro Pictures, New York

IN 1993 the artist Fred Wilson was invited by the Maryland Historical Society in Baltimore to curate an exhibition. The groundbreaking "Mining the Museum: An Installation by Fred Wilson" changed the way many people viewed museums, exhibitions, and curatorship. The population of the city of Baltimore is largely African-American and Wilson explored the reality that the history, culture, and views of Native and African-Americans in the area had been neglected or misinterpreted by the local museums.

Wilson, of African-American and Caribbean descent himself, "mined" the historical society's collection and created an installation that illustrated museums' and/or society's inherent racism, whether intentional or unintentional. Described by some as "artist as ethnographer" or a "museum interventionalist," Fred Wilson investigated how and why objects are selected for display and by whom. He chose over one hundred objects from the society's collection and arranged them in rooms representing themes of historical truths, emotions, slavery, dreams, and achievements. In the room exploring historical truths, for example, Wilson placed a bourgeois silver service in a cabinet together with slave shackles. By juxtaposing very different objects he illustrated that black history was not often related to white history and that white wealth was often the result of slavery.

Wilson graduated from the State University of New York at Purchase and worked in the education departments of museums in New York City. It was there that he began to examine museums' mission statements and their presentation of different histories. Wilson has stated that his work is not limited to African-American culture and suggests that installations could equally well examine museums' presentation of the history of women, Jewish history, or immigrant history. He has curated a number of shows in the same vein, collaborating for example with the Egyptology department at the British Museum and displaying artifacts so as to examine the museum's view of Egyptian cultural history.

JEFF KOONS *(1955–)*

JEFF AND ILONA (MADE IN HEAVEN) 1990

Sammlung Ludwig/AKG, London

JEFF Koons was born in New York. His initial career in New York's financial markets—he worked as a commodities broker on Wall Street—is an unusual beginning for an artist, to say the least, but it certainly gives us a great insight into Koon's particular approach to art and about the nature of his output. For many people he will be forever associated with the artist as celebrity and with the excesses of the money- and power-dominated 1980s, both because of his tireless self-promotion and because of the exorbitant price tags placed on his works.

Koon's work addresses issues of power, materialism, sex, obscenity, desire, and beauty in modern society and advertising's treatment of them. His intention is ambiguous and while commenting on consumerism and the commodification of art he also clearly benefits from it, applying skills he learnt on the money markets to the art market.

His best-known works, often described as kitsch, are a life-sized polychromed wooden sculpture of singer Michael Jackson and his pet chimpanzee Bubbles, basketballs floating in a glass tank, and pornographic sculptures and photographs of Koons and his now ex-wife, Ilona Staller. Ilona (perhaps better known as La Cicciolina) was a porn star and member of parliament in Italy. Koons, like Duchamp and Warhol before him, used everyday objects and images in his art to blur the divisions between high- and low-brow culture.

JEAN-MICHEL BASQUIAT *(1960–88)*

MAN FROM NAPLES 1982

Galerie Bruno Bischofberg, Zurich/AKG

JEAN-MICHEL Basquiat was born in 1960 to Haitian and Puerto Rican parents in Brooklyn, New York. He began his life as an artist in a somewhat controversial manner, vandalising buildings and subway cars in downtown Manhattan with graffiti. With this graffiti, which Basquiat created in magic markers and signed SAMO with a crown above it, he soon developed a cult following. So popular did his graffiti art become that Basquiat began working on canvas and selling his work. He wrote text on unprimed canvases, and drew pictures of faces that resembled African masks. He also painted on clothing and paper, and produced assemblages. Andy Warhol was an important mentor and friend to the young artist and the two collaborated on a number of works.

The origins of 1980s graffiti art were music and dance—rap, hip-hop, and breakdancing—American popular culture and, for some, like Basquiat, African culture. Keith Haring (1958–90) was another graffiti artist and contemporary of Basquiat. Haring used his graffiti art to raise awareness about AIDS, from which he later died. Both Haring and Basquiat were very successful financially and capitalized on an art market where the boundaries of what constituted art were being challenged. Basquiat originally took art out of the museum and the gallery by creating it all around him in the city in which he lived. His later career elevated street art and vandalism to the realms of high art. Basquiat died prematurely of a drug overdose at 28 years old.

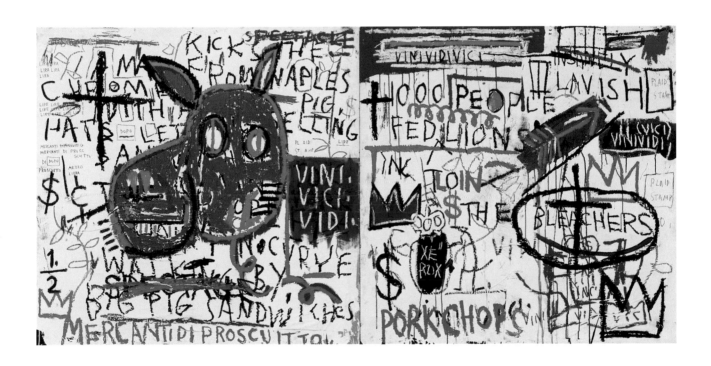

GLOSSARY

Abstract Expressionism: derived from abstract art (which finds meaning and value in the forms and colors of art rather than in its subject matter). "Ab-Ex" champions the power of the subconscious to express itself through "automatic painting" via the creation of involuntary shapes and drips of paint.

Armory Show: held in New York in 1913, an exhibition since acknowledged as having been instrumental in introducing modern, Postimpressionist art to the United States.

Ashcan School: name given to a group of US nineteenth- and twentieth-century Realist painters and illustrators—John Sloan, Robert Henri, and George Bellows among them— whose work concentrated on the seamier, urban side of life.

Bauhaus: school of architecture and design, founded in Weimar, Germany, in 1919, by Walter Gropius. Teachers there included Paul Klee and Wassily Kandinsky, but after its closure by the Nazis in 1933, the New Bauhaus opened in Chicago in 1937.

Color-field painting: spearheaded by Mark Rothko and Barnett Newman, this "paint for paint's sake" movement was concerned with the actual material and language of painting, utilizing the form as a vehicle for the expression of spiritual truth.

Conceptual art: work in which the emphasis placed on the idea is greater than that placed on the end result, and where documentation often becomes part of the art object.

Cubism: attempt, following Paul Cézanne, to concentrate on the structure and position in space of a subject rather than its outward appearance, resulting in the expression of an idea about the subject rather than a delineation of it.

Dada: literally "hobby-horse," deliberately provocative, anti-art, anti-meaning movement, a forerunner of Surrealism, which employed "found" objects and encouraged conscious outrages such as Marcel Duchamp's addition of a moustache to the *Mona Lisa*.

Expressionism: attempt to achieve artistic expressiveness by the use of exaggeration—even distortion—of color and line, emphasizing emotional impact rather than the naturalism aimed at by Impressionism.

Fauves: literally "wild beasts," a term applied to a group of artists—Henri Matisse and André Derain among them—whose penchant for wild colors and distortion attracted hostility at the 1905 Salon d'Automne in Paris.

Federal Art Project: attempt (1935–42) to funnel money into the arts to counteract the effects of the Depression, an offshoot from F. D. Roosevelt's New Deal and its consequent Works Progress Administration.

Futurism: movement launched by Marinetti in 1909, which claimed that "a roaring motor car, which runs like a machine gun, is more beautiful than the *Winged Victory of Samothrace*" and which concentrates on the depiction of machinery and figures in motion.

Impressionism: initially derisive term applied to a highly influential nineteenth-century artistic phenomenon, spearheaded by Monet (whose *Impression, Sunrise*, painted in 1872, gave the movement its name), Renoir, Degas, Morisot, Sisley, and others. Its proponents attempted to achieve naturalism by paying close attention to the effects of light, tone, and color.

Minimalism: an art style utilizing minimal color, minimal image, and asserting the self-sufficiency of the art work: "it's just there" was the movement's catchphrase.

Neoclassicism: an attempt to revive the strengths of Roman and Greek art in reaction to the perceived excesses of Baroque and Rococo.

New Realism: a reaction in favor of the figurative and against Abstract Expressionism (see above), led by Alice Neel in the US and Lucian Freud in the UK.

Op Art: (optical art) illusion-inducing productions, utilizing optical effects of the sort found in the work of Bridget Riley or Victor Vasarély.

Photorealism: movement begun in the US in the 1970s, spearheaded by Chuck Close and others, and which produced paintings resembling Polaroid photographs.

Pop Art: style utilizing features of modern life (photographs, posters, everyday objects, packaging, machinery, etc.) as ingredients of artistic productions. Among its chief exponents are Andy Warhol, Roy Lichtenstein, Jasper Johns, and Robert Rauschenberg.

Precisionists: group of artists, including Charles Sheeler, Charles Demuth, and Georgia O'Keeffe, who painted urban, industrial landscapes celebrating the clean lines and abstract patterns of such features as skyscrapers and bridges.

Realism: unlike Naturalism (the attempt to transcribe nature faithfully), a concentration on the darker, even squalid, side of life for moral purposes.

Regionalists: group of artists—Grant Wood, Thomas Hart Benton, John Steuart Curry—who championed an idyllic, rural, definitively American view of life in opposition both to the perceived superiority of European art and the less rose-tinted perception of their own country's Social Realists.

Social Realists: group of artists—among them Stuart Davis and Philip Evergood—who unflinchingly dealt with the social problems raised by the First World War, the Depression, etc.

Further Reading

The American Art Book (Phaidon, 1999).

H. H. Arnason *A History of Modern Art* (Thames and Hudson, 1998).

Ann Eden Gibson *Abstract Expressionism* (Yale University Press, 2000).

Jamie James *Pop Art* (Phaidon, 1996).

Ellen H. Johnson (ed.) *American Artists on Art 1940–80* (Westview Press Ltd, 1982).

Marco Livingstone *Pop Art* (Thames and Hudson, 2000).

Nicholas de Oliveira et al *Installation Art* (Thames and Hudson 1996).

Bennard Perlman *Painters of the Ashcan School: The Immortal Eight* (Dover Publications Inc., 1988).

Ivy Sundell *The Chicago Art Scene* (Crow Wood Publishing, 1998).

Kirk Varnedoe *Jackson Pollock* (Tate Gallery Publishing, 1992).